# PARIS
# ART GUIDE

**Fiona Dunlop**

**Art Guide Publications**

*Also available in this series:*
LONDON ART AND ARTISTS GUIDE
Second edition. Heather Waddell ISBN 0 9507160 0 6
NEW YORK ART GUIDE
First edition. Deborah Jane Gardner ISBN 0 9507160 4 9
AUSTRALIAN ARTS GUIDE
First edition. Roslyn Kean ISBN 0 9507160 3 0
THE ARTISTS DIRECTORY
(A handbook to the contemporary British art world)
First edition. Heather Waddell and Richard Layzell ISBN 0 9507160 57

PARIS ART GUIDE
Fiona Dunlop
ISBN 0 9507160 6 5
First edition April 1981 5000 copies
Reprint December 1981 7000 copies
Second edition March1983 10,000 copies

Photographs copyright Fiona Dunlop © 1983
Text copyright Fiona Dunlop © 1983
Maps copyright Fiona Dunlop © 1983

ISBN 0 9507160 6 5

*British Library Cataloguing in Publication Data*

Paris Art Guide — 2nd ed (Art Guide series)

1. Art — France — Paris — Handbooks manuals etc.

2. Paris (France) — Handbooks manuals etc.

1. Dunlop Fiona
914.4 '3604838 DC707

Published by ART GUIDE PUBLICATIONS
28 Colville Road London W.11 2BS England (01 229 4669)

Printed by Archway Press Ltd., Poole, Dorset, England

2

# CONTENTS

Introduction . . . . . . 7
Practical Notes . . . . . . 8
Museums . . . . . . . 8
    Future Museums . . . . . . 21
    Museums outside Paris . . . . . 22
Architectural Wonders . . . . . 26
Commercial Galleries: . . . . . 29
    Right Bank . . . . . . 29
    Left Bank . . . . . . 33
    Les Halles/Le Marais . . . . . 42
    Prints/Art Posters . . . . . 50
    Photography . . . . . . 52
Foreign Cultural Centres . . . . 56
Alternative art spaces and groups . . . 57
Art Organisations . . . . . . 60
Salons . . . . . . . 62
Art prizes and grants . . . . . 64
State aid . . . . . . . 66
Sponsorship . . . . . . 69
Photography/film/video: . . . . . 71
    Schools and courses . . . . . 71
    Audiovisual organisations . . . . 72
    Public photographic collections . . . 74
Print studios . . . . . . 75
Materials and suppliers: . . . . . 76
    Fine Arts and graphics . . . . 76
    Photography . . . . . . 78
    Sculpture . . . . . . 80
    Printmaking . . . . . . 80
    Framing . . . . . . . 80
    Restoring . . . . . . 81
    Art transporters . . . . . . 81
    Fabrics . . . . . . . 82
Art magazines . . . . . . 82
Art critics . . . . . . . 84
Bookshops: . . . . . . . 86
    Anglo-American . . . . . . 86
    Other foreign bookshops . . . . 87
    Arts bookshops . . . . . . 87
Art Libraries . . . . . . 90
Art schools: . . . . . . . 91
    State . . . . . . . 91
    Private . . . . . . . 92
    Local art-classes . . . . . . 93
Summer out of Paris — the Festivals: . . 96
    Visual Arts & Photography . . . . 96
    Film . . . . . . . 97
    Dance . . . . . . . 97
    Jazz & classical music . . . . . 98
    Mixed arts festivals . . . . . 98
    Festivals in Paris . . . . . . 99

GENERAL PARIS INFORMATION
    Transport & travel . . . . . 100
    Travel outside Paris . . . . . 101
    Emergency information . . . . . 103
    Antiques/Auctions/Markets . . . . 103

# CONTENTS — Continued
## GENERAL PARIS INFORMATION

Music-places:
jazz-clubs . . . . . . 108
discotheques . . . . . . 108
Café-théâtres . . . . . . 110
Salons de thé . . . . . . 110
Restaurants:
Les Halles/Bourse . . . . 114
Le Marais . . . . . . 116
St-Germain . . . . . . 119
Montparnasse . . . . . . 120
5th district . . . . . . 123
Other districts . . . . . 123
Parks & gardens . . . . . 124

Maps
St Germain Area . . . . . IBC
Beaubourg Area . . . . . IFC

# INTRODUCTION

Paris was once considered the art-capital of the world, rich with a cosmopolitan community of artists, writers and performers whose new forms echoed and re-echoed throughout the world. This together with a historical setting of astonishing beauty and intimacy made Paris the obvious and natural place to be for artists. Helping hands were lent by its galleries, salons and its essentially outdoor cafe life, enabling exchanges and inevitable clashes in theory and outlooks to run well into the depths of the boulevard night. However this sizzling cultural existence was interrupted by the Second World War leading to an exodus of artists heading, principally, for the U.S.A. Since then Paris has re-emerged, still bubbling and creating, with movements ranging through the late Surrealists, the École de Paris, Abstraction Lyrique, Nouveau Réalisme, Nouvelle Figuration, Support Surface and recently Figuration Libre — a rather delayed version of German and Italian movements. The commercial gallery circuit is generally rather less active in promoting new individual trends than in defending established artists and forms, although there are many exceptions. Alternative artists' spaces and group exhibitions organised by artists themselves are however a growing phenomenon and, together with more public recognition and financial support from the State, may lead to an 80's renaissance.

Photography, too, is gaining ground: the market is becoming professionally more organised and museums are building up considerable collections with consequent regular exhibitions. Parallel to this are the various film-making collectives and video groups, listed in the guide, which provide some absorbing viewing.

The fascination of the Parisian art-world lies above all in its international flavour whether found amongst current exhibitors or in the numerous arts festivals with invited foreign artists — an awareness of the rest of the world being essential for any possible overview. This cultural whirl in its superb Parisian setting complete with culinary and alcoholic pleasures is difficult for any visitor to reject but can also be bewildering in its complexity. This guide attempts to open up the horizon whether for visitors whose interests lie in this field or for long-term stays when the type of information listed will cut a few awkward and lengthy corners and hopefully lead to useful contacts. Obviously the area covered is a nebulous affair in which, apart from museums, organisations chop and change and come and go, so by its very nature the guide can never be exhaustive. In view of this I would be most grateful for any comments or further information to be included in the next edition and I thank those readers who sent some useful additions to the first edition. Further gratitude is extended to all organisations, public and private, that responded to my information-battering and also to the patience of Jean-Claude Meynard and the enthusiasm of Janice Hinckelfuss.

Fiona Dunlop                                    Paris, November 1982

# PRACTICAL NOTES

For easy locomotion invest in a *Plan de Paris* — arrondissement and street map. Free transport maps are available at most metro stations. For weekly events and general entertainment addresses buy *Pariscope* or *L'Officiel des Spectacles* — both out on Wednesdays. Remember that Monday evening gives a 30 per cent reduction at most cinemas, otherwise student reductions are valid weekdays only. Gallery private views (vernissages) are listed in various art publications and it is not generally frowned upon to attend, above all in smaller galleries, in order to meet others involved in the same field. A useful address for finding rented accommodation in Paris by the week, often with a bed and breakfast type system, in flats of all sizes is **Paris Accueil** 23 rue de Marignan, 8e 296.1426/256.3747. For student hostels etc see A.J.F. under TRAVEL section. Foreign artists living in France who need a residence permit "Carte de Séjour" should obtain an "attestation de professionalité" as the first bureaucratic step from **Confédération des Travailleurs Intéllectuels,** I rue de Courcelles, 8e 563.7328. Any correspondence to addresses listed in this guide should include 7500 before the arrondissement number.

# MUSEUMS

Traditionally Paris has always sheltered a vast and varied cosmopolitan art community, leaving the city with an equally rich heritage scattered and categorised throughout its myriad museums. The following lists cover not only the major art collections such as the Louvre and the Centre Pompidou which most visitors make a bee-line for on arrival, and why not, but also the smaller more specialised and intimate museums which can give insights into centuries, crafts or characters previously unknown to the visitor. So before embarking on a frenzied A — Z attack it is wise to figure out exactly where your interests lie. With the more obscure places it is advisable to check by phone beforehand as their idiosyncracies can be frustrating. Remember too that public holidays are always a good excuse to close, as is August for the smaller musuems, and watch out for the ubiquitous Monday and Tuesday closures throughout the year. Entrance can be costly, although students and teachers often get reductions and permanent collections are generally half-price or free for everybody on Sundays if you can weave through the millions. Otherwise all public museums have one day a week free entrance, mentioned by each below. Various membership schemes exist with varying benefits and aims — see the Musée d'Art Moderne de la Ville de Paris, the Louvre, the Bibliothèque Nationale, the Centre Pompidou for individual details.

**Direction des Musées de France** Hôtel d'Orsay, 9 Quai Anatole France, 7e (Bureau des Relations Extérieures: 544.4041 Organizes guided tours and lectures for groups.)

**Centre d'Information de la Ville de Paris** Hôtel-de Ville, 4e Museum information: 278.7381

**C.N.M.H.S.** Hôtel de Sully, 62 rue Saint-Antoine, 4e 274.2222 Organizes daily lecture tours round Paris and Ile-de-France

**Musée de l'Affiche et de la Publicité** 18 rue du Paradis, 75010 Paris 824.5004. metro: Château d'Eau. Open 12 — 6pm. Closed Monday & Tueday.
A rare museum dedicated to the development of the poster as an art-form and recently extended to cover the world of advertising. Regular temporary thematic exhibitions show sections of their extensive collection. The latest 'hits' in cinema and TV ads, together with extraordinary goodies from 1912 on, can be seen in a projection-room, while an advertising documentation and research section is housed upstairs. Painted ceramic tiles camouflaging the entrance courtyard make entry a pleasure too, at the same time revealing the building's origins — once a china warehouse.

**Musée de l'Armée** Hôtel des Invalides, 75007 Paris. 555.9320. metro: Invalides, Latour-Maubourg. Open 10-6pm. every day.
All a war-historian needs to see on military history from its origins to World War II: weapons, armour, uniforms, battle-plans, paintings as well as documentaries and films on the two world wars shown every afternoon in the cinema-room on the ground floor. Napoleon's imposing tomb can also be inspected.

**Musée de l'Art Juif** 42 rue des Saules, 75018 Paris. 257.8415. Open Tuesday, Thursday and Sunday 1-6pm. Closed in August.
A collection of historical and ethnic artifacts of the Jewish civilisation — maquettes of synagogues, decorative arts, sculpture, prints, photos, and some contemporary paintings — Chagall, Benn, Lipschitz. Well documented library with information on contemporary Jewish art.

**Musée d'Art Moderne de la Ville de Paris** 11 Ave du Président Wilson, 75016 Paris. 723.6127. metro: Iéna. Open 10-5.30pm and till 8.30pm on Wednesday. Closed Monday. Free on Sunday.
This monumentally sized and styled building houses the municipal collection of modern art with particular emphasis on Cubism, Fauvism, the Ecole de Paris, Gromaire and Matisse. Dufy's $60 \times 10$ metre mural homage to the wonders of electricity can be seen together with some excellent temporary exhibitions.
With the advent of Beaubourg, this lofty, rather gloomy museum is often mistakenly overlooked, although its contemporary department, A.R.C. (Animation-Recherche-Confrontation), arranges some exciting exhibitions of young artists. ARC 2 arranges regular musical and audio-visual events and there is also a Musée des Enfants catering for children's budding creative urges.

**Musée d'Art Russe Non-Officiel** Château du Moulin de Senlis, 91 Montgéron. 942.9652. Open 2-7pm but phone to check. Train from Gare du Nord.
A recently opened centre exhibiting works by Russian dissident artists, many of whom have chosen to live in Paris.

**Musée National des Arts Africains et Océaniens** 293 Ave Daumesnil, 75012 Paris. 343.1454. metro: Porte Dorée. Open 9.45-12/1.30-5.15pm. Closed Tuesday. Free on Wednesday.
A move away from Europe into the arts and crafts of Africa and France's ex-colonies in the Pacific. To lull the visitor even further away there is a tropical aquarium and audio-visuals.

**Musée des Arts Decoratifs** 107 rue de Rivoli, 75001 Paris. 260.3214. metro: Palais Royal, Tuileries. Open 2-5pm. Closed Tuesday. Temporary exhibitions open 1-7pm, weekend 11-6pm.
Situated in the Louvre complex this museum houses a magnificent collection of decorative arts/crafts — furnishings, furniture, ornaments etc. — from the Middle Ages to the present. As you glide over the highly polished floors you can also admire the Tuileries through the windows and for any documentation, go to the library (at no. 109) which has an extensive collection of books and magazines on the arts. It is open to the general public. Otherwise there are some important temporary exhibitions, often going beyond the purely "decorative arts" category.

**Musée National des Arts et Traditions Populaires** 6 Ave du Mahatma-Gandhi, 75116 Paris. metro: Sablons. Open 10-5.15pm. Closed Tuesday. Free on Wednesday.
Pre-industrial France seen through reconstructed interiors, furniture, models, and maquettes of rural life, exploring its roots — a far cry from the sophistication and riches of the Musée des Arts Decoratifs (above). Another section shows the techniques used in daily crafts with occasional demonstrations. Documentation section open Wednesday and Thursday.

**Maison de Balzac** 47 rue Raynouard, 75016 Paris. 224.5638. metro: Passy, La Muette. Open 10-5.40pm. Closed Monday. Free on Sunday.
An intimate museum in Balzac's abode of 1840-47, containing a specialist library, devoted to his works, criticisms and many of his contemporaries works. There is also a display of portraits and caricatures of Balzac himself.

**Bibliothèque Forney** Hôtel des Archevêques de Sens, 1 rue du Figuier, 75004 Paris. 278.1460. metro: St. Paul, Pont-Marie. Open 1.30-8.30pm. Closed Sunday and Monday.
Worth a detour if you are strolling in Le Marais — a fine example of a late 15th century "hotel" which is now being used for changing historical exhibitions of the applied arts — from illustration to patchwork — as well as housing an arts/crafts reference and lending library.

**Bibliothèque Nationale** 58 rue de Richelieu, 75002 Paris. 261.8283. metro: Bourse, Palais-Royal. Open 12-6pm every day.
This is the storing-house for a copy of every book, lithograph and newspaper ever printed in France. The library itself, (over 5 million books), is only open to authorized researchers and writers,

but take a peep through the doors at the soaring domed glass ceiling. Otherwise, there is a permanent collection of medals and antiques, both Oriental and Western, cameos, jewels from the Royal collections, prints, engravings, photographs, and several galleries which hold changing exhibitions of historical and contemporary interest. The "Galerie de Photographie", just across the road at 4 rue Louvois, (open 12-5pm, closed Sunday) holds some interesting shows of work by international photographers, known and unknown.

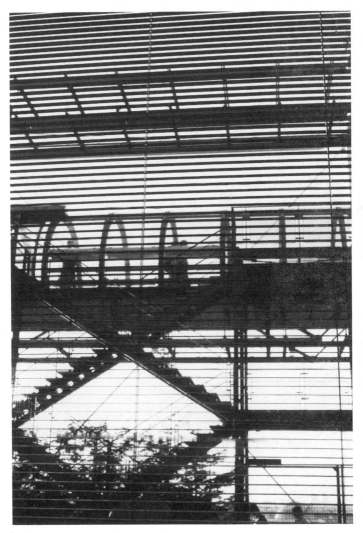

*Beaubourg inside-out.*

**Atelier-Musée Henri Bouchard** 25 rue de l'Yvette, 75016 Paris. 647.6346. metro: Jasmin. Open 2-7pm Wednesday & Saturday only.

The studio of Henri Bouchard, an official sculptor in the academic tradition who lived from 1875-1960. Sculptures, medals exhibited.

**Musée Bourdelle** 16 rue Antoine-Bourdelle, 75015 Paris. 548.6727. metro: Montparnasse, Falguière. Open 10-5.40pm. Closed Monday. Free on Sunday.

Tucked away behind Montparnasse station is this enormous and fascinating collection of Bourdelle's sketches and sculptures (over 1000) — both maquettes and casts — of all dimensions and in styles ranging from neo-Classicism to neo-Rodin. His studio and garden provide an overgrown setting, and a library is available for bona fide researchers.

**Musée Carnavalet** 23 rue de Sévigné, 75003 Paris. 272.2113. metro: St Paul. Open 10-5.40pm. Closed Monday. Free on Sunday.

For a complete understanding of Paris and its inhabitants this museum provides a fascinating background covering Parisian history from 16th-19th century i.e. from the flamboyant Francis I to the post-Napoleonic Republic with passing nods at the Revolution illustrated by mini-guillotines. Housed in a magnificent Renaissance building, once the home of the prolific epistolist Mme de Sévigné.

**✗ Centre National d'Art et de Culture Georges Pompidou** (commonly known as Beaubourg) Plateau Beaubourg 75004 Paris. 277.1233, recorded information: 277.1112. metro: Rambuteau, Hôtel-de-Ville, Châtelet. Open noon-10pm, week-end 10am-10pm. Closed Tuesday. Free on Wednesday.

Little more can be added to the notorious Beaubourgian controversy which has raged since its 1977 opening - except that it has overtaken the Eiffel Tower as number one on the tourist itinerary. It throbs daily to the tune of an average 25,000 pairs of culture-curious feet, while its only apparent defect is that of overcrowding in the summer months (try taking a lift to the 5th floor instead of suffering the glasshouse temperature of the caterpillar escalators). Its innovative free-weaving design allows fabulous perspectives and this openness is reflected in the flavour of the numerous inter-disciplinary exhibitions which are constantly changing.

The permanent national collection of modern art is on the 3rd and 4th floors and this alone makes a visit worthwhile, with its superb panorama of 20th century art from the Cubists, Futurists, Surrealists through to more contemporary 'nouveau realisme' and conceptual work.

Temporary large-scale exhibitions — thematic or retrospective — are held in the galleries on the 5th floor next to the cinémathèque (the cheapest cinema in Paris along with its sister at the Palais de Chaillot, and with extensive daily programmes), which in turn sidles with the snack-bar and restaurant, both with panoramic views of Paris. Other sections in the Centre include an excellent reference library with audio and visual facilities, a current periodicals — comics and record room, a music research and

performance unit in the basement, directed by Pierre Boulez (IRCAM) with regular concerts and dance performances, an urban design gallery and library (C.C.I.), a photography gallery and a well-stocked international arts bookshop. All that's left is to visit the centre... various news-sheets provide details on current activities and the information desks are always helpful. Entrance fees can mount up, so it's worth getting a "Laissez-Passer" valid for a day which covers all current exhibitions, or go on a Wednesday which is free.

**Musée National de Céramique de Sèvres** 4 Grande Rue, 92310 Sèvres. 534.9905. metro: Pont de Sèvres then walk across bridge. Open 9.30-12/1.30-5.15pm. Closed Tuesday. Free on Wednesday.
This collection not only displays examples of the famous Sèvres porcelain but also covers European pottery of the Middle Ages, Islamic & Chinese ceramics, Italian Majolica and a variety of European 17th, 18th and 19th century porcelain. Situated on the Seine and with easy access to the centre of Paris.

**Musée Cernuschi** 7 Ave Velasquez, 75008 Paris. 563.5075. metro: Villiers. Entrance to the museum at 111 Boulevard Malesherbes. Open 10-5.40pm. Closed Monday. Free on Sunday.
Originally a private collection, now donated to the Ville de Paris, which gives an impressive vista of ancient Chinese art, ranging from 1300 B.C. jades and bronzes to 200 B.C. funeral statues, to Buddhist statues and paintings on silk, covering the Han to the T'ang dynasties. A separate room displaying contemporary Chinese paintings provides startling comparisons.

**Musée du Cinéma (Henri Langlois)** Palais de Chaillot, Place du Trocadéro, 75016 Paris 704.2424. metro: Trocadéro. Open only for guided visits 10.30-4.30pm. Closed Monday. Phone to check times of tours.
A revelation for film-lovers. In the same imposing block as the Musée de l'Homme, this museum displays cinema-related objects: scripts, projectors, photos, décors, posters, stars' costumes and other nostalgia dating from the origins of this art (1895 Brothers Lumière) to the present. Particular attention is paid to Meliès, with a reconstruction of his studio and elements from his films. Downstairs is the cinémathèque, with a valuable and varied programme worth following.

**Musée et Hôtel de Cluny** 6 Place Paul-Painlevé, 75005 Paris. 325.6200. metro: St. Michel, Odéon. Open 9.45-12.30/2-5.15pm. Closed Tuesday. Free on Wednesdays.
A combination of 2nd century Gallic-Roman ruins and a 14th/15th century 'hôtel' provide the setting for this beautiful museum of the Middle Ages, now paradoxically on the fraught cross-roads of St Michel and St Germain. Famous for the "Dame à la Licorne", a series of 6 tapestries finely preserved, it also displays a rich collection of medieval treasures — statues, the "Book of Hours", carvings and varied objects. Well worth visiting, if only to escape from the very evident 20th century feel of the Boulevards.

**Musée de la Contrefaçon** 16 rue de la Faisanderie, 75116. 501.5111. metro: Porte Dauphine. Open 8.30-5pm. Closed at week-ends.

Counterfeits and imperceptibly altered labels: a museum which goes from "Audak", made-in-Portugal cameras, to those eternal Louis Vuitton initialled bags obtainable for a song in the Italian markets. . . through not quite the real thing. Chanel once stated that as long as her designs were copied it meant that she still had talent — but the big name labels now grind their teeth over their "defence" budgets. Here you can see examples of the ingenuous wide range covered by the counterfeiting industry — as well as its penalties.

**Musée National Delacroix** 6 Place de Furstemberg, 75006 Paris. 354.0487. metro: St Germain. Open 9.45—5.15. Closed Tuesday. Free on Wednesday.
Situated on a beautiful little square just behind St Germain, Delacroix's studio and flat now contain a collection of his drawings, documents and prints (for his paintings see the Louvre), and there is also a small garden and occasional special exhibitions.

**Fondation Le Corbusier** 8 Square du Docteur Blanche, 75016 Paris. 228.4153. metro: Jasmin. Open 9-1/2-5pm. Closed weekends and August.
Housed in Villa La Roche, designed by Le Corbusier in 1923, this collection is an opportunity to see Le Corbusier's "Esprit Moderne" work as a painter and sculptor as well as providing an extensive library with microfilm of his designs and drawings. Various architectural activities are organised here.

**Musée de la Franc-Maçonnerie** 16 rue Cadet, 75009 Paris. 523.2092. metro: Cadet. Open 2-6p.m. Closed weekends.
Try and fathom the secrets of the Freemasons through their ritualistic past — rather dusty small museum with documents and objects, more suitable for fellow Masons.

**Manufacture Nationale des Gobelins** 42 Ave des Gobelins 75013 Paris. 570.1260. metro: Gobelins. Workshops open Tuesday, Wednesday, Thursday pms. at certain hours.
This famous old tapestry industry has recently been reinjected with life and funds by the government and it is possible to visit the workshops to see future products in the weaving.

**Grand Palais** (Galeries Nationales) Ave Winston-Churchill, 75008 Paris. 261.5410. metro: Champs Elysées-Clémenceau. Open 10-8pm, Wednesday till 10pm. Closed Tuesday.
Built for the Paris Exhibition of 1900 along with the Petit Palais this vast and magnificent domed building is divided into several galleries which hold large-scale, changing exhibitions. Numerous "salons" are held here, and negotiations are underway to make it a regular home for **all** the salons, as it traditionally was. The Paris Book Fair and F.I.A.C. (Paris Art Fair) are also annual visitors. Facilities include films, a library and a snack-bar.

**Musée Grévin** 10 Boulevard Montmartre, 75009 Paris. 770.8505. metro: rue Montmartre. Open 1-7pm every day.
Here is hyperrealism revisited, inspired by Madame Tussaud's in London and almost as good. Constant new "in the headlines" additions remind you of recent budding starlets and who's President, amongst others.

**Musée National Guimet** 6 Place d' léna, 75116 Paris. metro: léna. Open 9.45-12/1.30-5.15pm. Closed Tuesday. Free on Wednesday. Annexe at 19 Ave d'léna.
The national collection of oriental art is found here, near the Musée d'Art Moderne, and impressively covers Afghanistan, India, Vietnam, Cambodia, Nepal, Japan, China and Korea, with audiovisuals to give a background to the fabulous works of art displayed. Both a library and a photo-library are available for research but check beforehand for opening hours. The annexe holds a collection of Japanese Buddhist iconography.

**Musée National Hébert** 85 rue de Cherche-Midi, 75006 Paris. 222.2382. metro: Vaneau, Sèvres-Babylone. Open 2-6pm. Closed Tuesday.
A walk along this long and winding street is always fascinating, so have a look at the paintings, water-colours and drawings of Ernest Hébert (1817-1908), a fairly orthodox society painter who later dabbled with the Symbolist movement. Occasional wider-based exhibitions are held.

**Musée de l'Histoire de France** 60 rue des Francs-Bourgeois 75003 Paris. 277.1130. metro: Rambuteau, Hotel-de-Ville. Open 2-5pm. Closed Tuesday. Free on Wednesday.
Situated in the heart of Le Marais the enormous and elegant "Hôtel de Soubise" lies halfway between the high-tech of Beaubourg and the dynamic exhibition centre, Centre Culturel du Marais. This however is another epoch and suitably houses the national archives. Various important historical documents are displayed and two rooms are devoted to the 1789 Revolution.

**Musée Nationale de l'Histoire Naturelle** 57 rue Cuvier, 75005 Paris. 336.5426. metro: Gare d'Austerlitz, Monge, Jussieu. Open 10-5 pm. Closed Tuesday.
Peacefully situated in the Jardin des Plantes (see Parks) this natural history museum houses numerous departments, each with its own opening hours. Included are Paleontology, comparative anatomy (a wonderful collection of skeletons), minerology, entomology as well as a menagerie and a maze in the gardens. Their temporary exhibitions can be fascinating.

**Musée de l'Holographie** Level 1, Forum des Halles, 75001 Paris. 296.9605. metro: Châtelet. Open 11-7pm (Sunday 2-7pm) Closed Tuesday.
Contemporary art/technology with stunning/disturbing displays of lasers and holograms. Changing exhibitions of international artists working with this fast-developing 3-D art-form, which could revolutionise many aspects of industrial creation and communication.

**Musée de l'Homme** Palais de Chaillot, Place du Trocadéro, 75016 Paris. 553.7060. metro: Trocadéro. Open 10-5pm Closed Tuesday.
Anthropological and ethnological wonders from Maori earrings to African masks, can be seen here as well as a prehistoric section. Several simultaneous temporary exhibitions are held regularly. The **Musée de la Marine** can be found next door with its extensive collection of maritime history, art and techniques from the 17th century onwards.

**Maison de Victor Hugo** 6 Place des Vosges, 75004 Paris. 272.1665. metro: St Paul, Bastille. Open 10-5.40pm. Closed Monday. Free on Sunday.
Victor Hugo lived here in the Hôtel de Rohan-Guéménée looking out over the porticos and trees of the square, from 1832-48. It now contains Hugo memorabilia:- his inkstand, letters, manuscripts, his own drawings and hand-decorated furniture, and various portraits of him, including a bust by Rodin. The library containing his works and a print collection is open to researchers.

**Musée Instrumental** 14 rue de Madrid, 75008 Paris. metro: Europe. Open 2-4.30pm. Wednesday and Saturday only. Closed August.
For those whose interests lie in a musical direction, this museum is fascinating. It is situated near the "Conservatoire" — Paris' Academy of Music, hence the density of music and instrument shops in the area and that double-bass you followed out of the metro. Lutes, lyres, harpsichords and numerous other ancient instruments are displayed, finishing with a blast on the bagpipes.

**Musée Jacquemart-André** 158 Boulevard Haussmann, 75008 Paris. 562.3994. metro: St. Philippe-du-Roule, Miromesnil. Open 1.30-5.30pm. Closed Monday and Tuesday and in August.
Situated near the main cluster of Right Bank galleries this beautifully cared for museum contains both 18th century French paintings (Watteau, Boucher) furnishings and tapestries and works of the Italian Renaissance (Titian, Botticelli, Uccello). Varied changing exhibitions have recently ranged from a retrospective of Vogue magazine photography to Leonardo da Vinci's Codex Hammer.

**Musée National du Jeu de Paume** Place de la Concorde, 75001 Paris. 260.1207. metro: Concorde. Open 9.45-5.15pm. Closed Tuesday. Free on Wednesday.
Set overlooking the frantic Concorde and at the far end of the Tuileries gardens, this is perhaps the most easily digestible and popular of Paris' museums (it apparently has the highest density of visitors per square metre of all museums in the world), its fabulous collection of Impressionist paintings being the reason — with their light and colour of scandal — a turning-point in the history of art. The collection is particularly strong on Degas, Gauguin and Van Gogh, while Manet's notorious "Déjeuner sur l'Herbe" dominates an end wall.
Just across the Tuileries is the Orangérie where Monet's "Waterlilies" occupies one entire room.

**Musée Kwok-On** 41 rue des Francs-Bourgeois, 75004 Paris. 272.9942. metro: Rambuteau, St Paul. Open 12-6pm. Closed week-ends.
A recently opened museum based on a collection from Hong-Kong which has been extended by other organisations. A wonderful array of colourful Asiatic theatrical objects — costumes, masks, string and shadow puppets, instruments, paintings, etc. are grouped according to their origin. The Japanese showcase has some superbly sculpted heads used for their doll theatre and unique outside Japan, while the Chinese Opera costumes are unrivalled in their richness. At the same time you learn that even

Greece once used shadow puppets. A documentation centre is available with films, photographs, recordings, books and magazines

**✗ Musée National du Louvre** Palais du Louvre, 75001 Paris. 260.3926. metro: Louvre, Palais-Royal. Open 9.45-5.15pm, some rooms till 6.30pm. Closed Tuesday. Free on Sunday and Wednesday.

This mammoth labyrinthine complex, originally a royal palace, houses the national art collection, starting with Egyptian and Coptic antiquities and finishing with the 19th century pre-Impressionist school. If you enter at the main entrance, porte Denon, it is easy to get stuck in the Greek, Roman and Egyptian sections, so, with a wave at Venus de Milo (now being reclaimed by the new Greek government) keep going. You will discover the beauties of the Renaissance, (Mona Lisa rules OK), the Dutch and Flemish Schools, the vast canvases of Géricault and of course Delacroix, Ingres, Gros, David, Corot . . . the illustrious names are all there, but it is impossible to see them all in one day. The Pavillon de Flore (geographically speaking the south-west wing) holds changing exhibitions and if there are long queues at the main entrance you can nip in here and work backwards. The bookshop has a wide range of catalogues and art books as well as a money exchange booth, and a selection of rather pricey repros of Louvre objects. Flagging visitors can go to the snack-bar on the first floor of the Pavillon Mollien and gaze out at the Tuileries and Maillol's sculptures.

**Musée des Lunettes et Lorgnettes de Jadis** Pierre Marly, 2 Ave Mozart, 75016 Paris. 527.2105. metro: La Muette. Open 9-1/2-7pm. Closed Sunday and Monday.

Another of Paris' eccentric private collections: 3000 examples of spectacles, reading glasses, binoculars, monocles etc. can be seen in this smart optician's shop, including the first western 13th century examples and the latest Eskimo designs. A paradise for myopics.

**Musée de la Machine à Sous (Las Vegas Museum)** Quartier de l'Horloge, 23 rue Beaubourg, 75004 Paris. 274.7721. metro: Rambuteau. Open 11-7pm every day

Hidden in an alleyway in the shopping/appartment complex next to Beaubourg, here is the universe of pinball wizards and addicts of one-armed bandits. Flashing lights and traditional garish colours greet you at the entrance before being swallowed into the nocturnal atmosphere with its range of machines from 1850-1980. The craft and decoration used in the older models is astonishing while heros of each era are immortalised.

**✗ Musée Marmottan** 2 rue Louis-Bouilly, 75016 Paris. 224.0702. metro: La Muette. Open 10-6pm. Closed Monday

This private collection now run by the Institut de France originally covered the Napoleonic period — paintings, sculpture and furniture — until Michel Monet's legacy was added so that it now possesses a superb display of Impressionist paintings, particularly Monet, together with Renoir, Signac, Pissarro, Manet, and Marmottan himself. The Wildenstein collection of chandeliers, and other lighting are also kept here. A manageably-sized museum, very much worth visiting, close to the Bois de Boulogne.

**Musée de la Mode et du Costume** Palais Galliéra, Ave Pierre-ler de Serbie 75116 Paris. 720.8546. metro: Iéna, Alma-Marceau. Open 10-5.40pm. Closed Monday.
Here the visitor can find the history of costume and fashion from 1735 to the present, displayed in regular changing exhibitions. Anyone interested should go despite a rather dusty atmosphere and predominance of elderly lady visitors who nevertheless often display clothes of greater historical interest than the lifeless exhibits. Chanel, Dior and other doyens of Haute Couture are represented. For more history of fashion see FUTURE MUSEUMS — the Musée des Arts Décoratifs.

**Hotel de la Monnaie de Paris** 11 Quai Conti, 75006 Paris. 329.1248. metro: Pont-Neuf, Odéon. Open 11-5pm. Closed week-end.
The main interest of this museum lies in its temporary exhibitions which are generally of one artist who has recently designed medals or coins and cover the rest of his work. The coin/medal workshops can also be visited — Mondays and Wednesdays at 2.15pm only, while displays of coins, medals and related documents are shown when no special exhibition is on.

**Musée de Montmartre** 12 rue Cortot, 75018 Paris. 606.6111. metro: Lamarck-Caulaincourt. Open 2.30-5.30pm, Sunday 11-5.30pm.
Here you can find the history of Montmartre, its buildings, its inhabitants, artists and/or eccentrics, 18th century local porcelain, a reconstructed Montmartre bistrot — "Le Lapin Agile" — caricatures of old locals and a lovely garden. Other activities of the museum cover poetry and painting. If you are visiting the heights of this district visit the museum rather than the trashy commercial shops and 'artists', who occupy the Place du Tertre, though some may prefer the living to the dead.

**Musée National Gustave Moreau** 14 rue de la Rochefoucauld, 75009 Paris. 874.3850. metro: Trinité. Open 10-1/2-5pm. Closed Monday & Tuesday. Free on Wednesday.
Another gratifying one-man-museum, which is a must for anyone remotely interested in the mystical Symbolist movement and its decadence. The house and studio of Moreau now contain an impressive display of his drawings and luminous, highly detailed paintings, including the seductress "Salomé" at work. The 1890's until Moreau's death in 1898 witnessed a number of future 'greats' working in his studio — Matisse, Rouault, the Fauves-Marquet and Puy, to name some.

**Opéra: Bibliothèque et Musée** 1 Place Garnier, 75009 Paris. metro: Opéra. Open every day 10-5pm. Closed Sunday. Go to the main entrance of the Opéra for tickets, but the museum entrance is on the rue Auber side.
The rooms of the Opéra, once intended for the receiving of Emperors, now house a museum and library — an apt setting for 'relics' of the Classical arts — opera, theatre, music & dance. Predominantly 18th century, you will find busts, paintings, photos, set and costume designs, with, at times, changing thematic exhibitions. The library is open to bona fide researchers.

**Musée Français du Pain** 25 bis rue Victor Hugo, 94220 Charenton-le-Pont. 368.4360. metro: Charenton-Ecoles. Open 2.30-5pm. Tuesday & Thursday.

More mundane but more familiar — bread. Only this baguette consuming nation could come up with a Bread Museum which, amongst over a thousand exhibits, includes repro Syrian cake-moulds from 1700 BC as well as real ones from Western countries. So, if you are taking it easy in the Bois de Vincennes and need some cerebral/cereal stimulation on a Tuesday or Thursday afternoon, go and see history through breadcrumbs.

**Palais de la Découverte** Grand Palais, Ave Franklin-D.-Roosevelt, 75008, Paris. 359.1665. metro: Ch. Elysées, Franklin-D.-Roosevelt. Open 10-6pm. Closed Monday.

Paris' Science museum showing its evolution from Da Vinci's inventions onwards, complete with replicas, real apparatus and machines. The planetarium holds 4 sessions a day, there is a cinema and library, and changing exhibitions cover such subjects as solar energy and medical photography.

**Palais de Tokyo/Musée d'Art et d'Essai** 13 Ave du Président-Wilson, 75116 Paris. 723.3653. metro: Iéna. Open 9.45—5.15pm. Closed Tuesday. Free on Wednesday.

Next door to the Musée d'Art Moderne and once part of it, this museum holds numerous changing exhibitions mainly originating from the vast Louvre collection, and covering several disciplines — paintings, interior decoration, sculpture. A large and rich Post-Impressionist collection is temporarily housed here, awaiting transfer to the future Musée d'Orsay in 1984—5, with major works by the Symbolists, Vuillard, Bonnard, Seurat, Gauguin, amongst others. Donations by Braque, Laurens and Rouault are also exhibited. Worth visiting, particularly as it is often neglected by visitors to Paris and therefore refreshingly empty.

**Musée du Petit Palais** Ave Winston-Churchill, 75008 Paris. 265.1273. metro: Ch. Elysées-Clémenceau. Open 10-5.40pm. Closed Monday. Free on Sunday.

The Grand Palais' baby sister which, in its permanent collection displays antiques, paintings from the Middle Ages to the 19th century (including Géricault, Delacroix, Monet, Cézanne). Otherwise it holds regular changing exhibitions.

**Musée Edith Piaf** 5 rue Crespin-du-Gast, 75011 Paris. 355.5272. metro: Ménilmontant. By appointment only.

Situated appropriately up in the faubourgs, this little museum is dedicated to Paris' famous 'sparrow' — her clothes, objects, letters as well as photos and paintings of her are displayed. Phone to arrange a visit. Remember to pay homage to her tomb if you are at the Père Lachaise cemetery nearby.

**Musée de la Poste** 34 Boulevard Vaugirard, 75015 Paris. 320.1530. metro: Montparnasse, Falguière. Open 10-5pm. Closed Sunday.

As may be expected from its name, here is the history of the Post Office and stamps. Its temporary exhibitions are often devoted to the work of a contemporary artist who has recently dabbled in philatelic design.

**Musée de Radio-France** 116 Ave du Président Kennedy, 75016 Paris. 230.2180. Open 10-12/2-5pm. Closed Monday.
This imposing curved building on the Seine houses the studios and administration of the national radio and T.V. stations. Guided tours can be arranged by telephoning the above weekday number, extension 2243. Their collection covers the history of broadcasting and includes Marconi originals.

**Musée Rodin** 77 rue de Varenne, 75007 Paris 705.0134 metro: Varenne. Open 10-6pm. Closed Tuesday. Free on Wednesday.
Another magnificent one-man-museum housed in a beautifully proportioned 'hôtel' surrounded by a leafy garden complete with roses and pond. This extensive Rodin collection includes some of his best known pieces such as The Kiss, Adam and Eve, The Hand of God as well as lesser known smaller sculptures where the quality sometimes wavers, and water-colour sketches. In the garden is The Thinker, hard at it, and the Burghers of Calais trailing their chains. Paintings by Edvard Munch are also displayed as well as some interesting temporary exhibitions.

**Musée du Sculpture en Plein Air** Quai St-Bernard, 75005 Paris. metro: Austerlitz, Jussieu. Permanently open.
Set among lawns and concrete steps on the banks of the Seine this open-air sculpture display possesses works by many major contemporary sculptors — Arman, César, Ipousteguy, Brice, Etienne-Martin, Zadkine, Rougemont etc. The tranquil aesthetic setting has led to it becoming a gay cruising ground.

**Musée de la SEITA** 12 rue Surcrouf, 75007 Paris. 555.9150. metro: Invalides. Open 11-6pm. Closed Sunday.
For all smokers who want to know the history of their intoxication and for non-smokers who want to gloat at what they've renounced: the history of tobacco (introduced to France by the diplomat Jean Nicot in 1561) and international historical smoking devices. Some fascinating examples such as Georges Sand's favourite pipe and a model engraved with astrological signs. All this courtesy of the State tobacco company — father of Gauloises — which also arranges some dynamic exhibitions of contemporary art.

**Hôtel de Sully** 62 rue Saint-Antoine, 75004 Paris. 274.2222 metro: St Paul. Open 10-6pm during months of opening.
This classic 17th century 'hôtel' contains the historic apartments of the Duchess of Sully, complete with orangery and garden, beautifully preserved. Here too are the offices of the "Caisse nationale des monuments historiques et des sites" — responsible for the upkeep of all historic buildings in France. Its library and bookshop contain a wealth of information and also lend out slides — phone 887.2414.

**Musée National des Techniques** 270 rue Saint-Martin, 75003 Paris. 271.2414 metro: Arts et Métiers. Open 1-5.30pm., Sunday 10-5.15pm. Free on Sunday.
A wide-based technical-science museum covering transport methods (including Peugeots parked in an integrated church) communications, astronomy, photography, cinema, mechanical toys, clocks, optics, glass-work (Daum, Lalique, Gallé, Baccarat,

Murano), electricity, acoustics with some rare exhibits in certain categories — e.g. a 5mm thick camera hidden in a cravat, good for the 'moles' of 1884.

**Musée du Vin** (Caves de la Tour Eiffel) rue des Eaux, 75016 Paris. 525.6326 metro: Passy. Open 2-6pm. Closed Sunday.
If a Bread Museum exists so must logically a Wine Museum. Here in vaulted 13th and 14th century cellars, containing some wax-works and more bottles, wine-tasting and oenological courses take place.

**Musée Zadkine** 100 bis rue d'Assas, 75006 Paris. 326.9190. metro: Vavin. Open 10-5.40pm Wednesday to Saturday.
The sculptor Ossip Zadkine's work — drawings, gouaches, prints and above all sculptures displayed in his studio/house/garden where he lived until his death in 1967. Another striking Zadkine piece can be seen by the Beaubourg side-entrance.

# Future Museums:

Numerous museum projects are afoot with varying preparation periods: the **Musée Maillol** will shortly be opened at 59/61 rue de Grenelle, 7e, concentrating, obviously enough, on Maillol's sculpture while the **Musée Picasso**, originally projected to open in 1982 at the Hôtel Sâlé, 5 rue de Thorigny, 3e, has been delayed somewhere along the line. From 1984 a new section of the **Musée des Arts Décoratifs** will be opened devoted to textiles, a large collection of costumes, a fashion library and promotion of latest trends. Paris' most ambitious museum project since the Centre Pompidou, the **Musée d'Orsay**, has also inevitably been delayed with opening now projected for 1986. This plan will eventually create a 19th century art museum exhibiting works at present spread around various collections — the Louvre, Jeu de Paume, Palais de Tokyo, Orangérie and various museum vaults. The intended period (1850-1914) will link the vast Louvre collection with the national modern art collection at Beaubourg, and will cover Romanticism, Symbolism, Impressionism, Pont-Aven, the Nabis and Fauvism. The accent will be on the links between the arts and apart from displays of fine and graphics arts, photography, furniture, decorative arts there will be temporary exhibitions of writers and composers. All this will be housed in the ex-station and Hôtel d'Orsay (across the Seine from the Louvre) at present undergoing radical transformations though leaving the shell of Laloux's magnificent 1900 design.

Another massive government project will open its doors, theoretically, in 1985 — the **Musée National des Sciences et de l'Industrie** in the future Parc de la Villette, a rather heavy, unfashionable district in north-east Paris. Here, apart from the museum and its homage to technology with cinemas, libraries etc, the park will be used to display artists' projects and to house a **Cité de la Musique** and, equally important, to give the Biennale de Paris one home — from 1984.

In a similarly uninspiring area the enormous sports complex currently being built among the warehouses in Bercy should also include the **Musée du Sport**, while back in central Paris and that same old hole in Les Halles, rumour has it that future filling-in will

*Bâtiment Lescot in Les Halles.*

provide a videotheque while the curved, mirrored structures already built will open as a dance and poetry centre in 1983, called **Bâtiment Lescot.** Sculpture will be catered for outside Paris with a **new museum of contemporary sculpture** at **Marne-la-Vallée** where Ricardo Bofill's neo-classical/post-modernist architecture can be seen.

# Museums outside Paris

After suicidal boulevard crossings and rehearsing the faubourg side-step you may be tempted to spend a day outside Paris, and the contrast makes it well worthwhile. The opulence and magnificence of Versailles can hardly be rivalled, but there are numerous other castles and palaces within close reach of Paris which provide some rich collections and spectacular surroundings. Below is a short list of places of historic and/or artistic interest but for more complete listing see **Pariscope** or even better go to the information centre at the Hôtel de Sully, or the Tourist Office, 127 Champs Elysées.

**Château d'Anet** 28 Anet. (37) 64.90.07. Open March-October, 2-6.30pm, Sunday 11-12.30/2-6.30pm. Closed Tuesday. By car take the Autoroute du Sud, exit at Mantes Sud and drive towards Dreux. This was Diane de Poitiers' castle, the notorious mistress of Henri II, and of particular interest here is the Chapelle Royale built by Philibert Delorme, a 16th century architect.

**Auvers-sur-Oise** By car R.N. 328, by train Gare St. Lazare and change at Pontoise.
There is no museum, no castle or palace to be found here, just the village and countryside of Van Gogh's last months in 1890. His rooms in an inn now called "Chez Van Gogh", can be visited and a sculpture of Van Gogh by Zadkine is set in the park near the

station. Otherwise the visitor can discover reminders of this painter in the 12th century church and the surrounding countryside complete wirh crows and cornfields. He shot himself here and was later buried in the village cemetery.

**Château de Chantilly** 60500 Chantilly Oise. (4)457.0362. Open 10.30-6pm (till 5pm in winter). Closed Tuesday. By car take R.N. 16 then autoroute du nord, exit at Beauvais/Chantilly. By train Gare du Nord. This superb palace set in the middle of artificial lakes, canals and very real forests together with its various out-buildings and stables, covers the 16th-19th century. Home of the Montmorency and the Condé families, its museum (Musée Condé) houses lavish furnishings and some remarkable works of art including the French and Italian Renaissance, Poussin, Van Dyck, Watteau, Lancret, Ingres, Delacroix, Fromentin, Gérome, as well as miniatures, tapestries, and 18th century porcelain. Museum open 1.30-5.30. The stables contain a horse museum with live pieces nosing the statues. The library contains documents relating to the history of manuscripts including the "Très Riches Heures du Duc de Berry", and books from the Middle Ages onwards together with archives.

**Château de Compiègne** 60200 Compiègne (4)440. 0202. Open 10-12/1.30-6pm (till 5pm in winter). Closed Tuesday. By car take Autoroute A1. By train from Gare du Nord.
Situated in one of the largest forests in France, once good hunting ground for the Kings of France, the palace was originally built in the 14th century, soon to witness Joan of Arc's imprisonment in 1430 and later to be rebuilt by Louis XV in the 18th century and again restored under Napoleon I who also designed the formal perspectives of the park to celebrate his second marriage here. The palace, apart from the richly decorated royal apartments, contains the Musée du Second Empire with memories of Napoleon III's brighter days and, moving rapidly through time, a Musée de la Voiture with its collection of 150 vintage cars.

**Château de Fontainebleau** 77 Fontainebleau. 422.2740. Open 10-12.30/2-5.15pm. Closed Tuesday. By car take the Autoroute du Sud. By train from Gare de Lyon.
This palace was originally built by François I in 1528 who imported Italian artists to provide murals and mosaic decoration which perhaps helped a onetime resident Pope to feel more at home. Although it was later redecorated and furnished by Napoleon (again) some magnificent Renaissance frescoes still remain. Napoleon's study and bed are all to be seen as well as the Cour des Adieux where he bade farewell on his pre-comeback exil. Again this palace houses some elaborate and rich furnishings together with Last Year In Marienbad-type formal gardens.

**Musée du Jouet** 2 rue de l'Abbaye, 78300 Poissy. 965.0606. Open 9.30-12/2-5.30pm. Closed Monday & Tueday. Afternoons only in August. Train from St Lazare.
Here is a paradise of second childhoods ... boys go straight up to the 2nd floor where armies of lead soldiers await you, backed up by the first clockwork cars invented by a certain André Citroén and holding the rearguard the inevitable electric trains. Ladies

may prefer the ground floor — with its harem of dolls starting in Ancient Egypt but more recognisable in the 17th century, with the addition of glass eyes. If you can tear yourself away from these idle ladies, the first floor with its society and educational games is forcibly instructive. A world of clockwork toys greets you together with magic lanterns — Monsieur Silhouette gains substance, having given his name to the game of Chinese shadows. For more enlightenment, a library specialises in the evolution and symbolism of toys.

**Château de Malmaison** 92500 Malmaison. 749.2007. Open 10-12.30/1.30-5.30pm. Closed Tuesday. Take the RER to La Défense and then bus 158a.
This was Empress Josephine's favourite hideout after her divorce, mainly transformed in the 17th century well before her arrival. Napoleonic relics inevitably abound supporting and enlarging on his legend, as well as a lovely park.

**Musée Claude Monet** 27200 Giverny. (32) 51.28.21. Open 10-12/2-6pm. Closed Monday and November-March. By car take the autoroute A13 and exit at Bonnières-sur-Seine. By train from the Gare St Lazare take the Paris-Rouen line to Vernon, then walk or taxi.
Here near the banks of the Seine is the house where Monet lived from 1883 until his death in 1926. The interior, after years of neglect, has recently been redecorated in the colours of Monet's time and with his original furniture, the decorator's dedication going as far as imitating Monet's precise hanging of his Japanese print collection . . . Then visit the enormous studio in the garden, similarly restored and finally, Monet's pride and joy, his garden, which he considered a work of art in itself — before painting its water-lilies. His use of a tributary to create an oriental garden with Japanese bridge, willows, azaleas and tumbling wysteria constantly astonished Monet's friends and present-day visitors feel similarly awed by its relation to his paintings.

**Musée Français de la Photographie** 78 rue de Paris, 91570 Bièvres. (6)941.1060. Open 10-12/2-6pm every day. By car take the RN 306 from the Porte de Chatillon. Tricky by public transport.
Joseph-Nicéphore Niepce's 1816 invention of the camera was really the beginning of an unimaginably vast industry which this museum attempts to do credit to in extremely limited space, with its collection of hundreds of cameras, accessories and photographs — including Daguerre's equipment and Kodak's first camera of 1888. Restricted space means only part of the collection can be seen, together with interesting temporary exhibitions.

**Musée du Prieuré-Maurice Denis** 2 bis rue Maurice Denis, 78100 St Germain-en-Laye. 973.7787. Open 10.30-5.30pm. Closed Monday & Tuesday. RER to St Germain-en-Laye.
As the address hints, this is the museum of the Symbolist and Nabis movements with paintings, sculptures, posters and particular accent on Maurice Denis. If you're coming from the station you can't miss the superb, massive 16th century castle, housing the national archaeological collection and its 13th century chapel. It was here in 1570 that the Wars of Religion drew to a signed close.

**Château de Rambouillet** 78180 Yvelines. 483.3454. Open 10-12/2-5pm. Closed Tueday & Wednesday.

Another castle covering periods from the 14th century to the 18th century, which also witnessed Marie-Antoinette's rural inclinations as here you can visit her "laiterie", where she kept her sheep. Otherwise the surrounding forest is a favourite for Sunday promenading.

**Musée National de la Renaissance** Château d'Ecouen, 95440 Ecouen. 990.0404. Open 9.45-12/2-5.15pm. Closed Tueday. Metro to St Denis — Porte de Paris then bus 268c to Ezanville.

This castle was built in the 1540's for Anne de Montmorency and now suitably houses the national collection of French Renaissence art with numerous tapestries, furniture, and decorative objects from that period. The statutory park and fairly large forest are also noteworthy.

**Château de Sceaux** 92330 Sceaux. 661.0671. Open 10-12/2-6pm. Closed Tuesday all day, Monday & Friday mornings. RER to Parc de Sceaux or Bourg-La-Reinc.

Easily accessible from the centre, this palace, again set in a vast park laid out by le Nôtre, containing pavilions and an Orangery in which summer week-end chamber music concerts are held (mid-July — mid-October), was completely rebuilt in 1860. It now houses the Musée de l'Ile-de-France with a collection of paintings, prints, ceramics, glass-work, tapestries and costumes covering several centuries.

**Musée du Surréalisme** 77 Melun at Vaux-le-Pénil. 068.0095. Open week-ends only 2-6pm. By car take the motorway A6, exit at Melun.

This is an interesting collection of Surrealist paintings, prints and sculptures — strong on Dali. Temporary exhibitions are held and there is a large park to wander around in.

**Musée du Théâtre** 77 Couilly Pont-aux-Dames. 434.5002. Open week-ends only 2-6pm. By car take the motorway A4.

In this small museum you can see costumes, memorablia, accessories of French actors and actresses including, of course, Sarah Bernhardt.

**Château de Versailles** 78 Versailles. 950.5832. Open 9.45-5pm. Closed Monday. Free entrance on Wednesday. Train from Montparnasse or St Lazare, RER line C, or the metro to Pont de Sèvres followed by Bus 171.

They say its the largest palace in the world . . . built by Louis XIV, who also completely transformed the surrounding countryside laying out gardens, and planting forests. It is now a favourite tourist haunt but justifiably so — to see this grandoise epoch in all its magnificence — and it is still used by the government to host and impress international top-level leaders. Don't mis the Galerie des Glaces (Hall of Mirrors) and the royal apartments in the main palace, before taking off into the park with its brilliant perspectives, where you can find the Grand and the Petit Trianon — another of Marie-Antoinette's idiosyncratic hideouts, together with Le Hameau — a too-pretty-to-be-true reconstruction of rustic dwellings where she played peasant. (Petit Trianon open afternoons only). Keep going towards the lake where rowing

boats can be hired, or, if you're really exhausted by all this opulence, head straight for a little building in the trees nearby where you can drink in style — coffee or cocktails — along with some of Versailles' elderly society.

# ARCHITECTURAL WONDERS

Most standard guides to Paris will provide a well documented list of historical buildings to visit which, as everyone knows, Paris is particularly rich in. The places listed below, with some exceptions, are monuments to 20th century architecture/design and well illustrate the city's continuing though sometimes controversial aesthetic concerns.

**Cimetière Père Lachaise** 20e metro: Père Lachaise or Gambetta Far from the 20th century, a mysterious partly overgrown, vast and occasionally crumbling cemetery with a beauty of its own. Originally Napoleonic (1804) but its tombs cover every period and style: neo-gothic, baroque, art deco etc. Numerous French and foreign artists are buried here and you can track down their tombs to pay homage, using a map of the cemetery supplied by the caretakers at the gates. Try spotting Nijinsky, Isadora Duncan, Delacroix, Modigliani, Daumier, Chopin, Proust, Oscar Wilde (tomb designed by Jacob Epstein and donated by a lady admirer) Edith Piaf (well furnished in flowers) or Jim Morrison whose gravestone has become a fine example of 20th century graffiti. Near the Gambetta entrance you can also see the wall — Le mur des Fédérés — where the last survivors of the 1871 Commune were killed and buried.

**Castel Béranger** 14 rue La Fontaine, 16e metro: Michelange-Auteuil.
Built in 1897/8 by the architect Hector-Germain Guimard — a superb example of turn-of-the-century design as is his metro entrance at **Porte Dauphine** (entrance Avenue Foch), built in 1902 and the last major existing example of the highly decorative curves of Art Nouveau to be found in a normally functional metro entrance.

**La Rûche** Passage Dantzig, 15e metro: Convention.
Gustave Eiffel's work, resurrected from the 1900 Exhibition and set up as an artists' living and working centre. Léger, Laurens, Modigliani passed through the hive and the tradition continues with many known contemporary artists in residence here.

**Le Train Bleu** Gare de Lyon.
A vast restaurant overlooking the platforms and departing trains — quite a devastating show of Art Nouveau design and florally based murals, well preserved and still functioning.

**Building at 124 rue Réaumur** 2e, metro: Sentier.
Here squeezed between the stone facades you can see Georges
Chadanne's sober metallic structure designed in reaction to the
Modern Style/Art Nouveau — though he still couldn't resist a few
curves within these beautiful clean lines.

**House at 26 rue Vavin** 6e, metro: Vavin.
Just behind the Boulevard du Montparnasse, this house is
entirely faced in glazed bricks with stepped balconies. Designed
by Henry Sauvage in 1911/12.

*Père Lachaise cemetery.*

**Rue Mallet-Stevens** 16e, metro: Jasmin.
Known for his Cubist architecture with its stark volumes, Robert Mallet-Stevens' houses built in the mid-Twenties can be seen in the street named after him — also close to Le Corbusier's Villa La Roche in the Square du Docteur Blanche.

**Pavillon Suisse** Cité Universitaire, 7 Boulevard Jourdan, 14e.
Designed by Le Corbusier and his cousin Jeanneret in 1930/2 and an example of his functional doctrine, it also includes a mural executed by Le Corbusier in 9 days flat . . . See also his Villa Savoye at Poissy, just oustside Paris, 1929-31.

**Maison de Verre** 31 rue St Guillaume, 7e, metro: Rue du Bac or St. Germain.
Designed by Pierre Chareau and built in 1932 this house uses glass where others use stone and/or brick. The true precursor of High-Tech which can be spied at from the courtyard and is quite a revelation.

**UNESCO building** Place de Fontenoy, 7e, metro: Cambronne.
Architects Breuer, Zehrfuss and Nervi. One of Paris' important post-war designs — 1953-58 — which also contains murals by Miro, Picasso, Calder.

**Maison de la Radio** Ave du Président-Kennedy, 16e, metro: Ranelagh.
Overlooking the Seine this vast circular building, controversial when built, houses all the national radio and TV broadcasting services. An impressive exterior but the interior is typically labyrinthine and bureaucratic. Architect: Henry Bernard. Built 1958-62. Immediately across the Seine can be seen true 60's urbanism in the area called 'Front de Seine'.

**La Défense** (western outskirts) and **Créteil** (eastern outskirts) are two formidable examples of over-enthusiastic 70's planners — 'the cities of the future' — hundreds of blocks with no overall unity and occasional odd splashes of colour tower aggressively over what little is left of the past. For urban hallucinations step this way.

**Centre Pompidou** 1e, has to be included here. First stage in a complete re-planning of the old central food-market district — Les Halles. Designed by the Anglo -Italian group Piano & Rogers and opened, controversially of course, in 1977. A spectacular landmark in urban design (see MUSEUMS).

Other recent 'spacey' design can be seen at the RER/metro station of **Auber** and at **Roissy** (Charles-de-Gaulle airport) built in the early 70's. After years of controversial bickering over the future development of the notorious 'hole' in Les Halles, the second stage was opened in 1979 (the Forum-des-Halles: a commercial shopping centre built on three stepped levels underground) and the third stage, the Bâtiment Lescot, an umbrella-like construction lying low over the Forum which will be a dance and poetry centre, was completed in late 1982. The remaining area will be landscaped with a city sports centre built below, while plans for telecommunications' museum and an aquarium are still under study.

Outside Paris, post-modernist development of satellite centres continues with Ricardo Bofill's work particularly prominent — see his 'aquaduct' flats at **St Quentin-en-Yvelines (RER from Invalides, or St Michel or Gare d'Austerlitz)** or his neo-classical 'Palacio de Abraxas' at **Marne-la-Vallée (RER line A from Châtelet or Auber).** And while you're out that way go to Nogent-sur-Marne to see one of the **Baltard Pavillions** resurrected from its original home in Les Halles — an 1850's use of iron and glass now used for rock-concerts.

# COMMERCIAL GALLERIES

The topographical distribution of Parisian galleries is conveniently settling into three distinct areas, as opposed to the old Right Bank/Left Bank division. The growth and development of Les Halles has led to a mushrooming of young galleries showing (obviously with exceptions) 'new tendencies' and general avant-garde work, while the demise of the Left Bank, once the contemporary art district, now seems paradoxically safe in comparison,though less swayed by ephemeral trends. Meanwhile the Right Bank galleries carry on regardless in a very different spirit with exhibitions ranging from Old Masters to 'contemporary' painters whose work has little in common with general current art movements. Nevertheless there are some landmarks in this area well worth visiting where superb examples of early 20th century art are often exhibited as well as more recent artists of note.

Watch out for opening times: most galleries are closed Sunday and Monday while some are open afternoons only (particularly round Les Halles and the Left Bank) during the week. Mid-July to late September is a dead period with many galleries closed. All galleries have been listed under surnames or main gallery title, and metro stations indicated when gallery is outside central gallery areas.

## Right Bank
## (mainly 8th arrondissement, also 17th and 18th)

**ABCD** 30 rue de Lisbonne, 8e, 563.3606.
Director. Christian Cheneau. Open Tues-Sat 11-12/2-6 pm. Important gallery for Cobra group and 50' and 60's abstract art — works by Appel, Christoforou, Hartung, Jenkins, Lindström, Natkin, Ortner, Poliakoff, Soulages, Tapies, Zao Wou-Ki amongst others.

**Ariel** 140 Boulevard Haussmann, 8e 562.1309.
Specialises in Cobra Group and European abstraction — represents Appel, Bootz, Lindström, Sallès, Tabuchi, Weidemann, also works by Alechinsky, Debré, Dubuffet, Andersen, Jorn, Messagier, Saura, Reinhoud.

**Artcurial** 9 Ave Matignon, 8e 256.7070.
Open 10.30-7.30 Tues-Sat.
Massive art institution housing galleries of painting, sculpture, prints and artposters generally by known artists — Braque, de Chirico, S. Delaunay, Ernst, Gleizes, Lam, Arp, Zadkine, Etienne-Martin, Gilioli, Mitoraj, Pomodoro, Takis. Worth visiting, also for its excellent art bookshop (see BOOKSHOPS).

**Artfrance** 36 Avenue Matignon, 8e 359.1789.
Director: C. Senille (expert). Open Mon-Sat 10-7pm.
Specialises in Impressionists, Post Impressionists and Ecole de Paris prints. Own print editions.

**Bar de l'Aventure** 53 rue Berthe 18e 255.3776. metro: Abbesses.
Director: Caroline Corre. Open Tues-Fri 2-7pm, Sat 10-7pm
Not the same area — high up in Montmartre a lively gallery showing young artists, artists' books. Other activities include open dinner with artists' every Wednesday — phone to reserve.

**Beauvau-Miromesnil** 15 rue de Miromesnil, 8e 265.6120.
Specialises in 19th century painting, watercolours, drawings, prints as well as some contemporary artists — Souverbie, Despierre, Chagniot, Raimbault.

**Jean-Claude Bellier** 30/32 Ave Pierre 1e-de-Serbie, 8e 720.1913
Director: J-C. Bellier (expert).
Important gallery with impressive collection of late 19th and early 20th century works — Bonnard, Dufy, Léger, Matisse, Mirò, Picasso, Renoir, Signac, Utrillo, Vuillard, Dali, Duchamp-Villon, Rodin, Bourdelle, Gnoli.

**Henri Bénézit** 20 rue de Miromesnil, 8e 265.5456.
Director: H. Bénézit (expert).
19th and 20th century paintings, sculptures and drawings — Hayden, Herbin, Palmeiro, Picabia, Valmier, Janson, Chapoval, Kijno, Treccani, Tal Coat.

**Marcel Bernheim** 18 Ave Matignon, 8e 265.2223.
Director: Yves Hemin (expert) Open Mon-Sat 10-7pm.
Long established gallery with collection of Old Masters, Impressionists, Post-Impressionists, Ecole de Paris. Also exhibits contemporary artists.

**Bernheim-Jeune** 83 Faubourg St-Honoré, and 27 Avenue Matignon, 8e 266.6031.
Contemporary artists and permanent collection of works by Morgan Snell, Le Bihan, Chalou, Belloni. Open Tues-Sat 10.30-12.30/2.30.-6.30.

**Berthe** 57 rue Berthe, 18e 259.2006. metro: Abbesses.
Open Tues-Sat 3-8pm. Small Montmartre gallery exhibiting ceramics and etchings.

**Claudine Breguet** 65 rue de Rome, 8e 522.1022.
Director: C. Breguet.
Contemporary painting and sculpture in young gallery, recently opened: Michel Tyszblat, R. Texier, B. Frize, Peter Briggs, Claude Cehes.

**Louis Carré** 10 Avenue de Messine, 8e 562.5707
Director: Patrick Bongers. Open Mon-Sat 10-12.30/1.30-6.30.
Original gallery director (grandfather) known for his 'making' of
Villon. Established gallery with exceptional exhibitions of R.
Delaunay, Kupka, Gromaire, Léger, Geer Van Velde, Laurens,
Villon, Poliakoff-sculptures by Gilioli, Hajdu.

**Jeanne Castel** 3 rue du Cirque, 8e 359.7124.
Established 20th century artists including Alejandro, Borès,
Camacho, Fautrier, Hélion, Mathieu, Meurice, Tapiès, Warren.

**Iris Clert** 19 rue Madeleine Michelis, 92200 Neuilly 722.8979.
By appointment only, after 11am. Iris Clert's gallery in the 60's/
70's was important for European avant-garde movements.

**Espace 215** 215 Faubourg St-Honoré, 8e 256.2795
Newly opened space, showing contemporary artists. Currently
by appointment.

**Paul Facchetti** 20 Ave de Friedland, 8e 563.8026 by appointment
only.
Deals in known contemporary artists such as Ivor Abrahams,
Brauer, Ciussi, Del Pezzo, Dubuffet, Forrester, Hundertwasser,
Stefanoni.

**Mathias Fels** 138 Boulevard Haussmann, 8e 562.2134.
Important gallery, though small, dealing in known artists of 60's/
70's such as Louis Cane, Kudo, Rivière, Spoerri, Fontana.

**Wallay Findlay Galleries** 2 Ave Matignon, 8e 225.7074, annexe
at Hotel George V. Open Mon-Sat 10-7pm.
International gallery chain. Deal in Impressionists, Post-Impres-
sionists, Fauves as well as contemporary figurative painters.

**Gorosane** 52 Faubourg St-Honoré, 8e 265.3600.
Contemporary figurative art.

**Henriette Gomès** 6 rue du Cirque, 8e 225.4249.
Open Tues-Sat 10.30-12/2.30-6.30pm.
Accent on Surrealism with works by Balthus, Brauner, O. Domin-
guez, Penrose — also Helion, Rouault, Gromaire.

**Katia Granoff** 92 Faubourg St-Honoré, 8e 265.2441 also at 13
Quai de Conti, 6e 354.4192. Open Mon-Sat 10-12.30/2.30-7pm.
Traditional established gallery.

**Marwan Hoss** 12 rue d'Alger, 1e 296.3945.
Open Mon-Fri 10-6.30 and Sat morning.
Gallery exhibiting established 20th century artists: Paul Klee,
Giacometti, Dubuffet, Fontana, Mondrian, Rodin, Nevelson,
Smith, Serra, Sakis.

**Jean-Pierre Joubert** 38 Avenue Matignon, 8e 562.0715.
Open Tues-Sat 10.30-12.30/2.30-7pm.
Specialises in Villon, Duchamp, Duchamp-Villon, Gleizes,
Metzinger, Desnoyer, La Fresnaie.

**Louise Leiris** 47 rue de Monceau, 8e 563.2885.
Long-established gallery with works by Braque, Gris, Laurens,
Léger, Masson, Picasso, S. Roger, Rouvre.

**Maeght** 13 & 14 rue de Téhéran, 8e 563.1319.
Open Mon-Fri 9.30-1/2.30-6pm.
Other branches of this art mammoth, founded by Aimé Maeght, in Zurich, Barcelona and superb Foundation at St-Paul de Vence. Two large galleries exhibit known contemporary artists including Adami, Pol Bury, Kienholz, Monory, Titus-Carmel, Calder, Alechinsky, Riopelle, Chillida, Steinberg, Takis, Rebeyrolle and collection covers most major art figures of 20th century. A separate print shop sells its own publications — prints, catalogues.

**Daniel Malingue** 26 Ave Matignon, 8e 266.6033.
Dealer in Impressionists and Bonnard, Matisse, Foujita, Kandinsky, Laurencin amongst others.

**Jacques Massol** 12 rue La Boétie, 8e 265.9365.
Open Tues-Sat 10-12/2.30-6pm.
Mainly figurative work by contemporary artists including Socquet, Cad'Oro, Chaminade, Germain, Lacasse, Simian.

**Hervé Odermatt** 85 bis Faubourg St-Honoré, 8e 266.9258.
Director: H. Odermatt. Well established gallery representing known artists such as Germaine Richier, Vieira da Silva, Weisbuch, Penalba also Velickovic, Tai, Leproust.

**André Pacitti** 174 Faubourg St-Honoré, 8e 563.7530.
Open Mon-Sat 9.30-12.30/2-7pm.
Exhibitions of contemporary figurative work.

**Passali** 33 rue de Miromesnil, 8e 265.4696.
Open Mon-Sat 10-7pm.
Specialises in Ecole de Paris of 20's/30's, Impressionists, Post-Impressionists, Aubusson tapestries (Picart Le Doux). Works by Modigliani, Epstein, Soutine, Kars, represents Ebiche, Tobiasse, Dobrinsky.

**Le Robinson** 54 rue d'Orsel, 18e 264.5846. metro: Abbesses.
Director: Nicola Wheatley. Open Tues-Sat 3-8pm, Sun 5-9pm.
Another invader from Montmartre . . . a young British-owned gallery showing British and European figurative sculpture and works on paper. Programme of concerts in gallery.

**Jacques Spiess** 4 Ave de Messine, 8e 256.0641.
Paintings, sculpture, drawings by Impressionists, Pont-Aven, Cubists, Ecole de Paris, Surrealists, Abstraction. Represents contemporary artists Weber, Amann, Gil Wolman — geometric/conceptual work.

**Suillerot** 8 rue d'Argenson, 8e 265.5488.
Director: R. Suillerot. Interesting contemporary work by Tolmer, Schuursma, Zack and many others. Cubist works — Gleizes, Gondouin, Hayden, Herbin, Lhote.

**Félix Vercel** 9 Ave Matignon, 8e 256.2519.
Recognised artists include Renoir, Utrillo, Van Dongen, Herbin, while amongst contemporary artists are Sobaic, Venard, Danton.

# Left Bank
## (mainly 6th and 7th arrondissements, also 5th, 14th, 15th) metro: Odéon, St. Germain, Rue du Bac.

A useful bi-monthly gallery map with certain exhibition dates in St-Germain and Les Halles areas exists and can be found in most of the listed galleries.

**Galerie 10** 10 rue des Beaux-Arts, 6e 325.1072.
Directors: Jany & Laurence Jansem.
Recently opened gallery with drawings by Fautrier, Pascin and paintings by Buffet and Jansem. Interesting young artists include G. Gulland, Teffo, Lepoureau, Sorlier, Ferrand, — varying tendencies.

**Galerie 1900-2000** 8 rue Bonaparte, 6e 325.8420.
Director: Marcel Fleiss. Open Tues-Sat 10-7pm.
Fascinating collection of decorative arts and industrial design from the 20's to 50's as well as upstairs gallery section with collection of Surrealism including lesser known British surrealists — regular theme exhibitions, often original. Munch, Picabia, Matta, Ernst, Grosz, Paalen, W. Freddie, Y. Klein, Malaval, Magritte, Man Ray. American hyper-realism.

**Aleph** 38 rue de l' Université, 7e 261.2905.
Open Tues-Sat 2.30-7 pm.
Traditional gallery, artists include Chagall, Czobel, Dobrinsky, Epstein, Friesz, Kantorowicz, Kleinmann, Pressman.

**Art Contemporain** 22 rue de l'Odéon, 6e 633.4924.
Director: Pierre Calté. Open Mon-Fri 9-6pm.
Works by Picabia, Piscasso, Léger and post-war abstraction — Mathieu, Soulages. Young artists include Hastaire, Vaughn-James. Small but pleasant gallery.

**Art International** 12 rue Ferrandi, 6e 548.8428 (Montparnasse).
Director: Anto Glihota. Other branches in Milan and Chicago.
Very small space, exhibiting mainly abstract work, some important artists J. Messagier, Barros, Bellegarde, Ernst.

**Bateau-Lavoir** 18 rue de Seine, 6e 354.9683.
Director: Mira Jacob. Open Tues-Sat 10.30-12.30/2.30-6.30.
Pioneer gallery opened in 1955 with impressive history of literary-related exhibitions, often thematic, covering Symbolism and Surrealism. Collection includes Giacometti, Tanguy, Ernst, Wunderlich, and strong representation of Ensor, Odilon Redon, Delvaux's prints (published by gallery). Younger artists include Bernadette Kelly, P. Jannen. Annexe at no.16 with contemporary prints.

**Bellechasse** 10 rue de Bellechasse, 7e 555.8369 (phone for new 1983 address).
Director: Mr Masrour. Open Tues-Sat 10-1/2-7pm.

Accent on abstraction and 'nouvelle figuration' of late 60's: Mogens Andersen, Bertholo, Criton, S. Delaunay, Erro, Goetz, Kudo, R. Jansson, E. Luiz, Pelayo, Perez-Celis, Del Pezzo, Piza, Pomar, Rancillac, Tobey.

**Huguette Berès** 25 Quai Voltaire, 7e 261.2791.
Director: Mme Berès. Open every day 10-1/2-7pm.
Specialises in Japanese prints (Sharaku, Utamaro) and drawings, paintings of late 19th century — Bonnard, Vuillard.

**Berggruen** 70 rue de l' Université, 7e 222.0212.
Open Mon-Sat 9-7pm.
Traditional gallery with rich collection of drawing and etchings by Beringer, Braque, Chagall, Dali, G. Diaz, Horst Janssen, Kandinsky, Klée, Léger, Matisse, Moore, Picasso, Wunderlich, Zao Wou-Ki.

**Claude Bernard** 5-9 rue des Beaux-Arts, 6e 326.9707.
Director: Claude Bernard (expert). Open Tues-Fri 2.30-6.30, Sat 10.30-12.30/2.30-6.30pm.
Important gallery of contemporary realism. Artists represented include Francis Bacon, Balthus, Botero, César, Cremonini, Csernus, D'Haese, Estève, Giacometti, Guccione, Hockney, Ipousteguy, Léger, Lindner, McGarrell, Masson, Picasso, Szafran. Recently opened section exclusively for young, undiscovered artists — mainly group shows. Director: Mr Deledicq. Phone for appointment if applying — 634.5471

**Fabien Boulakia** 20 rue Bonaparte, 6e 326.5679.
Director: Mr. Boulakia. Open Mon-Sat 10-12.30/2-7pm.
Gallery specialising in Cobra group (Alechinsky, Jorn, Corneille), abstraction (Sam Francis, Mathieu) also Picasso, Ernst. Young artists include Louttre B.

**Isy Brachot** 35 rue Guénégaud, 6e 354.2240.
Director: Mr Brachot. Open Tues-Sat 11-1/2-7pm.
Interesting gallery lay-out and some artists of note are shown. Originally from Brussels with collection of Magritte and Delvaux, exhibitions vary from Surrealism to mainly contemporary realism — Sandorfi, Yannick Vu, De Jaeger (polaroids), B. Stern. Also America photo-realism.

**Bréteau** 70 rue Bonaparte, 6e 326.4096.
Open Mon-Sat 2-6pm.
Works by Arakawa, Etienne-Martin, Forain, Gromaire, Zadkine, Saint-Phalle as well as exhibitions by younger artists.

**Jean Briance** 23-25 rue Guénégaud, 6e 326.8551.
Director: Mr Briance. Open Tues-Sat 2.30-7pm.
Spacious gallery showing contemporary artists often with a graphic, humorous edge in figurative field, and frequent group shows. Included are G. Beringer, Samuel Buri, Cieslewicz, Jim Dine, Gerard Diaz, Hopf, O. Olivier, Roland Topor, Wiegand, Oscar de Wit, Zeimert.

**Michèle Broutta** 31 rue des Bergers, 15e 577.9379 metro: Ch. Michel.
Open Tues-Sat 10-6pm.
Off the beaten track, a gallery showing mainly works on paper,

also own print editions. Sculpture by Asada, Batbedat, Houtin, Le Bars. Also Moreh, Houtin.

**Jeanne Bucher** 53 rue de Seine, 6e 326.2232 (in courtyard).
Director: Mr J. F. Jaeger. Open Tues-Sat 9-12.30/2-6.30pm.
Long-established gallery, spacious and sky-lit, showing known contemporary artists and some lesser known, including Aguayo, Amado, Asger Jorn, H. Reichel, Nicolas de Stael, Szenes, Tobey, Vieira da Silva.

**Cahiers d' Art** 14 rue du Dragon 6e 548.7673.
Director: Yves de Fontbrune. Open Mon-Fri 9.30-12.30/2-6.30pm.
Gallery belonging to the magazine "Cahiers d' Art" exhibiting geometrical abstraction. Upstairs bookshop with specialised catalogues, art books.

**Jean Camion** 8 rue des Beaux-Arts, 6e 633.9563.
Director: Mr. Camion. Open Tues-Sat 10.30-6.30pm.
Established gallery.

**Etienne de Causans** 25 rue de Seine, 6e 326.5448.
Director: Mr de Causans. Open Tues-Sat 10.30-12.30/2.30-7pm.
Large gallery generally showing realist drawings and paintings with astonishing technique — young Spanish, French and German artists: Garayo, Serra de Rivera, Galindo, Pina, Grützke, Tuma, Baumgartel, Grisor, Skira, Soisoliet.

**Charmy l'Envers** 61 rue Lhomond, 5e 707.3950 metro: Censier-Daubenton.
Director: Charles Sablon. Open Tues-Sat 2-7pm, Weds till 10pm.
Again, a gallery outside the usual circuit near the rue Mouffetard with a collection of 20th century paintings, sculptures and objects shown in thematic exhibitions with figurative base.

**Clivages** 46 rue de l'Université, 7e 296.6957.
Director: Jean-Pascal Léger, Open Tues-Fri 2.30-7pm, Sat 10.30-1/2.30-7.
Gallery associated with magazine 'Clivages' showing lyrical abstraction. Artists represented: M. Bokor, Marfaing, Cordesse, Tal-Coat.

**Coard** 12 rue Jacques-Callot, 6e 326.9973.
Open Tues-Sat 11-1/2-7pm.
Specialised in contemporary abstraction — Bolin, A.de Caro, Florensa, Germain, Karavousis, Pougny.

**Colette Creuzevault** 58 rue Mazarine, 6e 326.6785.
Director: Mme Creuzevault. Open Tues-Sat 2.30-7pm.
Exhibitions of known contemporary artists including Niki de Saint-Phalle, Cesar, Calder, Baj, Matta, Folon, Dewasne, Germaine Richier. No young artists.

**Zoe Cutzarida** 8 rue Guénégaud, 6e 633.1216.
Open Mon-Sat 1-7pm. Gallery specialising in school of Afro-Caribbean art. Principal artists: S. Helenon, L. Laouchez.

**Darial** 22 rue de Beaune, 7e 261.2063.
Director: Mme Tali. Open Tues-Sat 3-7pm.
Small gallery, squeezed between numerous antique shops,

showing mainly constructed abstract work by contemporary artists including Pagava, Lelonget, Lioté, I. Levy, C. Gariffa, M. Fayol, Ehanno. Open to apply.

**Nina Dausset** 16 rue de Lille, 7e 297.4107.
Director: Mme Dausset. Open Tues-Sat 11-7pm.
Represents mainly contemporary figurative artists — include Recalcati, Petlin, Pat Andrea, Kantorowicz, Dieterle, Michel Haas, K. Laffitte, also works by Segui, Matta.

**La Demeure** 26 rue Mazarine, 6e 326.0274.
Open 10-12.30/2-7pm. Mon afternoon-Sat.
Important gallery for contemporary tapestry with works by young artists and known ones including Calder, Coignard, S. Delaunay, Gilioli, Le Corbusier, Masson, Picasso, Picart Le Doux, Prassinos, Ubac. Also tapestries from Egypt and Lesotho.

**Le Dessin** 27 rue Guénégaud, 6e 633.0466.
Directors: Claire Burrus, Marie-Hélène Montenay. Open Tues-Sat.
Nice space mainly specialising in works on paper by contemporary artists: Baruchello, H. Bordas, S. Buri, Cueco, A. Davie, Dégottex, Erro, Anne Madden, A-M. Pécheur, Pommereulle, F. Martin, Robert Wilson.

**Dragon** 19 rue du Dragon, 6e 548.2419.
Directors: Max & Patricia Clarac-Sérou. Open Tues-Sat 10.30-12.30/2.30-6.30pm.
Opened in 1955, a gallery that successfully launched young painters such as Velickovic, Cremonini, Aillaud. Continues policy of showing young artists in figurative/imaginary field. Works by Bertholo, Charasse, Chemay, Hultberg, Klusemann, Martin, Matta, Tai, Villanueva, Cardenas, Lutz. Friendly and ready to view work.

**Lucien Durand** 19 rue Mazarine, 6e 326.2535.
Director: Mr Durand. Open Tues-Sat.
Open since 1953 with policy of showing young artists. Recent exhibitions include A. Lambilliotte, P. Lanneau, Ange Leccia, M. Lechner, J-L Poivret, D. Nadaud, S. Merkado, Works by César, Kermarrec, Moninot, F. Rouan. Wide tendecies — open for application.

**Eric Fabre** 6 rue du Pont-de-Lodi, 6e 325.4263.
Director: Mr Fabre. Open Tues-Sat 2.30-7.30pm. Sat also 11-12.30.
Vast gallery space showing conceptual often large-scale work using objects, art pauvre, new structures. Artists include J. P. Bertrand, Calzolari, S. Charlesworth, Czersinsky, Toni Grand, Kowalski, B. Pagès, P. Saytour, Présence Panchounette, Woodrow, Art-Language. Stimulating.

**Erval** 16 rue de Seine, 354.7349.
Director: Mr Erval. Open Tues-Sat 10.30-1/2-7pm.
Young abstract painters include J.F. Koenig, B. Dorny, A. Bendov, J. Clerté, J. Dumesnil. Also collection of post-war abstraction — Riopelle, Appel, Messagier, Vieira da Silva, Hartung and others. Sculptures by Feraud, Reinhoud, Dorny, Gilioli.

36

**Faris** 50 rue de l'Université, 7e 544.2948.
Director: Waddah Faris. Open Tues-Sat 10-7pm.
Young artists mainly from Middle East in spacious and friendly gallery include Akhras, Haddad, Azzawi, Fattah, Hassan, Henein, Motashar, Abboud, Salah, Samra. Colourful abstract work and some figurative.

**Galerie des Femmes** 74 rue de Seine, 6e 329.5075.
Gallery space part of bookshop, both devoted to women's work. Some interesting exhibitions, both historical (Sonia Delaunay) and contemporary — Maglione, F. Martinelli, M. Knoblauch, D. Garros, S. Clavel, M. Orensanz.

**J. Fischer** 46 rue de Verneuil, 7e 261.1782.
Directors: Jacques Fischer, Chantal Kiener.
Gallery specialising in academic 19th century paintings, drawings.

**Karl Flinker** 25 rue de Tournon, 6e 325.1873.
Director: K. Flinker. Open Tues-Sat 10-1/2.30-7pm.
Important gallery with consistently interesting exhibitions ranging from known artists:- Kandinsky, Magnelli, Hélion, Kupka, to younger 'objective realists' such as Aillaud, Arroyo, Moninot, Gafgen, Raysse, Equipo Cronica, Fred Deux.

**Au Fond de la Cour** 40 rue du Dragon, 6e 544.6834.
Director: Gabrielle Maubrie. Open Tues-Sat 2.30-7pm.
Paintings and sculpture by young artists.

**Robert Four** 28 rue Bonaparte, 6e 329.3060.
Open Tues-Sat 10-7pm.
Contemporary tapestry work — also foundation to encourage this art/craft.

**Liliane François** 15 rue de Seine, 6e 326.9432.
Director: Mme François.
Limited gallery space showing young European realists and American pop-realists (Clem Clark, Lichtenstein, Warhol, Wesselmann). Young artists include de Courval, Joussaume, Kritikos, Lekarski, Pelizzari, Poujon, W. Ritter, Tennenhaus.

**Philippe Fregnac** 50 rue Jacob, 6e 260.8631.
Director: Mr Fregnac. Open Tues-Sat 2.30-7.30pm.
Relatively new gallery exhibiting young artists of a high standard — both abstract and figurative work — including M. Houssin, Levigoureux, Desarmenien, C. Boujon, Karsiu Lee.

**Furstenberg** 8 rue Jacob, 6e 325.8958.
Open 10-6pm, Tues-Sat. Specialises in surrealist works on paper — Bellmer, Chirico, Dali, L. Fini, Kandinsky, Kazandljan, Wunderlich.

**Galarté** 13 rue Mazarine, 6e 325.9084.
Director: Anne J. Bodet. Open Tues-Sat 10.30-1/2-7pm.
Recently opened gallery showing abstract/textural work: contemporary artists include Zorko, Raimbaud, Pugnaire, C. Malval, Ferrand, Morin, Akerji.

**Daniel Gervis** 34 rue du Bac, 7e 261.1173 by appointment.
Well known dealer in contemporary established artists. Own gallery prints. Debré, Dubuffet, Malaval, Nevelson, B. Olson, Marta Pan, Pasotti, Reinoso, and some younger artists.

**Lia Grambihler** 14 rue Domat, 5e 326.1142.
Open Mon-Fri 12-8pm.
Small gallery mainly showing young abstract artists.

**Haut Pavée** 3 Quai Montébello, 5e 354.5879.
Director: Frère Vallée. Open Tues-Sat 3-8pm.
A religious association with open exhibition policy for its gallery open since 1952. Any artists can apply — appointments Tuesday, Thursday. Wide tendencies of young work.

**Heyraud-Bresson** 56 rue de l'Université, 7e 222.5809.
Open Tues-Sat 2-7pm.
Superb collection of art deco furniture, objects, and paintings of same period (1920-40).

**Horizon** 21 rue de Bourgogne, 7e 555.5827.
Small gallery mainly exhibiting contemporary abstraction.

**Jacob** 28 rue Jacob, 6e 633.9066.
Director: Denise Renard. Open Tues-Sat.
'Interiorised' painting, abstract and figurative, by young artists including Cargaleiro, Debré, Dialsser, Maggiani, Marq, Szenes. Not open for application.

**Samy Kinge** 54 rue de Verneuil, 7e 261.1907.
Director: Mr Kinge. Open Tues-Sat 10.30-1/2.30-7pm.
Small but well known gallery representing surrealist artists, French 'pop' and new realism. Matta, Brauner, Malaval, Tinguely also M. Bradley, Arthur, Raynaud, Raysse, P. Thek, M. Raysse, Saint-Phalle.

**Krief-Raymond** 50 rue Mazarine, 6e 329.3237.
Director: Elisabeth Krief-Raymond. Open Tues-Sat 2-7pm, Sat 11-7pm.
Active young gallery promoting young European artists in a fairly graphic line of painting, some well known contemporaries — Babou, Biasi, Chambas, Fanti, Limerat, Rancillac, Stéphant, C. Bouillé.

**Koryo** 8 rue Perronet, 7e 222.3789.
Open Tues-Sat 11-1/2.30-7pm. Generally non-figurative young artists include Campa, Laubiès, Renzi, Ung-No-Lee.

**Georges Lavrov** 40 rue Mazarine, 6e 326.8435.
Directors: G. Lavrov, Laurence Sallenave. Open Tues-Sat 3-7pm.
Young gallery showing neo-expressionist figurative work by contemporary painters — J-P. Bourquin, Oleg Tselkov, Claude Plessier, F. Heaulmé, Zlotnik. Some colourful exhibitions.

**Albert Loeb** 10 rue des Beaux-Arts, 6e 633.0687.
Director: A. Loeb. Open Tues-Sat.
Son of famous collector-dealer Pierre Loeb. Small gallery but with high standard of contemporary American and European figurative/realist work: Caballero, Carron, Cuartas, Philippe Garel, R. Guinan, Messagier, Munoz, Theimer. Also Arp, Lam, Pascin and sculptures by Berrocal, Jeanclos.

**Régine Lussan** 7 rue de l'Odéon, 6e 633.3750.
Director: Mme Lussan. Open Tues-Sat 2-7.30.
Fairly academic contemporary figurative painting, sculpture, photography, etchings. Works by Claus Semmler, Pierre Brun, J. Boullairre, Marcello, Tommasi, Avvoki, J. Girard. Open to new work.

**Adrien Maeght** 46 rue du Bac, 7e 222.1259 (in courtyard).
Directors: A. Maeght, A. Massiot. Open Tues-Sat 10-1/2.30-6.30pm.
Son of Aimé Maeght with interesting exhibitions of some known, others unknown, contemporary artists, in spacious gallery. Jacques Poli, P. Klasen, Télémaque, Jan Voss, Kuroda, F. Bouillon, O. Garand.

**James Mayor** 34 rue Mazarine, 6e 326.6034.
Tiny gallery specialising in works on paper by contemporary artists.

**Melki** 55 rue de Seine, 6e 325.9470.
Director: Mr Melki.
Dealer in Cubists, German Expressionists, Surrealists, Abstraction. Valmier, Picasso, Léger, Herbin, Albers, Poliakoff, Miro, Ernst, Kirchner, Otto Muller.

**Marion Meyer** 15 rue Guénégaud, 6e 633.0438.
Director: Mme Meyer. Open Tues-Sat 10.30-12.30/2.30-6.30pm.
Recently opened gallery specialising in Dadaism, Surrealism and abstraction. Bellmer, Bertini, Herold, Ljuba, Man Ray, Masson, Matta, Wols.

**Mona Lisa** 32 rue de Varenne, 7e 548.1725.
Naive art, in particular Yugoslavian — paintings and prints.

**Naifs et Primitifs** 9 rue du Dragon, 6e 222.8615.
Open Tues-Sat 12-8pm, Sun 3-7pm.
Contemporary naive art.

**Naiv'art** 19 rue Mazarine, 6e 345.3370.
Represents exclusively Bonnin, Duranton, L. Greffe, Rimbert.

**Negru** 40 rue Mazarine, 6e 329.8509 (in courtyard).
Director Mr Negru. Open 10.30-1/2.30-7.30 Tues-Sat.
Specialises in established and new surrealist work — artists include Grosz, Dado, Wunderlich, Delvaux, Korab, Amaral, J. Hernandez, Heinzen, sculptures by Ben Jakober.

**Paris Art Center** 36 rue Falguière, 15e 322.3947. metro: Montparnasse.
Director: Mr Patrick Amoore, Ante Glibota. Open Tues-Sat 1-7pm
Large airy exhibition space with monthly exhibitions of contemporary artists, often retrospectives, covering various tendencies. Regular concerts.

**Paris-Pékin** 9-11 rue des Grands-Augustins, 6e 633.0920.
Director: Mr Ziane. Open Tues-Sat 12-7pm.
Gallery specialising in Chinese prints, paintings (antique and modern) costumes, fabrics — also books and special art materials.

**Peinture Fraîche** 29 rue de Bourgogne, 7e 551.0085.
Open Tues-Sat 1.30-7.30pm.
Association formed a few years ago to exhibit young artists' work
— no strict tendencies. Also has regular concerts in basement.

**André-François Petit** 196 Boulevard St Germain, 7e 544.6483.
Director: Mr Petit.
Important gallery promoting surrealist works — Bellmer, Fuchs,
Dali as well as young American and European realists/surrealists.

**Yves Plantin** 33 rue de Seine, 6e 633.8241.
Director: Mr Plantin. Open Tues-Sat 2-7pm.
Specialises in paintings and decorative arts of the early 20th
century — exhibitions have included Tamara Lempicka.

**La Pochade** 11 rue Guénégaud, 6e 354.8903.
Director: Alain Digard. Open Tues-Sat 11-8pm.
Prints and paintings by known and unknown contemporary
artists: J. Champion, Dedicova, Dussau, Dubuffet, Kolar,
Vasarely, Vermeille, Velickovic.

**Point Cardinal** 3 rue Jacob, 6e 354.3208.
Open Tues-Sat.
Represent Cardenas, Louis Pons, Henri Michaux, Joseph Sima
exclusively.

**Proscenium** 35 rue de Seine, 6e 354.9201
Gallery specialising in theatre-related art: costume and stage
designs, by Bakst, Carzou, Clavé, Cocteau, Erté, Fassianos, Fini,
Labisse, Noël, de Nobili.

**Abel Rambert** 38 rue de Seine, 6e 329.3490.
Dealer in Ecole de Paris paintings and other mainly known artists:
Borès, Dimier, Ernst, Lanskoy, Masson, Pascin, Poliakoff, Z.
Staack, Tal Coat.

**Rancilio** 29 rue Hippolyte-Maindron, 14e. 542.1489. metro:
Pernety.
Director: Cesare Rancilio.
Although outside Left Bank gallery circuit, a friendly Italian
owned gallery combining exhibitions and their own print
editions. Artists include Taulé, Gueffurus. Ready to view new
work.

**Claudine Ratié** 6 rue Bonaparte, 6e 325.1649.
Director: Mme Ratié. Open Tues-Sat 2-7pm.
Ecole de Paris artists and some younger work.

**Regards** 40 rue de l'Université, 7e 261.1022.
Open Tues-Sat 2.30-7pm.
Interesting exhibitions from contemporary abstract expressionism to more sober minimal work. Artists include S. Boxer, O.
Debré, Serpan, C. Sorg, Zach also sculpture by Chadwick,
Fachard, Guardagnucci.

**Denise René** 196 Boulevard St Germain, 7e 222.7757.
Important gallery for contemporary abstract and kinetic art:
Agam, Arp, Bill, Claisse, Cruz Diez, S. Delaunay, Gerstner, Soto,
Tsai, Vasarely.

**Jean-Claude Riedel** 12 rue Guénégaud, 6e 633.2573.
Director: J-C. Riedel. Open Tues-Sat.
Contemporary conceptual and/or figurative work. Interesting exhibitions have included R. J. Clot, J. Dupuy, J. Keyser, Yu Sanyu, Giat-Miniet Christine Gaussot. Sculptures: Abel Orgier, Van Lamsweerde.

**Valerie Schmidt** 41 rue Mazarine, 6e 354.7191.
Director: Mme Schmidt. Mixed tendencies of contemporary art — including Augereau, Aveline, Camolli, Lamy, Veillot.

**Darthea Speyer** 6 rue Jacques Callot, 6e 354.7841.
Director: Mme Speyer. Open Tues-Sat 2.30-6.30pm.
American owned gallery promoting American and European contemporary artists — colour being the governing factor from figurative to some conceptual work. Artists include Dean, De Forest, R. Granet, Art Green, Ed Paschke, Pikoula, Serrano, I. Sigg, N. Speyer, Ursula, Viswanadhan, Zuka.

**Stadler** 51 rue de Seine, 6e 326.9110
Director: Rodolph Stadler. Open Tues-Sat 10.30-12.30/2.30-7pm.
Gallery once known for Body Art and pop 'happenings' now mainly representing field of abstract expressionism in large space. Principal artists: Norman Bluhm, Damian, Saura, Zenderoni, A. Delay, E. Friedrich, J-P. Huftier, Urs Luthl, A. Vrainer, O. Romberg.

**Nane Stern** 25 Avenue de Tourville, 7e 705.0846. metro: Ecole Militaire.
Director: Mme Stern. Open Tues-Sat 3-8.30pm.
Long-standing gallery specialising in contemporary abstraction, painting and sculpture, often loosely geometrically based. Artists include C. Brunschwig, Godin, Guiot, Ivackovic, Kallos, T'ang, Elzbieta Violet, Wolman, Roesz, Pazzi.

**Galerie Suisse de Paris** 17 rue St-Sulpice, 6e 633.7658.
Open Tues-Sat 2-7pm.
Gallery representing contemporary Swiss artists such as Klée, Smutny, Reussner, Indermand.

**Trans/form** 22 Ave de la Bourdonnais, 7e 550.4032. metro: Bir-Hakeim.
Director: Antonio Furone. Open Tues-Sat 3-7pm.
Accent on post-transavantgarde movements — post-Modernism, represents Dicrola, Montesano. Italian gallery which has also exhibited Futurism.

**Galerie de Varenne** 61 rue de Varenne, 7e 705.5504.
Director: Jacques Damase. Open Tues-Sat.
Occasional painting exhibitions, more prints and publications by Damase, book art. Artists have included S. Delaunay, Patrick Raynaud, Klasen.

**Varnier** 4 rue des Beaux-Arts, 6e 634.5709.
Director: Patrick Varnier.
Young gallery/framers recently opened, intends to have regular exhibitions of young artists combined with collections of older works.

**Dina Vierny** 36 rue Jacob, 6e 260.2318.
Naive paintings by Bauchant, Bombois, Vivin, drawings by Matisse, sculpture by Zitman.

**Lara Vincy** 47 rue de Seine, 6e 326.7251
Director Liliane Vincy. Open Tues-Sat.
Active gallery retaining 70's spirit of happening-exhibitions, performances, musical events, gallery transformations, Mail Art, Video. Artists have included R. Bianco, R. Hains, Clavel, Plessi, Gil Wolman, Hubaut, Polacci, Van Amen — Dadaist humour reigns.

**Lucie Weill** 6 rue Bonaparte, 6e 354.7195.
Director: Lucie Weill.
Traditional gallery dealing in Picasso, Miro, Ernst, Cocteau, Zadkine, Derain and some younger artists.

**Galerie d'Art Yomiuri** 5 Quai Conti, 6e 326.1535.
Director: Mr Akihiro Nanjo. Open Tues-Sat 10-12/2-7pm.
Mixed tendencies by four gallery artists: Kimura, Chan Kin-Chung, Sacksick, Quiroz. Spacious gallery. Not open for application.

# Les Halles/Le Marais
## (1st, 3rd, 4th arrondissements) metros: Châtelet, Hôtel de Ville, Rambuteau

**Bama** 40 rue Quincampoix, 4e 277.3887 (1st floor).
Director: Mme Ninon Robelin. Open Tues-Sat 2.30-7 pm.
Pioneer gallery in the field of conceptual art: installations, video photography, painting. Exhibitions have included Beuys, Tim Head, Tom Phillips, Jochen Gerz, Dieter Roth.

**Beaubourg** 23 rue du Renard, 4e 271.2050.
Directors: Pierre & Marianne Nahon. Open Tues-Sat 10.30-1/2.30-7 pm.
Well known gallery showing important contemporary painters and sculptors, mainly realist/figurative, including Martial Raysse, Fassianos, Barelier, Spoerri, Dufour, Schlosser, Jacquet, César Arman — also young painters Combas, Di Rosa. Adjoining art bookshop.

**Jacqueline Blanquet** 5 Boulevard Bourdon, 4e 271.9394 (metro: Bastille)
Director: Mme J. Blanquet . Open Tues-Sat 2-7pm.
Relatively young gallery, large and winding with exclusive representation of three young artists: Jean-Marc Philippe, Willaumez, Victor Roman, with figurative basis — painting and sculpture.

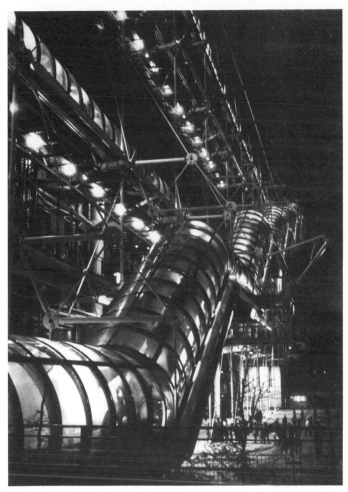

*Beaubourg (Centre National d'Art et de Culture Georges Pompidou).*

**Alain Blondel** 4 rue Aubry-le-Boucher, 4e 278.6667.
Director: A Blondel. Open Tues-Sat 11-1/2-6.30pm.
Gallery showing mainly figurative artists also trompe-l'oeil paintings and sculptures: Claude Yvel, Van Hove, M. Lévine, C. Renonçiat, Billy Sullivan. Combines with showing Symbolist paintings.

**Farideh Cadot** 77 rue des Archives, 3e 278.0836 (1st floor).
Director: Mme F. Cadot. Open Tues-Sat afternoons.
Large space showing avant-garde work. Was first to show new image painting in Paris. Artists include MacAdams, Boisrond, Bramson, Fisher, Hazlitt, Laget, Stuart, Tremblay.

**Galerie du Centre** 5 rue Pierre-au-Lard, 4e 277.3792.
Director: Alain Matarasso. Open Mon-Fri 10-6pm.
Spacious gallery hidden behind Beaubourg showing realism and
hyperrealism, representing Radko, Authouart, Lazar. Open for
application.

**Charley Chevalier** 27 rue de la Ferronerie, 1e 508.5863.
Director: Mr Chevalier. Open Tues-Sat 2-7.30pm.
Preference for Constructivist works, though eclectic range of
work by young unknown artists.

**Jean Chauvelin** 147 rue St-Martin, 3e 887.7776 (1st floor).
Director: J. Chauvelin. Open 10-1pm. and by appointment.
Well established in his specialisation of Russian and European
Constructivists and Dadaism. Picabia, Malevitch, M. Barre, Arp.

**Galerie Créatis** 50 rue du Temple, 271.1952.
Director: A. Champeau. Open Mon-Sat 1-7pm.
With large new space this gallery is extending its field from
photography to cover installations, sculpture, performance,
dance. (see PHOTOGRAPHY GALLERIES).

**Chantal Crousel** 80 rue Quincampoix, 3e 887.6081.
Director: C. Crousel. Open 2.30-7pm.
Good space showing specifically avant-garde work — American,
British and European — installations, photography, paintings by,
amongst others, Tony Cragg, P. Briggs, C. Sherman, F. Boué, M.
Disler.

**J & J Donguy** 57 rue de la Roquette, 11e 700.1094. metro:
Bastille.
Director: Mr Donguy. Open 2.30-7pm. Back of courtyard.
Loft-style gallery on 3 levels with rapidly changing exhibitions/
installations/performances by young European artists. Saturday
afternoon openings have become a Saturday afternoon spot.

**Durand-Dessert** 3 rue des Haudriettes, 3e 277.6360 (in court-
yard).
Directors: Liliane & Michel Durand-Dessert. Open Tues-Sat
2-7pm.
Known for unusual exhibitions of European conceptual artists.
Have included Beuys, M. Merz, David Tremlett, Parmiggiani, Dan
Graham, Anselmo, B. Flanagan, Garouste. Mainly installations
and sculpture.

**Espace Latino-Americain** 44 rue du Roi-de-Sicile, 4e 278.2549.
Collective. Open Tues-Sat 2-7pm.
Founded in late 1980 by a group of South American artists
(Gamarra, Krasno, Le Parc, Netto, Noe Novoa, Pisa, Ravelo,
Tomasello). Diverse tendencies, painting and sculpture, often
interesting.

**Flow Ace Gallery** 12 Quai d'Orléans, 4e.
Recently opened American gallery with Fort Knox entry
procedures. Rauschenberg, Klaus Rinke.

**Jean Fournier** 44 rue Quincampoix, 4e 277.3231 (in courtyard).
Large and long established gallery showing known international
abstract artists including Buraglio, Degottex, Sam Francis,

Hantai, S. Jaffé, A. Clement, Viallat. Specialist art history books and publications.

**Galerie de France** 50-52 rue de la Verrerie, 4e 274.3800.
Director: Catherine Thieck. Open Tues-Sat 12-7pm.
Enormous gallery on three levels with established artists such as Hartung, Meurice, Pincemin, Soulages as well as more contemporary work by B. Efrat, A. Jacquet, Tadeusz Kantor, Nevelson, Reigl and photography includes Florence Henri, Domela.

**Gillespie/Laage/Salomon** 24 rue Beaubourg, 3e 278.1171 (2nd floor) Small gallery once concentrated on minimal and conceptual work, now exhibiting new image painting. German, American, French and British artists include Penck, Immendorff, Lupertz, G. Thomas, R. Ackling, M. Barre, Baselitz, H. Fulton.

**Hérouet** 44 rue des Francs-Bourgeois, 4e 278.6260.
Traditional gallery with landscapes and figurative work.

**Jaquester** 85 rue Rambuteau, 1e 508.5125.
Director: Mme. E. Topiol. Open Tues-Sat 2-7pm.
Long-standing gallery promoting young artists ranging from abstract expressionism to new figurative work. Artists include C. Brunschwig, Fitzia, A. Vaito, E. Ortlieb, S. Le Bret — predominance of women artists.

**Lambert** 14 rue St-Louis-en-l'Isle, 4e 325.1421.
Open Tues-Sat 10.30-12/2.30-7pm.
Paintings, sculpture, lithos, Polish art posters. Artists mainly East-European.

**Yvon Lambert** 5 rue du Grenier-St-Lazare, 3e 271.0933.
Director: Y. Lambert.
Gallery ranging from minimal/conceptual to new image painting — "figuration libre" — Richard Long, Cy Twombly, R. Blanchard, Middendorf, Jan Dibbets, and other young international artists.

**Gérard Laubie** 2 rue Brisemiche, 4e 887.4581.
Director: G. Laubie. Open Tues-Sat 2-7pm.
In the shadow of Beaubourg, a gallery devoted to contemporary sculpture on two floors. Varied media and form, from clay to kinetics. Works by Vanarsky, Parigi, Waldberg, Jutta Cuny, Lavesre, Disa, Rhaye, D. Macedo.

**Jean-Pierre Lavignes** 15 rue St-Louis-en-l'Isle, 4e 633.5602.
Director: J-P. Lavignes. Open 10.30-12.30/2.30-7.30pm.
Young European and American realist work in a lively gallery. Represents Fromentin, Heckscher, Kawalerowicz, Lecoeur, Lima, Jean-Claude Meynard, Soto, Kacere. Sculptures by Melois. Good selection of prints.

**Baudoin Lebon** 36 rue des Archives, 4e 272.0910 (1st floor).
Director: B. Lebon. Open Mon-Sat 10-1/2.30-7pm.
Nice space showing diverse non-figurative work. Principal artists: Bertholin, Bustamente, Frydman, Gafgen, Lemoisse, Pagès, Reynier, Stoltz, Uematsu. Also collection of Surrealist and Pop artists.

**Pierre-Lescot** 28 rue Pierre-Lescot, 1e 233.8539.
Directors: Michèle Coche, Lisbel Foissac. Open Tues-Sat 2-7pm.
Gallery usually shows two young artists simultaneously on 3

*Courtyard in Le Marais.*

levels with accent on figurative work. Sculpture, objects, paintings by Cupsa, Franta, Naccache, A. Burke, Harada, Fioretti, Vignes, Rival. Ready to look at new work.

**Marais 19** 19 rue des Blancs-Manteaux, 4e 274.1385.
Traditional gallery recently opened promoting Italian artists — Virgilio, Rivalta — in figurative form.

**Carmen Martinez** 12 rue du Roi-de Sicile, 4e 278.3011 by appointment only.
Director: C. Martinez. Prints, drawings, sculpture by Anguera, Domela, J. Gonzalez, Hicks, Ivens, Penalba, Ségui, Stavitsky.

**Martine Moisan** 6/8 Passage Vivienne, 2e 297.4665 (metro: Bourse).
Open 12-7pm.
Contemporary tapesteries, weaving and prints.

**Ghislain Mollet-Viéville** 26 rue Beaubourg, 3e 278.7231 by appointment only.
Minimal and conceptual work.

**N.R.A.** 2 rue du Jour, 1e 508.1958 (upstairs).
Director: Nicole Rousset-Althounian. Open 3-7.30pm.
Mainly specialises in unique books as art expression, also some performance. Linked with contemporary Italian movements. Group exhibitions arranged around theme.

**L'Oeil de Boeuf** 58 rue Quincampoix, 4e 278.3666.
Director: Mme. Ceres Franco. Open Tues-Sat 2-7pm.
Colourful small gallery, first to open up in this street. Specialises in neo-expressionist work, art brut, and Brazilian naives. Exclusivity of Chaibia, other artists include Atila, Bertini, Celestino, M. Gerard, McDevitt, Rustin, Wolman.

**L'Oeil Sévigné** 14 rue de Sévigné, 4e 277.7459.
Director: Jean Peyrole. Open Tues-Fri 2-7pm, Sat. mornings too.
Regular exhibitions of gallery artists: Bibonne, Gutherz, Iscan, A. M. Jaccottet, Léobardy, Queneau, Salzmann, Wolf. Graphic, figuratively based paintings.

**Alain Oudin** 28 bis Boulevard de Sébastopol, 4e 271.8365.
Director: A. Oudin. Open Tues-Sat 2.30-7.30pm.
M. Oudin is an architect, explaining 'spatial' gallery interests. Installations, monumental works, maquette projects and occasional choreography and performance. Artists can leave portfolio for viewing.

**Michel Ozenne** 28 Passage Véro-Dodat, 1e 236.2699 (off rue J. J. Rousseau).
Director: M. Ozenne. Open Tues-Sat 2-7pm.
Once the Bijan Aalam gallery. Mainly figurative/"fantastic" work by M. Forgeois, M. Milcovitch, Poumeyrol, A. Stein, C. Zeimert amongst others. Worth visiting also to see this beautiful covered passage.

**Françoise Palluel** 91 rue Quincampoix, 3e 271.8415 (through porch).
Open Tues-Sat 2-8pm.
Young gallery showing avant-garde work by mainly French artists: Yann Dugain, D. Castellas, L. Godart, J-L. Poivret, Lepoitevin, Pandini. Paintings, installations. Friendly.

**Le Parvis St-Merri** 84 rue St-Martin, 4e 271.9303.
Open Mon-Sat 10.30-1/2.30-7pm.
Fairly traditional gallery showing contemporary realist/surrealist paintings.

**La Passerelle** 5 rue Payenne, 3e 272.4350 also at: 81 rue Pernety, 14e 542.9941.
Director: J-C Vernier. Open Tues-Sat 2-7pm.
Association founded in 1981 to open up links between the arts — painting, photography, poetry, traditional music. Publish monthly newsheet of activities and workshops.

**La Peinture Fraîche** 16 rue Le Regrattier, 4e 633.2183.
Collective. Open Tues-Sat 3-7pm.
Another Ile St-Louis gallery, small, showing young artists of varying tendencies.

**La Platone** 93 rue Vieille du Temple, 3e 887.7983 (in courtyard).
Director: Jean Razy. Open Tues-Fri 11-7pm.
Recently opened with exhibition of Mady Andrien's sculpture but with mixed future policy. Large space.

**Poisson d'Or** 7 rue des Précheurs, 1e 233.1020.
Director: Mme Lejeune. Open Tues-Sat 2-7pm.
Small gallery showing young artists working in field of textural relief: tapestry, fabrics, ceramics, sculpture.

**Râ** 7 rue de Turbigo, 1e 236.4574.
Director: Hervé Sérane. Open 1.30-7pm.
Contemporary surreal and 'fantastic' visionary art in smart gallery: M. Bordet, Di-Maccio, Klaus Dietrich, Giannini, Kablat, Landais.

**Raph** 12 rue Pavée, 4e 887.8036.
Open Mon-Fri 2-7pm.
Small gallery near St Paul exhibiting young artists including Amann, Bauduin, Domela, Dufrene, Salvado.

**Paolo Santini** 88 rue St-Martin, 4e 271.8575.
Director: Mme Santini.
Specialises in sculpture with good selection of books, small pieces and exhibition space used for group and one-man shows — various materials and styles of sculpture.

**Sarver** 20 rue St-Paul, 4e 274.5207.
Open 2-7.30pm.
Exhibitions of ceramics, ceramic sculpture, glass. Open to seeing new work.

**Brigitte Schéhade** 44 rue des Tournelles, 4e 277.9674.
Open 11-7.30pm.
Drawings and prints by Masson, Ernst, Delvaux, Maurice Denis, Louttre. Documents, letters of Derain, Picasso, Gris, Laurens, Pascin, Léger.

**Le Soleil Bleu** 16 rue Chanoinesse, 4e 329.9750.
Directors: Lucila Viso, Jorge Volpe. Open Tues-Sat 2-7pm.
Young gallery showing essentially South American artists known in own countries, but not in Paris. Run by artists, gallery open to various tendencies. Thursday reserved for seeing new artists.

**Daniel Templon** 30 rue Beaubourg, 3e 272.1410 (in courtyard).
Large important gallery covering main movements from 60's onwards — Pop, Conceptual, Minimal, Abstract Expressionism, new image — 'figuration libre'. Artists include Bioulès, Louis Cane, O. Debré, de Kooning, Sol Lewitt, Motherwell, R. Ripps, Stella, B. Venet, A & P. Poirier, Ben, Don Judd, Poons, Warhol.

**Tendances** 105 rue Quincampoix, 3e.
Directors: Mr Plaussu, Mr Pirollo. Open Tues-Sat 12-7pm.
Specialises in works on paper and prints, exclusively representing Minaux, other works by Hartung, Soulages, Fautrier. 3 exhibitions a year.

**Françoise Tournié** 10 rue du Roi-de-Sicile, 4e 278.1318.
Director: Mme Tournié. Open Tues-Sat 11-7pm.
Specialises in Surrealist works by Bellmer, O. Dominguez, Man Ray, Matta, Paalen, Picasso Gleizes. Sculptures by Penalba, Hajdu, Peyrissac, Van Thienen.

**Trente** 30 rue Rambuteau, 3e 278.4107 (1st floor).
Collective. Open Weds. and Sat. 2-7pm.
Very precise line of conceptual work leading to geometric imagery shown in this young gallery run by 5 artists. Also work on calligraphy, installations. Artists exhibited have included Pierrette Bloch, G. Duchêne, Le Bouil, Pénard, Bonargent, Limerat.

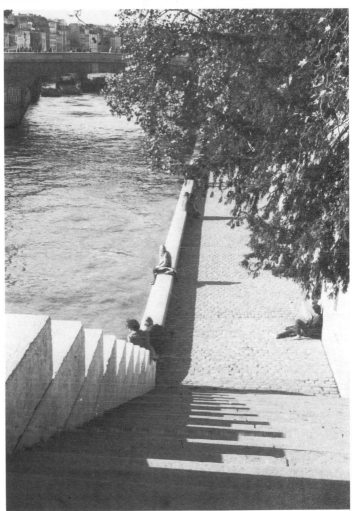

*Ile de la Cité.*

**Vivian Véteau** 4 rue des Guillemites, 4e 271.9590.
Director: V. Véteau.
Eclectic tendencies in small, relaxed gallery — from paintings to prints, photography, artists' books. Has shown Sara Holt, Hervé Bordas, M. Simbruck, B. Turiot.

**Jacques Wyrs International** 31 rue au Maire, 3e 277.3271.
Open Mon-Fri 2-6.30pm.
Exhibitions in field of science fiction and contemporary surrealism/'fantastic' art. Represents B. R. Bruss, F. Corco other works by Canta, Paternoster, Senkel, Symes, Weber, Wyrs.

**Zabriskie** 37 rue Quincampoix, 4e 272.3547.
Director: Sherry Barbier. Open Tues-Sat 11-7pm.
Originally a photography gallery, now extended to cover painting and sculpture — represents Archipenko, Baizerman, Zorach and contemporary sculpture by Mary Frank, T. Roszak, K. Snelson, T. Woodman. Paintings by A. Gallatin, Pat Adams amongst others. Main gallery in New York.

# Prints/Art Posters

**Antarès** 218 Boulevard Raspail, 14e 322.3194.
Directors: G. Prouté, J. Ezratty.
Limited editions (also some paintings) by Asada, Antonini, Boni, Gentilli, Hayter, Méan, amongst others.

**Apocalypse** 12 rue de la Paix, 2e 261.7524.
Director J. Fôret.
Lithographs and etchings by Bellmer, Dali, Fini, Trémois and others.

**Art 204** 204 Boulevard St-Germain, 7e 222.2629.
Large selection of prints (also gouaches and paintings) by wide range of established and contemporary artists — Brauner, Dufy, Gauguin, Matisse, Maillol, Pechstein, Rouault, Vlaminck, Calder, Okamoto, Hockney.

**Art Concorde** 36 rue de Penthièvre, 8e 562.0044.
Open Mon-Fri 10-12.30/3-7pm.
Publish artists' prints and books — Cocteau, Dali, Ernst, Fuchs, Papart, Totero, Kumlin — also paintings and sculpture.

**Art de Lutèce** 57 rue de l'Abbé-Groult, 15e 250.5601. metro: Convention.
Collection of fairly traditional artists' prints.

**Art Pluriel** Forum des Halles, 1e 233.1307.
Director: Marie-Hélène Michelet. Small gallery showing art posters, subjects from cinema to jazz.

**Atelier Lacourière et Frélaut** 11 rue Foyatier, 18e 606.1770.
Director: Mr Frélaut.
Etching studios with own editions by Bryen, Brandstatter, Condé, Dado, Dmitrienko, Haass, Prassinos, Singier, Stavitsky amongst many others.

**Carmen Casse** 10 rue Malher, 4e 278.4314.
Directors: Carmen & Michel Casse. Own lithography editions by contemporary artists, well presented. Artists include Chemay, Corneille, Segui, Fassianos, La Salle, Ronald Searle, Schoendorff, Zapata. Friendly gallery.

**Champfleury** (Editions) 17 rue de Nantes, 19e 201.1931.
Director: Jacques Champfleury. Lithography studios with own editions — Belley, Broisson, Casado, Farrell, Goezu, Jaccard, Rozen, Wolff and other contemporary printmakers.

**Le Chapitre** 21 rue Guénégaud 6e and 36 rue St-Louis-en-l'Isle, 4e 633.5609.
Art posters/reproductions by contemporary European and American artists.

**Editions Combat pour la Paix** 35 rue de Clichy, 9e 874.3586.
Limited edition prints with pacifist ideology: Picasso, Miro, Kijno, Ayuso, Picart le Doux, Pignon, Viard.

**Editions de l'Ermitage** 33 rue Henri-Barbusse, 5e 354.7144.
Open Tues-Fri 11-7pm, Sat 2-7pm.
Publishers of limited editions — Friedlander, Yves Milet and others.

**Editions Galilée** 9 rue Linné, 5e 331.2384.
Limited editions and print gallery.

**Editions Lahumière** 88 Boulevard de Courcelles, 17e 763.0395.
Large selection of own print editions — including Adami, Clavé, Folon, Dewasne, Paolozzi, Ipousteguy, Wesselmann, Vasarely, Manzu, Magnelli, Herbin. Also paintings and sculpture.

**Galerie 212** 212, Boulevard St-Germain, 7e 548.4335.
Recently opened, gallery specialising in exhibitions of contemporary American limited edition prints as well as museum and gallery posters.

**Georges Fall** 57 Quai des Grands Augustins, 6e 633.5245.
Open Tues-Sat 11-7pm.
Publish own editions of contemporary artists including A. Baber, Jiri Kolar, S. Serri, Vasarely. Also some paintings.

**La Gravure** 41 rue de Seine, 6e 326.0544 (in courtyard).
Etchings and lithographs by established and lesser known 20th century artists. Occasional painting exhibitions.

**Pierre Hautot** 36 rue du Bac, 7e 261.1015.
Open 9-12/2-6.30.
Large selection of own editions of fairly established traditional artists — Brayer, Carzou, Chapelain-Midy, Fini.

**La Hune** 14 rue de L'Abbaye, 6e 325.5406.
Tues-Sat 10-1/2-7pm.
Small gallery associated with bookshop mainly dealing in artists' prints, some works on paper. Alechinsky, Cremonini, Dorny, Goetz, Hayter, Jaccard, Man Ray, Monory, Titus-Carmel, Soulages, Bram Van Velde, Velickovic.

**L'Imagerie** 9 rue Dante, 5e 325.1866.
Open Mon-Sat 10-1/2-7.30pm.
Gallery dealing in original posters mainly from 1920's and 1930's also 19th century with humorous/unusual images. Japanese prints. About 5 exhibitions a year.

**Images** 39 Quai d'Anjou, 4e 634.1770.
Open Tues-Sat 10-7pm.
Gallery with lithographs, posters, photographs books by contemporary artists.

**Multiple** 5 rue de Varenne, 7e 544.2944.
Contemporary art posters from Europe and the States.

**La Nouvelle Gravure** 42 rue de Seine, 6e 633.1912.
Large selection of contemporary artists' prints.

**Peintres Graveurs** 159 bis Boulevard du Montparnasse, 6e 326.6229.
Open 10-12.30/2-7pm Tues Sat.
Gallery with prints dating from the Impressionists onwards — Bonnard, Gromaire, Giraud, Lars Bo.

**Romanet** 30 rue de Seine, 6e 326.4670.
Traditional gallery with large selection of artists' prints covering 20th century — from Braque to Ecole de Paris.

**Sagot Le Garrec** 24 rue du Four, 6e 329.5685.
Open Tues-Sat 10-12.30/2-7pm.
Traditional and new prints.

**Le Soleil Noir** 2 rue Fléchier, 9e 280.4702 by appointment only.
Director: François Di Dio. Specialises in books as art, also books illustrated by contemporary artists such as Camacho, Erro, Monory, Télémaque, Ipousteguy.

**Vision Nouvelle** 63 rue Pierre-Charron, 8e 225.7025.
Publisher of limited edition prints by artists such as Gantner, Tobiasse, Coignard, Papart, Garzou, Toffoli, Weisbuch.

**Varenne** (Jacques Damase) see Left Bank galleries.

# Photography Galleries

Included in the list below are several organisations which are either clubs, requiring membership to exhibit, or agencies which have no regular exhibition space but organise exhibitions elsewhere and deal in photography.

**Art Photographique du XXe siecle** P.O. Box 228, 75827 Paris Cedex 17 277.718.
Director: D. Malek.
Agency which arranges and exchanges photographic exhibitions in France and abroad.

**Bibliothèque Nationale** — Galerie de Photographie, 4 rue Louvois, 2e 296.8741.
metro: Bourse. Open Mon-Sat 12-6pm. Curators: B. Marbot (historical), J-C Lemagny (contemporary).
Gallery belonging to National Library with regular exhibitions of young international photographers and also sections of collection of great historical value.

**Centre d'Information Kodak** 38 Avenue George V, 8e 723.5921.
metro: George V. Open Mon-Fri 9.30-6.30pm.
Overtly commercial centre with well designed exhibition space for young photographers using Kodak material, often of very high standard. Reference section includes wide selection of international photo magazines, Kodak technical information and comfortable chairs.

**Centre d'Information Polaroid** 143 Avenue de Wagram, 17e 758.1325.
metro: Wagram. Open Mon-Fri.
Occasional exhibitions of Polaroid work.

**Centre de Recherches sur l'Image** Atelier Médicis, 5 rue de Médicis, 6e 354.3313. metro: Luxembourg.
Co-director: Herman Puig.
Association which organises exhibitions and workshops on portraiture and male nude, also seminars, use of studio and exhibition space for members.

**La Chambre Claire** 14 rue Saint-Sulpice, 6e 634.0431.
metro: Odéon. Gallery open Tues-Sat 1-7pm.
Director: Sami Tabet.
Specialised photography bookshop with lovely vaulted downstairs gallery recently opened for exhibitions. Open for application.

**Michèle Chomette** 240 bis Bld St-Germain, 7e 278.0562.
By appointment only. 19th and 20th century photography. Exhibitions arranged in galleries and museums.

**Galerie Créatis** 50 rue du Temple, 4e 271.1952/887.2856.
Open Mon-Sat 1-7pm. Director: Albert Champeau. metro: Rambuteau. Back of courtyard, 1st floor.
Recently transferred to a vast new space with loft type area destined for video, installations, sculpture, dance, performance as well as normal space for photography. Membership of association "Contemporisme" leads to possible exhibitions (see ART ORGANISATIONS). Publish magazines and books. Important collection of 20th century photography.

**Viviane Esders** 12 rue St-Merri, 4e 271.0312 (1st floor).
metro: Rambuteau. Open Tues-Sat 2-7pm. Director: V. Esders.
Pleasant airy space showing young American, British and European photographers, sometimes in mixed thematic exhibitions. Worth visiting.

**Espace Canon** 117 rue St-Martin, 4e 278.7420.
metro: Chatelet, Rambuteau. Open Mon-Sat 10-6.30pm.
Ground-floor exhibitions often have strong commercial note but basement can have some exceptional shows of young photographers. Canon info and books on sale.

**FNAC** Open Tues-Sat 10-7.30pm. Mon 1-7.30pm.
136 rue de Rennes, 6e. metro: Montparnasse.
Level 2, Forum-des-Halles, 1e metro: Châtelet.
26 Avenue de Wagram, 8e metro: Etoile.
The three branches of this discount book/record/photo/hi-fi chain hold regular photography exhibitions of exceptional quality in the shops with some master photographers and other contemporary work. Also organise workshops, seminars etc. — also for video.

**Agathe Gaillard** 3 rue du Pont Louis -Philippe, 4e 277.3824.
metro: Hôtel de Ville, Pont Marie. Open Tues-Sat 1-7pm. Director: A. Gaillard.
Well known and pioneering photography gallery with large space for exhibitions of masters such as Kertesz, Ralph Gibson as well as younger photographers. Books and postcards for sale.

**Galerie du Mamiya-Club** 25 rue St-Sulpice, 6e 325.6498.
metro: St-Sulpice (1st floor). Open Mon-Sat 10-1/2-7pm.
Regular exhibitions of photography by members, also studio, workshops and seminars.

**Galerie Marion-Valentine** 18 rue Gabrielle, 18e 259.4515.
metro: Abbesses. Directors: Marion-Valentine, Dominique Leguay. Open Tues-Fri 2-7.30pm. Sat & Sun 10.30-12.30/2-7.30pm
Young gallery in Montmartre with eclectic range of exhibitions. Publish portfolios and produce video-films of exhibiting photographers. Large selection of international photography postcards.

**Octant** 10 rue du 29 juillet and 5 rue du Marché St-Honoré, 1e 260.6808
Director: Alain Paviot. metro: Tuileries. Open Tues-Sat 2.30-7pm.
Two galleries situated on same street showing 19th and 20th century (to 1950's) photography — no contemporary work.

**Odéon-Photo** 110 Bld St-Germain, 6e 329.4050.
metro: Odéon.
Photo supplies/processing shop with occasional exhibitions.

**Photo-Club du Val de Bièvres** 28 ter rue Gassendi, 14e 322.1172.
Director: Jean Fage. metro: Denfert-Rochereau. Open Mon-Fri 10-12/2-7pm.
Photography club with studios, dark-rooms, exhibition space at 57 rue Daguerre (back of courtyard). Also organise seminars, workshops etc.

**La Remise du Parc** 2 Impasse des Bourdonnais, 1e 236.4456.
Director Samia Saouma. metro: Chatelet. Open Tues-Sat 1-7pm. Tucked away down a cul de sac this gallery represents Deborah Turbeville, Duane Michaels, K. Knorr, D. Seidner, M. Bouetti, D. Rochnile. Exhibitions often have a bite at society. Not open for application.

**Recontres d' Olympus** Level 2, Forum des Halles, 1e.
metro: Chatelet. Open Tues-Sat 10-7pm. Mon 2-7pm.
Small well lit space for showing work by Olympus photographers.

**Studio Ethel** 82 Bld St-Germain, 5e 354.6556.
metro: Maubert-Mutualité.
Photo processing shop which uses its space to exhibit young photographers.

**Studio 666** 6 rue du Maître Albert, 5e 354.5929.
Directors: Catherine and Carol-Marc Lavrillier. metro: Maubert-Mutualité. Open Tues-Sat 3-8pm.
Fairly large space for showing international contemporary photographers — generally 2 or 3 at once grouped in thematic exhibition. Also arrange seminars and 6-day workshops. Publish own portfolios, good selection of photography publications. Open for application, mainly B/W.

**Texbraun** 12 rue Mazarine, 6e 633.1457.
Director: François Braunschweig. metro: Odéon. Open Tues-Sat 2.30-7pm.
Large space for showing contemporary photography, often American. Bettina Rheims, R. Mablethorpe, P. Sarfati, Joel-Peter Witkin, Pierre de Fenoyl, H. Lewis, G. Incandela. Open for application.

**Galerie de l'Agence Magnum** 20 rue des Grands-Augustins, 6e.
metro: Odéon.
Photo-gallery attached to famous photographic agency, Magnum — exhibitions of reportage.

**Zabriskie** 37 rue Quincampoix, 4e 272.3547.
Director: Sherry Barbier. metro: Châtelet. Open Tues-Sat 11-7pm.
One of the original photography galleries in Paris — opened in 1977 of American parentage. Exclusive representation of H. Callahan, Friedlander, Paul Strand, John Batho and extensive collection of 19th and 20th century master photography (Abbott, Arbus, Atget, Beaton, Brassai, Klein, Papageorge, Man Ray, Weston etc). Also exhibitions of sculpture and painting (see ART GALLERIES). Ready to look at new work but leave portfolio on certain dates.

For lovers of photographic memorabilia and dusty relics there are two shops in Paris specialising in this:

**Chez Verdeau** 14-16 Passage Verdeau, 9e 770.5191.
Large collection of old, and very old cameras (wooden stand cameras of 1860 to 1928 Leicas), stereoscopic viewers and cards etc. In charming covered passage off rue du Fbg. Montmartre.

**Aux Fontaines de Nièpce et Daguerre** 20 rue André del Sarte, 18e.
A shop just below Montmartre stuffed with photography relics: old cameras, unusual prints etc.

# FOREIGN CULTURAL CENTRES

**Ambassade d'Australie** 4 rue Jean-Rey, 75015 Paris 575.6200. metro: Bir-Hakeim.
Large exhibition space on ground floor of this exceptionally designed embassy. Library and associated activities.

**American Center** 261 Boulevard Raspail, 75014 Paris 321.4220. metro: Raspail. Open Mon-Fri 12-7, Sat 12-5.30.
The most active of foreign cultural centres in Paris. Wide variety of activities ranging from modern dance to video projections to performance to exhibitions. Dance workshops with visiting Americans. French and American language courses, and numerous other participant activities. Arts administrator: Madeleine Deschamps.

**Centre Culturel Britannique** 9-11 rue Constantine, 75007 Paris 555.5499. metro: Invalides.
Alias the British Council and Institute combined. Activities/facilities mainly literary and musically inspired — sadly no visual arts — and lectures, films and concerts regularly take place. Good library for reference and lending, including records. Closed at weekend. Useful noticeboard downstairs for odd jobs, accommodation etc.

**Centre Culturel Canadien** 5 rue de Constantine, 75007 Paris 551.3573. metro: Invalides.
Again, a cultural centre which lives up to its name: exhibitions of Canadian artists, concerts, films, video, a library and a music reference room with records, tapes. Answering machine with daily activities: 551.3041. Closed at weekend. Open 10-7pm

**Centre Culturel de la Communauté Française en Belgique** 127-9 rue Saint-Martin, 75003 Paris 271.2616.
metro: Châtelet, Rambuteau, Open 11-6 closed Sun.
Regular exhibitions of Belgian artists, both historical and contemporary and often dynamically laid out. Cafe at back of centre sells varieties of Belgian beer . . . Centre closed on Sunday.

**Centre Culturel Irakien** 11 rue de Tilsitt, 75017 Paris 754.2690. metro: Etoile.
Occasional exhibitions of contemporary Iraqui art.

**Centre Culturel Latino-Americain** 6 rue des Fosses-St-Marcel, 75005 Paris 336.5604. metro: St. Marcel.
Also see ESPACE LATINO-AMERICAIN and LE SOLEIL BLEU under COMMERCIAL GALLERIES.

**Centre Culturel du Mexique** 47 bis Ave Bosquet, 75007 Paris 555.7915. metro: Ecole Militaire. Closed Sunday.
Regular exhibitions of contemporary Mexican art, also meetings, lectures.

**Centre Culturel Portugais (Gulbenkian Foundation)** 51 Ave d'Iéna, 75016 Paris 720.8684. metro: Etoile. Closed Sunday.
Another national art foundation which works hard for its artists with regular exhibitions and grants.

**Centre Culturel Suedois** 11rue Payenne, 75003 Paris 271.8220. metro: St. Paul. Open Mon-Fri exhibitions also Sat and Sun 2-6 pm.
Housed in a typical and beautiful 'hôtel' overlooking the tranquil gardens of the Parc Royal with two large exhibition spaces and a library devoted to Swedish art. Regular contemporary and historical exhibitions, concerts and theatre.

**Centre Culturel de la Yougoslavie** 123 rue Saint-Martin, 75003 Paris 272.5050.
metro: Chatelet, Rambuteau. Open 11-7pm. Closed Monday.
Large gallery space for artists — other activities include concerts. Situated opposite Beaubourg.

**Délégation Générale du Québec** 117 rue du Bac, 75007 Paris 222.5060. metro: Sèvres-Babylone.
Regular contemporary exhibitions of Quebecois artists.

**Espace Japon** 12 rue Sainte-Anne, 75002 Paris 261.6083. metro: Pyramides.
Exhibitions of contemporary Japanese art and graphics.

**Goethe Institut** 31 rue de Condé, 75006 Paris 326.0921. metro: Odéon and main centre at 17 Ave d'Iéna, 75116 Paris 723.6121. metro: Iéna. Open Mon-Fri 10-8pm.
Well conceived and designed exhibitions of contemporary German art, video, photography and prints — several run contemporaneously between the two centres. Also conferences and related activities.

**Institut Autrichien** 30 Boulevard des Invalides, 75007 Paris 705.2710. metro: St François-Xavier.
Lectures and music.

**Institut Culturel Italien** 50 rue de Varenne, 75007 Paris 222.1278. metro Rue du Bac. Closed Sunday.
Exhibitions generally on historical art themes.

**Institut Néerlandais** 121 rue de Lille, 75007 Paris 705.8599. metro: Chambre-des-Députes. Closed Monday. Open 1-7pm.
Contemporary art exhibitions and occasional concerts.

**Maison du Danemark** 142 Champs-Elysées, 75008 Paris 359.0202.
More of a commercial centre with restaurant etc. but some surprising exhibitions of Danish crafts.

# ALTERNATIVE ART SPACES & GROUPS

The perennial tooth-grinding problem of finding exhibition space together with a severe accomodation shortage means that many artists have found it profitable to group together in ex-industrial spaces — following the New York and London loft schemes — where they live, work and exhibit. Despite the number of com-

mercial galleries, directors are not always ready to risk showing 'unsaleable' work and many artists simply refuse to enter the commercial circuit. Consequently 'alternative' spaces proliferate and come and go but the list below is of seemingly more stable organisations. Also included are spaces for rent and artists' groups which don't necessarily have exhibition premises. If looking for an ex-industrial property consult the list "Locaux et Terrains industriels vacants dans Paris" published by the Chambre de Commerce (561.9900 ext. 458) also obtainable at the Hôtel de Ville info centre.

**Arcade** 4 rue Trousseau, 11e 700.8738.
An association set up around a bookshop which uses its adjoining space for exhibitions, meetings etc.

**Atelier 74** 74 rue de la Verrerie, 4e.
Collectively run gallery for exhibitions — mainly crafts, some photography.

**Astrakan** 4 rue du Ponceau, 2e 261.4342.
Artists' group which organises exhibitions (painting, polaroids) and performance.

**L'Atelier** 20-22 Passage Vivienne, 2e 260.9901.
Group of photographers who use this space to meet and exhibit work which remains outside normal photographic circuits.

**Association Quai de la Seine/Quai de la Loire** Ateliers de l'Ourcq, 68 Quai de la Seine, 19e 241.1276.
Organiser: Nadjia Mehadji.
Group of 30 painters, photographers, film-makers, dancers etc living in warehouse studios on a canal in north Paris. Organise occasional group shows and performances in rapidly deteriorating surroundings.

**Cairn** 151 rue du Faubourg St-Antoine, 11e 307.0848.
Long-standing co-operative of artists situated near Bastille — fast becoming an artists' quarter in itself. Interested in overseas exchanges of work and studios. Video installations and screenings, catalogue of audio-visual work.

**Centre International d'Art Contemporain à Paris** 27 rue Taine, 12e 887.0044. Very large centre used for rather obscure salons.

**Centre Culturel du Marais** 28 rue des Francs-Bourgeois, 3e 272.7352.
Organisers: Jacqueline & Maurice Guillaud.
Alternative gallery-museum with vast space used for dynamic exhibitions of living and dead artists (Picasso, Turner, Vostell . . .). Theatre and installations, salon de thé, bookshop/gallery at no. 20. Long history of withdrawn subsidies means it now exists on private support.

**Confluences** 15 Passage Lathuile, 18e 387.6738.
Long-standing film-makers' collective — space used for visual arts activities.

**Diagonale** 10 rue Edgar-Quinet, 14e.
Started in 1979 and organised by critic Egidio Alvaro with a group of artists and collectors. Exhibitions and performances by artists of all nationalities — regular activities with accompanying info on artists.

**Da et Du** 1 rue Saint-Maur, 11e 700.1934, 355.2330.
A recycled factory with international outlook, started by Italian Dedalo Montali. Space is sufficiently extensive to accomodate visiting artists who leave half work accomplished during their stay. Exhibitions are arranged and the amassed work is sold (hopefully) leaving a percentage to Da et Du who reinvest in the space. Also used for performance and music.

**Espace Avant-Première** 6 rue Saint-Nicolas, 12e 341.5576.
Regular and temporary members of this group choose the work of a young unknown artist to exhibit in their space — 20% commission. Extremely organised.

**I.C.O.M.O.S.** 75 rue du Temple, 3e 277.3576.
Irregular use of these premises belonging to an international preservation association. Activities have included film, video, dance.

**Lascaux des Villes** 9 Boulevard du Montparnasse, 6e 567.4519.
Recently formed alternative group of artists. Exhibitions space in an apartment.

**Galerie 30** 30 rue Rambuteau, 3e (1st floor) 278.4107.
Open Wed. & Sat. 2-7pm.
Long-standing artists' collective that uses its well situated apartment (next to Beaubourg) for exhibiting artists of their choosing within a line of conceptual work. Produce catalogues and analysis of work presented.

**Group Brouillage** 49 rue Santos-Dumont, 15e.
Recently formed artists' group.

**Groupe des Peintres du Marais** 10 rue Ste-Croix de la Brétonnerie, 4e 272.0599.
Group of artists who organise occasional street art activities in the Marais and Les Halles.

**Groupe 633 × 314** or Association "Pour l'Art", 5 rue Hélène, 17e 294.9346.
Three women artists who occupy and work in a cul-de-sac using both interior and exterior for exhibitions/activities together with invited artists. Central theme: the unsociability of creation and daily life. Monique Kissel, Daniele Gibrat, Barabara Pollak.

**La Main d'Or** 18 rue Nollet, 17e 294.0450.
Run by Agnès de Grammont, this printing studio groups printmakers for etching facilities and arranges exhibitions on techniques and the group.

**Pali Kao** ?? rue de Pali Kao, 20e 358.1828.
(Espace de recherches et de rencontres artistiques). Enormous living/working/exhibiting/performing space created in an old factory by four young artists who invite others to perform or exhibit. Organised by Bruno Rousselot.

**La Passerelle** see Galleries in Les Halles.

**Les Portes** Spont'Act, 17 rue du Cygne, 1e.
Street art group aiming to accomplish 6 "poetic and graphic acts".

**Villa Corot Association** 2 rue d'Arcueil, 14e 588.5277. Artists' group.

If you feel like hitting the inner & outer suburbs of Paris there are some adventurous exhibitions and other cultural activities organised in the local cultural centres (Maison de Jeunesse et de Culture). The **André Malraux centre** at Créteil is particularly well equipped and a number of outstanding performances/exhibitions have taken place here, so it is well worth making the slight effort in transportation logistics to visit them — "Pariscope" covers activities. They are also open for exhibition application.

# ART ORGANISATIONS

Artists' unions included in this section. For audio-visual organisations see section PHOTOGRAPHY/FILM/VIDEO.

**A.D.A.G.P.** (Association pour la Diffusion des Arts Graphiques) 11 rue Berryer, 8e 561.0387.
Administrator: Claude Roederer.
Deals with artists' rights: reproductions, royalties, legal and tax advice etc.

**ADMICAL** 116 rue La Boétie, 8e 225.6593.
President: Jacques Rigaud.
Association dealing with relations/contacts between art and industry (see SPONSORSHIP).

**Alternative Architecture Association** 103 rue Raymond-Losserand, 14e 541.0332.

**Art Dialogue** 34 rue Laborde, 8e 296.3712.
Organisation which rents out prints to offices. Buys from individual artists.

**A.R.T. P.R.O.S.P.E.C.T.** 50 rue de l'Ouest, 14e 322.8518.
Administrators: Jean-Louis Connan, Alain Garo.
Recently initiated a billboard operation throughout France, commissioning artists — 150 painters and photographers were thus shown to the general public.

**Association pour le Développement de l'Environnement Artistique** (A.D.E.A.) 65 rue Marius Aufan, 92300 Levallois-Perret. 757.8360.
Similar spirit to above, symbolic of desire to produce art in urban settings. 13 walls were recently painted by known artists all over France.

**Association de l'Atelier de Création** 40 rue François I, 8e 720.7803.
Helps, encourages and promotes young artists who present portfolios and are accepted by the association.

**Association Internationale des Critiques d'Art** 11 rue Berryer, 8e Secretary: Raoul Jean-Moulin. International art-critics association.

**Biennale de Paris** Porte J, Grand-Palais, Ave Winston-Churchill, 8e 256.3344.
Important bi-annual event, started in 1959 (now even years) showing artists under 35, covering experimental film, music and architecture as well as painting, sculpture, installations, photography video. 1984 Biennale will take place in May at the recently developed Parc de la Villette — at last under one roof.

**Centre National d'information et de documentation sur les métiers d' art** Musée des Arts Décoratifs, 107 rue de Rivoli, 1e 260.5658.
Open 12.30-5.30pm closed Tuesday & Sunday.
Information centre for craftsmen/women with register, addresses of galleries, salons, shops, suppliers' index, lists of courses/workshops and administrative info. Very helpful.

**Comité Professionel des Galeries d'Art** 5 rue Quentin-Bauchart, 8e 723.7429.
President: G. Caputo. Committee of art galleries.

**Contemporismes** 39/41 rue d' Artois, 8e or at Galerie Créatis 887.2856.
Newly formed group of artists, critics and others, subscription 300 F/yr. organises exhibitions and activities at the gallery — video, performance, painting, sculpture, photography. Members' discount on Créatis works (books, mags, prints) and technical assistance with book projects.

**Etats Généraux des Arts Plastiques** 8 Impasse de l'Epine, 92160 Anthony 666.5430.
Group of militant artists that organised a general meeting of all concerned with the art-world to discuss needs and propose reforms and projects to government. Continuing activity and dossier available.

**F.I.A.C.** (Foire Internationale d'Art Contemporain) 34 rue du Bac, 7e 261.1173.
President: Daniel Gervis.
Annual art fair at Grand Palais with international representation of galleries — controversial selection. Takes place in late October.

**Fondation Nationale des Arts Graphiques et Plastiques** 11 rue Berryer, 8e 563.5902.
Founded in 1976 to aid artists, financially and technically. The mansion bequeathed by Salomon de Rothschild is fast becoming a central arts institution housing numerous art organisations, unions, departments of the Ministry of Culture as well as its exhibition rooms regularly used for promoting contemporary art.

**International Association of Art** UNESCO, 1 rue Miollis, 15e.
French committee secretary: J-P. Verdeille, 32 Bld St Michel, 6e.
Annual subscription gives free entrance to certain museums world-wide, discounts at some suppliers, bookshops etc.

**Institut Français d'Architecture** 6 rue de Tournon, 6e 633.9036.
Active institute with regular exhibitions of new architectural projects, slide-shows, diverse info. Publish a monthly newsheet with calendar of activities, seminars and international news (Editor: G. Querrien).

**Savoir au Présent** 16 rue Lacuée, 12e.
Aims to create contacts between artists (visual, music, photo) and workers at their office/factory through discussions, video, exhibitions, workshops etc.

**Sociéte d'Encouragement aux Métiers d'Art** 20 rue la Bóetie, 8e 265.2694.
Official crafts' organisation dealing with subsidies, grants, etc.

**Société Française des Architectes** 100 rue du Cherche-Midi, 6e 548.5310.

**S.P.A.D.E.M.** 12 rue Henner, 9e 285.4101.
The official copyright organisation for registering any visual image — also deals with ensuing problems. Photographers and designers are included as well as painters, sculptors, printmakers etc.

**Syndicat National des Artistes Plasticiens** (S.N.A.P.) 14-16 rue des Lilas, 19e.
Secretary: R. Forgas. Fine-artists' union.

**Syndicat National des Graphistes** 31 rue François I, 8e 723.3511.
Secretary: M. Auriac. Graphic artists' union.

**Syndicat National des Peintres, Graveurs et Sculpteurs** (S.N.P.G.S.) 11 rue Berryer, 8e.
Monday night 6-8pm open for information.

**Syndicat National des Peintres et Illustrateurs** (S.N.P.I.) 11 rue Berryer, 8e 563.9054.
Secretary: Jean Madelin. Afternoons only.

**Union des Syndicats de Créateurs Professionels en Arts Graphiques et Plastiques** 1 rue de Courcelles, 8e.
Secretary: Bernard Mougin. The unions' union.

---

# SALONS

---

An old Parisian tradition giving every artist an opportunity to exhibit, although the gallery-explosion has more recently countered their value and utility. Many of them take place at the Grand Palais which, when well-filled, can give you a case of art-indigestion, but think of the days when the Impressionists shocked Paris society with their revolutionary paintings at the Salon des Indépendants. The following is a list of the most important salons in which it is possible to apply for exhibition space with varying handling fees. Also see section FESTIVALS.

**Salon d' Automne** Porte H, Grand Palais, Ave Winston Churchill, 8e 359.4607. Chairman: Edouard MacAvoy, 102 rue du Cherche-Midi, 6e 548.3245.
The salon at which the Fauves upset artistic norms in 1905. Large-scale and exhibits remain within figurative tradition. November. Also film and photo.

**Salon des Indépendants** Porte H, Grand Palais. 225.8639.
Chairman: Jean Monneret, 134 Bld. Berthier, 17e 380.1396.
Often extremely overcrowded with correspondingly varied
standard. Started in 1884. February/March.

**Salon Comparaisons** Grand Palais.
Chairman: Rodolphe Caillaux, 189 rue Ordener, 18e 606.5793.
May/June.

**Salon de Mai** Espace Pierre Cardin or elsewhere.
President: Gaston Diehl 66 rue de Lisbonne, 8e 267.2249. Sec-
retary: Jacqueline Selz, 8e Ave Victorien Sardou, 16e 288.2249.
Generally includes some well known contemporary artists as
well as experimental work, though painting remains within figu-
rative field. May.

**Salon des Réalités Nouvelles** Musée du Luxembourg, 19 rue de
Vaugirard, 6e 325.2409.
Chairman: Jacques Busse, 21 rue Daguerre, 14e 322.0751.
April/May. All tendencies except surrealism.

**Salon de la Jeune Peinture** Grand Palais.
Secretary: Mme S. J. Chapelle, 215 Bld Raspail, 14e 320.6572.
Started in 1949 and parent to many splinter salons. Mainly politi-
cal/social criticism. December.

**Jeune Peinture/Jeune Expression** 11 rue Berryer, 8e 256.2703.
Splinter group from above — collectively run. Political bias.
December.

**Salon de la Jeune Sculpture** 61 rue Galande, 5e 329.6468.
Secretary: Eva Chevalier. May/June.

**Salon de la Jeune Gravure Contemporaine** 42 Place Jules
Ferry, 92320 Montrouge. 253.0587.
Chairman: André Fougeron. For printmakers.

**Salon des Surindépendants** 5 rue Emile Gilbert 12e. 628.3159.
Chairman: Miguel Devèze.
Mammoth salon covering all forms.

**Salon Figurations Critiques** Grand Palais. 1 rue Louis Gaubert,
78140 Vélizy-Bas. 946.7564.
Chairman: Mme Dors-Rapin.
Splinter group from the Jeune Peinture salon. Similarly political
bias, accent on figurative work. April/May.

**Salon des Illustrateurs** c/o Procomex, 10 rue Duvergier, 19e
241.4499
Started in 1981 June.

**Salon de Montrouge** Centre Culturel et Artistique de
Montrouge, 43 Ave de la République, 92120 Montrouge.
656.5252.
Administrator: Nicole Bessec 32 rue Gabriel Peri, 92120
Montrouge.
A municipally organised salon just outside central Paris with
excellent representation of contemporary artists — known and
unknown. Apply by December, salon in May.

**Grands et Jeunes d'Aujourd'hui** Grand Palais.
Chairwoman: Marylène Dénoval 12 bis rue de l'Etoile, 17e.
380.3875. Also 584.7685 (mornings).
The most interesting and well selected of the large salons with a good spectrum of art trends. September/October.

**Société des Artistes Francais** Porte H, Grand Palais 359.5249.
Chairman: Georges Muguet, 38 rue Boileau, 16e.
Salon in March/April and other activities for members.

**Union des Femmes Peintres et Sculpteurs** Musée du Luxembourg.
Chairwoman: Mme Fay-Vidal, 11 rue Berryer, 8e.
International women's salon — founded in 1884.

# ART PRIZES AND GRANTS

Below is a list of some of the numerous art prizes/awards offered in Paris. Apart from those mentioned, most Salons have prize systems, as do commercial photography centres such as Canon, Mamiya etc (see PHOTOGRAPHY GALLERIES) and also foreign cultural centres which often allocate grants for artists to work in their countries. For graphics/design competition see the C.C.I. notice-board at Beaubourg, or their monthly bulletin "Bulletin Mensuel d'Information du C.C.I." which lists design competitions world-wide. To seriously investigate all possibilities buy UNESCO's annual publication "Study Abroad" which lists courses and grants available world-wide (200,000 of them . . .) available at UNESCO bookshop, 7 Place Fontenoy, 7e.

**Fondation Caplain Saint-André**
Annual national sculpture competition, all forms and materials accepted — 20,000 F.

**Fondation Kodak-Pathé** 38 Ave George V, 8e 723.5921.
Annual prizes for photographers and film-makers with follow-up exhibitions and distribution. 10,000 F each to 4 photographers.

**Fondation Photorush** c/o Dorset Communication, 18 Ave de la République, 11e.
Newly instituted to help young photo-reporters. 20 portfolios are selected and given concrete aid in material/processing. May/June.

**Fondation pour l'Art et la Recherche** 6 rue Clément Marot, 8e 723.6328.

**Fondation Robert Four** 28 rue Bonaparte, 6e 329.3060.
Contemporary tapestry gallery which gives awards in this field.

**Fondation Philip Morris pour le Cinéma** 33 Ave Mac-Mahon, 17e 755.7140.
Well known for its competitions/sponsoring of young film-makers, script-writers and film-poster designers.

**Fondation Taylor** 1 rue de la Bruyère, 9e
Every one or two years, a prize for an artist aged minimum 55, French, known, and working in figurative field . . . not exactly elastic but prize money of 90,000 F.

**Fondation de la Vocation** 20 Ave Mac-Mahon, 17e 380.6235.
Annual awards to 10 artists/craftsmen under age of 30 — 10,000 F each and exhibition of winning artists' work as well as other practical aid. French nationality, July application.

**Grand Prix des Arts de la Ville de Paris,** Hôtel de Ville, 4e (January).

**Grand Prix d'Architecture** Sécrétariat de l'Académie des Beaux-Arts, 23 Quai Conti 6e. For either qualified foreign architect or French architecture student.

**Grand Prix Video** G.I.E.L., 11 rue Hamelin, 75783 Paris Cédex 16. 505.1427. Two annual video prizes of 10,00 F and material. Apply by December.

**Prix Bourdelle** Musée Bourdelle, 16 rue Antoine-Bourdelle, 15e 548.6727.
Annual sculpture prize.

**Prix Connaissance des Arts** 25 rue de Ponthieu, 8e 720.2653.
Prize of 50,000 F awarded to painter or sculptor, no age limit, foreigner must be resident in France.

**Prix Feneon** Secretary: J. Huet, 7 rue de la Sorbonne, 5e.
Generous prizes for painters, sculptors, writers, French nationality under 35. Apply by January.

**Prix Jeanne Gatineau** 116 Boulevard Haussman 8e 522.7710.
Annual prize of 10,000 F for a painting around a theme which changes every year. Exhibition of runners-up. Apply by July.

**Prix Claude-Raphael Leygues** Académie des Beaux-Arts, 23 Quai Conti, 6e
Competition for sculptors, resident in France at least two years, under 45 — prize of 20,000 F. Apply in early June.

**Prix Lacourière** Dept. des Estampes, Sécrétariat du Prix, Bibliothèque Nationale, 58 rue Richelieu, 2e.
Annual prize of 30,000 F for etchings: maximum 35 years old, resident in France at least 5 years. Apply in October.

**Prix Nichido,** Galerie Nichido, 61 Faubourg St-Honoré, 8e 200.0206.
Various forms of practical help (exhibitions, purchasing, travel awards) offered to 10 painters under 40 of any nationality. Links with Japan. Apply in March.

**Prix Weiller** Académie des Beaux-Arts, 23 Quai Conti, 6e 326.2247.
Painting prize for portraiture, alternating with sculpture portrait prize. Under 35, any nationality, 20,000 F and 10,000 F prizes. Apply in January.

**Photography prizes** U.e.m. "Photo", Cedex 892, Paris-Brune 75808.
This magazine devotes its December issue to readers' photos, awarding prizes. Check November issue for details.

Government grants:

**Prix de Rome/Villa Médicis** Délégation aux Arts Plastiques, 27 Avenue de l'Opéra, 1e 261.5616.
For French artists (painters, sculptors, architects, photographers, film-makers, restorers etc.) aged between 20 and 33. One year entirely subsidised, living and working at Villa Medicis in Rome.

**Research/creation grants** Délégation aux Arts Plastiques.
Grants allocated to artists (painters, sculptors, photographers, industrial designers or craftsmen) to live and work abroad for a year — 100,000 F each. Minimum 25 years old, professional, resident in France for at least 5 years. Apply in early May.

**Research/creation grants** to spend a year at the Chartreuse in Villeneuve-les Avignon. 2 grants of 100,000 F for artists, photographers or industrial designers. Apply in May.

**Ministère des Relations Extérieures:** Service de la Co-opération Culturelle 34 rue Lapérouse, 16e 502.1423.
Arranges grants for foreigners to study in France, or French abroad, but mainly in academic research field.

**Art grants for Germany** Deutsch-Französisches Ingendwerk Rhondorfer strasse 23, D 5340 Bad Honnef. 222.413.255.
For French artists under 30 — grant for travelling and living expenses for one year.

**Commission Franco-Américain d' Echanges Universitaires** 9 rue Chardin, 16e 520.4654.
Grants to study in the U.S.A. (including fine-arts), also deal with private American foundations which offer opportunities to foreign artists/academics.

# STATE AID

State support for artists is not centralised and with the recent and considerable increase in the government budget for the Arts the labyrinthine network has been extended even further. Both the municipal town council (Ville de Paris) and the state entities can aid artists towards finding studios, obtaining grants, getting subsidies and the organisation of exhibitions, as well as the purchase of paintings, sculpture, photographs etc. for public collections. Below is a list of public organisations dealing with this field.

## Studios

**Délégation aux Arts Plastiques** 11 rue Berryer 8e 563.9055.
Used to be called the Service de la Création Artistique. Deals with allocating artist's studios and also grants for improving and

transforming an existing property for studio use (between 10,000 and 30,000 F — called a 'bourse à l'installation'). The waiting list is long and conditions for obtaining an artist's studio currently include being a professional — i.e. belonging to the artists' social security organisation (see below). In the past many studios have been situated outside central Paris in rather uninspiring suburbs, but there has been a recent effort to convert old properties in more central areas. Grouped studios dating from the beginning of this century such as the Cité des Fusains (between Place Clichy and Place Blanche) and La Rûche (Passage Dantzig) still exist but are not for newcomers.

**Direction Culturelle de la Ville de Paris** 17 Boulevard Morland, 75181 Paris Cedex 04.
The municipal body which allocates studios is at this address — the same comments as above can apply. It also subsidises the Cité Norvins in Montmartre and the Cité des Arts and is working together with the state on the conversion of various central sites.

**Cité International des Arts** 18 rue de l'Hôtel de Ville, 4e 278.7172.
An international artists' centre set in central Paris, founded in 1965, with the aim to house foreign artists (visual arts and music) for an average of one year in studio-flats. Other facilities include a concert-hall, a large gallery, etching studios etc. Three studios are reserved for qualified architects — application by November to **Académie d'Architecture** 3 Place des Vosges, 4e. Rent is minimal — about 800F a month but demand greatly exceeds space, naturally enough. Certain studios are reserved by foreign organisations/art-schools which select their own artists. Otherwise for applying on an individual basis submit photos of your work in November or April — the committee meets soon after.

# Purchasing Committees

**Délégation aux Arts Plastiques** 11 rue Berryer, 8e 563.9055.
Administrator: Mme Morette-Maillant. Bureau des Achats et Commandes. Apply to this address to have work considered by state purchasing committee.

**Direction des Affaires Culturelles de la Ville de Paris** (above address)
Annual purchasing for municipal collections of contemporary art. Leave your portfolio at Bureau 7116.

**Centre National Georges Pompidou** 277.1233 ext. 47.05
Purchase for Beaubourg collection.

**La Bibliothèque Nationale** 58 rue de Richelieu, 2e 261.8283.
(Dept. des Estampes et de la Photographie) Purchasing of etchings, prints etc

**Conseil Régional Artistique de l'Ile de France** Grand -Palais, Porte C, Ave. F-D Roosevelt, 8e 225.1140.
President: Jean-Michel Foray. One of many regional committees concerned with purchasing contemporary art, from local or foreign artists and covering painting, sculpture, photography, graphics , applied arts, crafts. Also organise project competitions. The works bought are then loaned to cultural centres and touring exhibitions.

## Grants

Apart from those grants mentioned in the section PRIZES & GRANTS others are available from the **Ministère des Relations Extérieures** at the Association pour le développement des échanges artistiques et culturels (ADEAC) 101 Boulevard Raspail, 6e 544.5638 including help to live and work on the American continent — open to all art-forms.

**Société d' Encouragement aux Métiers d'Arts** 20 rue La Boétie, 8e 265.2694.
Grants, subsidies and general help for all crafts.

## Subsidies

**F.I.A.C.R.E.** 27 Avenue de l'Opéra, 1e 261.5616 (Ministère de la Culture). Administrator: Geneviève Gallot.
Recently created to 'incite' and encourage creation in general, covering fine-arts, graphics, crafts, photography, design etc. and subsidises art-related organisations (art-centres, alternative spaces) activities (performance, actions in hospitals, prisons etc.) and publications. Also allocates research grants in France and abroad.

**Délégation aux Arts Plastiques** (above address).
Gives financial aid towards a first exhibition: for any artist who has not exhibited in France for at least 10 years. 50% of the expenses are advanced to the gallery concerned — reimbursable on sales. Artist's portfolio and gallery budget-plan must be submitted together. As usual demand exceeds availability.

## Commissions

**The law of the 1%:** a mystifying title but with valid aim: it means that any new public building (from hospitals to schools to law courts) must spend 1% of its construction budget on art, which ranges from mosaics to tapestry as well as the fine arts. The commissions are made by the Ministries concerned in conjunction with the architect though the choice ultimately lies with the latter. Mobile studios have also been used by sculptors moving around on their 1% jobs . . .
**Association pour le Developpement de l'Environnement Artistique** subsidised by F.I.A.C.R.E. (see ART ORGANIS-ATIONS).

## Social Security

**Maison des Artistes** 11 rue Berryer, 8e.
Organises the social welfare of professional artists. To register, proof must be given that income is from an artistic activity. Quarterly contributions are estimated according to the income declaration. Useful in the long run as all medical treatment in France is payable in cash on the spot.

## Hiring of work

**Association technique pour l'action culturelle** 19 rue du Renard, 4e 227.3322.
State subsidised organisation which deals with exchanges

between local cultural centres and touring exhibitions for which it hires work from artists. ATAC also publishes a monthly magazine "Partenaires" with useful information on government cultural policies and calendar of state-subsidised exhibitions.

# SPONSORSHIP

Private sponsorship in France is a relatively recent phenomenon and is still behind activities in other countries, despite publicity and development. The association **ADMICAL,** founded in 1978, exists to promote this important function and for an annual subscription (currently 400 F) advises both companies and artists on projects . Individual advice to artists includes help with making up a portfolio and orientation towards companies likely to be interested.. They also publish a newsheet 'Lettre du Mécénat' and award sponsorship 'Oscars' to particularly active firms or projects. President: Jacques Rigaud. 116 rue La Boétie, 8e 225.6593.

Below is a list of companies which have sponsored living artists in the past and will hopefully continue to do so. Any correspondence should include "Action Culturelle" in the address, otherwise the letter may lose itself in the vast networks concerned.

**Alfa-Romeo** 150 Ave des Champs-Elysees, 8e 359.1314.
Recently commissioned 10 artists to paint works with an Alfa-Romeo theme for the Salon d'Auto — could be perceived as classy advertising.

**Assurances Générales de France** 57 rue de Richelieu, 2e 244.1313.
Policy and projects change from year to year but have included a photography competition.

**Baccarat** 30 bis rue de Paradis, 10e 770.6430.
Obviously glass related projects; include a museum of glass and financed projects by contemporary artists.

**Crédit du Nord** Mme Jacqueline Blazot. 6 Bld. Haussmann, 9e 247.1234.
Generally concerned with art projects located in northern France.

**Fédération Nationale du Crédit Agricole** Patrick Boccard, 26 Quai de la Rapée, 75561 Paris Cedex 12. 346.1230.
All projects and activities centred round rural areas.

**Fondation Bélier Conseil** Patrice Lobut, 14 Bld. du General Leclerc, 92200 Neuilly sur Seine. 758.1250 ext. 3200.
Recently promoted various young artists with 500 hill-board posters in the metro — at the same time promoting the supermarket Felix Potin which contributed to the project.

**Fondation de France** 40 Avenue Hoche 8e 563.6666.
Enormous foundation with wide network of activities. Cultural aid includes grants for audio-visual projects and awards to young artists (painting, photography, printmaking, dance . . .), financing of museum exhibitions.

**Fondation Peter Stuyvesant** 10 rue Hamelim, 16e 505.1433.
Known for its interest in contemporary art, it also recently commissioned 5 artists to decorate real taxis which circulated in Paris.

**Johnson** Z. A. Vert Galant, 10 rue Saint Hilaire, 95004 Saint-Ouen l'Aumone 363.4521.
Occasional art projects and collaboration with students at artschool in Pontoise.

**Kodak-Pathè** 8-26 rue Villiot, 75594 Paris Cedex 12. 347.9000.
Well known for its support of young photographers and filmmakers, its prizes and grants are always well subscribed. Collaborates with Paris-Audiovisuel for aid for first photography book and exhibitions.

**Lintas** 2 rue du Pont-Neuf, 1e 260.3824.Advertising agency which arranged an impressive art exhibition mainly of known contemporary painters.

**Mobil Oil** 20 Ave André Prothin, 92081 Courbevoie-la Défense. 773.4241.
Organises poster competition annually and occasionally finances publications.

**Philip Morris** c/o Promo 2000, 33 Ave Mac-Mahon, 17e 755.7140.
Contact: Francine Torrent. Continuous action sponsoring and financing film projects — scripts, posters, distribution.

**Pierre Cardin** Espace Cardin, 1 Ave Gabriel, 8e 265.9410
Cardin's sponsorship of the performing arts in his centre is well known — performances of theatre, dance, music as well as use of large space for exhibitions and salons. . Now that he has taken over Maxim's maybe his interests are wavering towards culinary arts . . .

**Rank Xerox** 4 rue Nicolas Robert, 93600 Aulnay-sous-Bois. 886.9280.
Foundation allots financing to changing associations and has also supported copy-artists.

**RATP** 53 ter Quai des Grands Augustins, 6e 346.3333.
Surprising activities for an underground in the field of performing and visual arts. Châtelet and Auber metro stations often have concerts while St Augustin has occasional exhibitions (photography, illustration) on the platform and once put 9 painters before the public splashing around on the bill-boards. Also organise competitions.

**Régie Renault** 8/10 Ave Emile Zola, 92109 Boulogne-Billancourt 603.1313
Contact: Claude Renard. Long practice of sponsorship with commissions by Soto and Arman well displayed at the Point du Jour offices. Continuing support to artists, often modestly unannounced. Major art collection.

**Société Générale** 29 Bld Haussmann, 9e 266.5400.
Regular sponsorship of young artists with help towards exhibitions, all over France.

This list does not include a number of firms and foundations that have supported festivals, concerts etc. outside Paris — for further information there exists a brochure "Le mécénat en France" available at the C.N.M.H.S. or at La Documentation Francaise, 29 Quai Voltaire, 7e, which describes all sponsored projects until 1980.

Other business support comes in the form of exhibition space with varying interest. Below is a list of various banks, hotels etc. which provide this alternative.

Frantel Windsor 14 rue Beaujon, 8e 563.0404.
Hotel Meridien, Porte Maillot. Wall-space in foyer for exhibitions.
Salons Paul Ricard 35 Ave Franklin-D-Roosevelt, 8e. Occasional exhibitions — the private view must flow past.
Sheraton Hotel 19 rue du Comm. Mouchotte, 14e 260.3511 has a 'galerie ovale' on its second level.
Union de Banques de Paris 22 Bld Malesherbes, 8e 266.9336 has an exhibition hall regularly used.
Caisse d' Epargne de Paris, 33 Bld Sebastopol, 1e 296.1500.

# PHOTOGRAPHY/FILM/VIDEO

## Schools and courses:

**Ecole Nationale Louis Lumière** 20 rue Chatillon, 14e 542.9157.
Two-year courses in photography and film techniques.

**Ecole Nationale de Photographie, Cinéma, Son et Vidéonie** 8 rue Rollin, 5e 329.5123.
Two year courses in audio-visual field.

**Ecole Supérieure d'Etudes Cinématographiques** 22 rue Beranger, 3e 272.1454.
Two-year courses in film.

**Institut des Hautes Etudes Cinématographiques** 28 Ave Corentin Cariou, 19e 201.6271.
3-year course covering all aspects of film-making.

**Ecole Nationale Supérieure des Arts Décoratifs** 31 rue d'Ulm, 5e.
2-3 year course in audio-visual field. Good facilities for video, also available for use to non-students.

**F.L.E.C.** (Filmographic, Loisirs et Culture) 24 Boulevard Poissonière, 9e 770.3197.
Open to cine-club members only. Workshops in film-making. Large cinema library with information on directors, production groups, techniques, actors etc. — open Wednesday 10-12/2-6pm. Outside these hours phone 770.8299.

**Paris I** 162 rue St Charles, 15e 558.5342.
Department of the Sorbonne with 2-3 year multimedia course in film, video, photo, animation.

**Paris VIII** Dept. d'Etudes Cinématographiques et Audiovisuels, 2 rue de la Liberté, 93526 St-Denis (ex-faculty of Vicennes). 821.6364.
More experimental audio-visual university course.

A blossoming variety of private courses and workshops in photo and film, some organised by galleries and/or clubs /see PHO-TOGRAPHY GALLERIES ALTERNATIVE ART SPACES & GROUPS and section below). For current details check columns of 'Libération' and the photo magazines.

# Audiovisual organisations:

**Adicinex** 64 rue Blomet, 15e 783.6242.
Screening of experimental art films.

**Association du Cinéma St-Sévérin,** 12 rue St-Sévérin, 5e 354.5091.
Sociological/political film screenings with video, discussions, relevant literature etc organised by production collectives and teaching association

**Association pour la Défense et la Promotion de la Photographie Originale** 11 rue Surcrouf, 7e.
An association of photography galleries with the auctioneer Pierre Cornette de Saint-Cyr giving certain guidelines as to the 'rules' of the market — type of print, historical prints etc.

**Association Française du Cinéma d'Animation** 21 rue de la Tour d'Auvergne, 9e 878.9719.

**Centre Simone de Beauvoir** 32 rue Maurice Ripoche, 14e 542.2143.
Recently opened audio-visual centre on the women's movement: film, photography and sound archives, register of relevant international productions. Also produce own films, loan equipment and technicians and organise video workshops. Carole Roussopoulos, Delphine Seyrig, Ioana Wieder.

**Cairn** see ALTERNATIVE ART SPACES & GROUPS.

**Ciné-Doc** 18 rue Montmartre, 1e 508.5422 (2nd courtyard).
Open: Tues/Thurs/Fri 9.30-6.30pm.
Documentation centre with varied and useful information on film, video and performance activities in France: technical details, photos, bibliographies, screening dates etc.

**Ciné-MBXA** 12 rue de l'Abbaye, 6e 354.3075 metro: St-Germain.
Administrator: Dominique Willoughby.
Film club showing international experimental films and video every Monday evening during academic year (approx. Nov-June). Part of local cultural centre — good place to meet other film-makers and see their work.

**Ciné-Club St Charles** 162 rue St Charles, 15e metro: Boucicaut.
New independent experimental films — screenings on Wednesday evenings.

## Ciné-Club Federations
Fédération Française Ciné-Clubs, 6 rue Ordener, 18e 209.1712.
Fédération Jean Vigo, 8 rue Lamarck, 18e 258.0995.
U.F.O.L.E.I.S. Oroleis, 23 rue Dagorno, 12e 307.5930.
F.L.E.C. 24 Bld Poissonière, 9e 770.3197.

**Cinéma du Musee** 3rd floor, Centre Pompidou (within Musée d'Art Moderne).
Screenings of experimental and art-related films every evening except Monday & Tuesday.

**Cinémathèque Française** Musée du Cinéma, Palais de Chaillot, Place du Trocadéro, 16e 704.2424. Closed Monday. Also at Centre Pompidou 278.3557 — closed Tuesday.
Both have daily programmes of rarely shown film classics and cheap entry. Administration: 82 rue de Courcelles, 8e 227.0726.

**Club Photographique de Paris 30 × 40** Centre International de Séjour à Paris, 6 Ave Maurice Ravel, 12e 343.1901.
Organise discussions and seminars with professional photographers.

**Confluences** 15 Passage Lathuile, 18e 387.6738 metro: Clichy.
One of original independent film-makers' collectives: distribution, meetings, screenings and audio-visual workshops — also photography.

**Festival International du Son et de l'Image Vidéo** 20 rue Hamelin, 16e 505.1317.

**Paris Audiovisuel** 44 rue du Colisée, 8e 561.0068.
President: Henri Chapier. Administrator: Jean-Luc Monterosso. Municipal centre for organising photographic exhibitions and activities which include the bi-annual *'Mois de la Photo'* started in 1980 which takes place in November and inundates Paris with exhibitions, lectures, discussions in public and private galleries, — of both contemporary and historical work. Also purchases photographs (old and new) for municipal collections and gives grants to young photographers to help them show and publish their work.

**Paris Films Co-op** 18 rue Montmartre, 1e 508.5422 (2nd courtyard).
Distribution centre for independent film-makers which produces a catalogue listing new films, distributed throughout France and at Film Festivals.

**Salon Art, Vidéo et Cinéma** 26 rue Charles et René Auffray, 92110 Clichy 731.2976.
Autumn audiovisual salon with screenings, debates etc.

**Société Française de Photographie** 9 rue Montalambert, 7e 222.3717.
Started in 1854 . . . has an impressive collection of early photography, a library and organises photography courses/workshops and exhibitions.

**Transatlantic Video** 6 rue des Deux-Ponts, 4e 326.1458.
Private video production group working on documentaries also hire out equipment.

**Tricontinental Productions** 6 rue Saulnier, 9e 523.4240.
Private video production group.

**Video-Ciné-Troc** 15 Passage de la Main d'Or, 11e 806.5500.
Private video production group.

**Video in Paris** 153 rue St-Martin, 3e 887.4286.
Small production group — N.T.C. equipment.

**Video Info + Research** 6 rue de la Bienfaisance, 8e 522.9590.

**Video Montage** 12 rue de la Pierre Levée, 11e 806.0295.
Editing of VHS system, sound and Super 8 films.

**Videothèque de Paris** 4 rue Beaubourg, 4e 271.2670.
Audio-visual archives of Paris covering its history and develop-
ment with library of documents, films, videotapes and new pro-
ductions. Screening room with regular programmes of French
and foreign TV productions on certain themes. Library in process
will be open to public and specialise in audiovisual and television
publications. Photo exhibitions and debates.

# Public Photographic collections

With the massive increase in the cultural slice of the budget more
attention is being paid to photography, reflected in the number of
public centres devoted to purchasing and preserving photo-
graphs.

**Archives Photographiques** de la Direction du Patrimoine du
Ministère de la Culture, 3 rue de Valois, 75042 Paris Cedex 01.
296.1040 ext.22.58.
Administrator: Philippe Neagu.
Large collection from calotypes to ektachromes — available to
public.

**Bibliothèque Nationale** Dept. des Estampes et de la Photo-
graphie, 58 rue de Richelieu, 2e. 261.8283.
Curators: B. Marbot (historical), J-C. Lemagny (contemporary).
Reading-room open Mon-Sat 9-5.30pm and the vast collection
started in 1851 is available to researchers. Also currently being
put on film to make it available to general public.

**C.N.M.H.S.** Service Photographique, 1 bis rue de Valois, 1e
261.3734.
Administrator: J-J. Poulet-Allamagny.
Collection of photos covering history of France — topographic
and thematic indexes open to public. Monuments, fine-arts, por-
traits.

**Musée d'Orsay** The future museum of the 19th century is build-
ing up a considerable collection of photography with inter-
national representation and organising, temporarily, exhibitions
at the Palais de Tokyo.

**Musée National d'Art Moderne** Centre Pompidou.
Purchases for collection and regularly exhibits contemporary photography with the theme of relation to fine-art (Man Ray, Rauschenberg, Hockney) or current pictorial research (Legac, Boltanski, H. Fulton) as well as classics such as Arbus, Kertesz, Paul Nash.

**Bibliothèque Historique de la Ville de Paris** 24 rue Pavée, 4e 274.4444.
Curator: Marie de Thézy.
Large collection of historical photos (Marville, Atget) and contemporary (Amson, Doisneau, Jahan, Séeberger) with Paris and its inhabitants as central theme.

Many press agencies also have considerable collections of photography which are available to the public for consultation and purchasing. For a list of these agencies see: "Repertoire des Collections Photographiques en France" published by the Documentation Française, or available for reference at the Centre Pompidou and Bibliothèque Forney. Included in the list of agencies are specialised photo-libraries, for example **Giraudon,** 9 rue des Beaux-Arts, 6e 326.9383 (photos on art, archaeology, history) and **Roger-Viollet** 6 rue de Seine, 6e 354.3290 (founded in 1880 with an extensive collection).

# PRINT STUDIOS

**Atelier Arcay** 11 rue Boulard, 14e 322.5056.
Screen-printing.

**Atelier André Béguin** 2 rue Danville, 14e 321.4116.
Etching studio which also sells printmaking materials (paper, ink, plates, presses). Aquatinting with airbrush.

**Atelier Francoise Bricant** La Taille Douce, 18 rue Vernier, 17e 574.7655.
Etching, engraving, colour, also workshops for learners.

**Atelier Bordas** 7 rue Princesse, 6e 326.2697.
Litho-printing, also handpress.

**Ateliers Champfleury** 17 rue de Nantes, 19e 201.1931.
Litho-printing, also handpress. Used by many Anglo-Saxon printmakers — very reasonable prices.

**Atelier Lacourlère et Frélaut** 11 rue Foyatier, 18e 606.1770.
Etching studios — long established and once frequented by Chagall, Picasso etc.

**Atelier La Main d'Or** 18 rue Nollet, 17e 294.0450.
Monthly subscription to use etching facilities.

**Clot, Bramsen & Georges** 19 rue Vieille du Temple, 3e 272.8938.
Another long-established studio for lithographers.

**H. Deprest** 208 rue St Maur, 10e 208.3058.
Litho-printing.

**Mourlot** 49 rue du Montparnasse, 14e 329.7165.
Famous for printing of Picasso's lithographs. Oldest atelier in Paris but expensive.

**Joëlle Serve** 54 rue Daguerre, 14e 322.2178.
Etching studios with system of monthly subscription. Run by ex-assistant of S. W. Hayter, using Hayter colour processes. Also run workshops.

**Atelier des Grandes Terres** 5 rue de Charonne, 11e 700.2937.
Screen-printing workshop.

**Atelier 92** (Association Replique) 1 rue des Fontaines, 92 Sèvres 626.3789.
Etching, stone lithography and handpress.

---

# MATERIALS AND SUPPLIERS

## Fine Arts and Graphics

**Adam** (Montmartre) 96 rue Damrémont, 18e 606.6038.
Small, local fine-arts shop.

**Adam** (Montparnasse) 11 Boulevard Edgar Quinet, 14e 320.6853.
Large selection of painting, sculpture, printing and graphics materials — canvas, stretchers at reasonable prices.

**BHV** department store, 64 rue de Rivoli, 4e.
Good arts department on 1st floor — paints, inks, brushes, paper, frames, small stretchers. Useful on Mondays when most other suppliers are closed.

*Art-supplier.*

**Henri Girard** 13 rue Bonaparte, 6e.
Fine-arts supplier located opposite Ecole des Beaux-Arts.

**Chez Aulodie** 1 rue Biscornet, 12e 345.2116 (Bastille).
Open 12.30-7pm only.
Fine-arts materials, canvas, stretchers — cheap.

**Co-op de l'Entraide aux Artistes** 11 rue Berryer, 8e 563.6298.
Open Mon-Fri.
Membership fee of 50F leading to dividend at end of year depending on your purchases and their sales. Reasonable prices for canvas, stretchers and general fine-art materials.

**Desangles** 52 rue Vavin, 6e 354.3745.
Small paints and framing shop.

**Gattegno** 13 rue de la Grande Chaumière, 6e 326.6318.
Paints, canvas, frames.

**Graphigro** 12 Villa de Guelma, 18e 258.9340 metro: Pigalle.
Open Mon-Fri.
An enormous warehouse specialising in all arts materials: graphics, photography (lab equipment), special paper, brushes, paints, canvas (in large quantities). Cheerful service and currently up to 20% cheaper than elsewhere.

**Graphidessin** 235 bis, rue de Vaugirard, 15e 783.3378.
Graphics and fine-arts materials.

**Mecanorma Graphics Center** 49 rue des Mathurins, 8e 265.5165.
Apart from graphics materials it runs a gallery with occasional unusual illustration exhibitions and organises competitions.

**La Palette du Faubourg** 16 rue du Faubourg du Temple, 11e 805.5185.
Small but crammed with paints, inks, paper, canvas, stretchers, also a framing service.

**Papeteries de Guyenne** 46 Quai des Célestins, 4e 274.1012.
Fine-papers.

**Paris-American Art Co.** 2 rue Bonaparte, 6e 326.0993.

**Paris Papiers** 54 Boulevard Pasteur, 15e 322.9360.
Paper specialists.

**Rougier & Plé** 13/15 Boulevard des Filles du Calvaire, 3e 272.8290.
Three floors of arts/crafts materials: fine-arts, graphics, sculpture, printing tools plus numerous 'hobby' craft materials and demonstrations. Not over-friendly assistants.

**Royer** 47 rue des Archives, 3e 278.0856.
Large selection of drawing materials, paints, brushes but not the cheapest.

**Rennes 80** 80 rue de Rennes, 6e 548.5427.
Paints, canvas, stretchers, drawing materials and graphics.

**Sennelier** 3 Quai Voltaire, 7e 260.2938.
4 bis rue de la Grande Chaumière, 6e 633.7239.
Vast stock of painting, printing and drawing materials: oils, acrylics, tempera, water-colours, canvas, stretchers — not cheap.

# Photography

For film buying and general processing the FNAC (branches: Forum des Halles; 136 rue de Rennes; 26 Avenue Wagram) is cheapest and also has an express service and duplication service. If stuck on a Sunday with no film go to the Drugstores (St Germain, Opéra, Franklin D. Roosevelt etc) or shops surrouunding Beaubourg.

## Professional Labs:

**Atelier Cibachrome** (Gamichon) 42 rue Laugier, 17e 380.4045.
Cibachrome enlargements — reasonable rates.

**Atelier Dahinden** 2-10 rue Française, 2e 233.6135.
Open 7am-8.30pm.
B/W, Ektachrome and all Agfa and Kodak processing. Enlargements, photo-montage, mounting.

**Chromos Service** 5 rue du Coq-Héron, 1e 233.7189.
Professional colour processing and enlargements, colour copies.

**Copitel** 5 rue du Foin, 3e 272.0451.
Cibachrome enlargements.

**JPC** 3 rue Véronèse, 13e 535.3303.
B/W processing and printing.

**Laboflash** 11 rue Torricelli, 17e 574.0029.
B/W and colour developing and printing, also cibachrome.

**Picto** 9 rue Delambre, 14e 320.1212 also at:
4 Villa des Entrepreneurs, 15e 577.6636.
Fast B/W and colour work for professionals.

**Pro 5** 37 rue Coquillière, 1e 508.8165.
Colour lab, duplication, microfilm.

**Publicit-Color** 10 rue Hérold, 1e 508.5684.
B/W and colour services.

**Publi-mod Photo** 18 rue Roi de Sicile, 4e 271.6510.
Professional photographic service — all processing within the hour.

## Others:

**Cash & Carry** 31 Ave St Ouen, 17e 294.0318. metro: La Fourche.
Reputedly one of the cheapest shops in Paris; also second-hand equipment and processing - colour in 24 hrs.

**Cipière** 28 Boulevard Beaumarchais, 11e 805.7160.
Good for second-hand cameras, lenses etc. and standard processing.

**Foto-Quick** 114 rue du Théâtre, 15e 579.7445.
Enlargements in 24 hours, prints and slides in one hour.

**Graphigro** 12 Villa de Guelma, 18e 258.9340.
Low prices for all films and darkroom equipment.

**Images** 31 rue St Augustin, 2e 742.4849.
Second-hand camera equipment and standard processing.

**Minutcolor** 10 rue Littré, 6e 544.1863.
Kodacolor and Fuji films developed in $\frac{1}{2}$ hour, prints from slides in $\frac{1}{4}$ hour.

**Photo-Ciné du Cirque** 9 bis Boulevard Filles du Calvaire, 3e 887.6658.
Large camera shop, also second-hand; standard processing, (express), video.

**Photo 9** 10 bis rue Buffault, 9e 878.2094.
New and second-hand, hire, processing, repairs.

**Shop-Photo** 33 rue du Commandant Mouchotte, 14e 320.1535.
Large complex devoted to photography, film, video — all facilities including processing, hire, second-hand equipment.

## Hire and repairs:

**BIP** (Claude Rigal) 91 Avenue de Maine, 14e 327.1414.
Camera and lens hire. Repairs.

**Clichy-Photo** 35 rue de Clichy, 9e 874.1866.
All kinds of camera, video and sound equipment for hire.

**France Location Services** 37 bis rue du Colisée, 8e 225.2649.
All important makes of 24 × 36 and 6 × 6 — hire of cameras, accessories, also film, video and sound equipment.

**Jean Foucat** 6 rue Schoelcher, 14e 354.1214.
Second-hand and repairs of all camera makes.

**LMA** 7/9 rue W. Rousseau, 17e 574.2600.
Hire out projectors, cameras, lenses, video and sound equipment etc.

**Photo-Ciné M.S.** 3 rue Charles Baudelaire, 12e 344.2567.
Camera repairs and general equipment.

**Tecphot** (Landon) 5 rue Saint-Bon, 4e 278.1404.
Open 7 days/week. 10am-midnight.
Hire of darkrooms for B/W and colour, photo studio and all photo, film, video and sound equipment.

## Colour copiers:

**Copy-Color** 41 rue Letellier, 15e 578.8112.
Colour-copies on ektachrome paper.

**Déléage Laboratoire** 58 rue Notre Dame de Lorette, 9e 285.4213.
Colour photocopies on paper, also copies on acetate for back-projectors as well as professional processing services.

**Dubois** 20 rue Soufflot, 5e 354.4360.
Colour photocopies from paper or slides — do-it-yourself on cibachrome machine. Also copies on acetate for back-projectors, A3 and A4 sizes.

**Rank Xerox** 80 Boulevard de Sebastopol, 3e 887.0331 and Centre Maine, Tour Montparnasse, 15e 538.9896. Xerox colour-copies

# Sculpture

**Cassou** (Quincaillerie Montparnasse) 55 bis Boulevard du Mont-parnasse, 6e 548.9922.
Specialised in materials and tools for sculpture.

**Fracoloso** 18 rue Etienne Dolet, 92240 Malakoff 253.6854.
Stone-cutting tools and machines. Cutters for marble, enamel.

**Gaignard-Millon** 24 rue Jules Vallès, 11e 371.2896.
Sculpture tools for stone and wood.

**Fonderie Saint-Maur** 3 rue Chevreul, 11e 373.5077.
Bronze-casting.

**Georges Rudier** 36 rue de la Mairie, 92320 Chatillon 253.6525.
Bronze-casting.

**Promoplastiques** 15 Cité Voltaire, 11e 371.7180.
Perspex in sheets, tubes and blocks.

**Richardson** 11 rue Adolphe-Mille, 19e 208.7200.
Cut-offs available in perspex, polystyrene, PVC etc.

# Printmaking

**Arjomari-Prioux** 3 Impasse Reille, 14e 589.1212.
Main manufacturers/suppliers of all types of paper, particularly for prints.

**Stroobant-Charbonnel** 13 Quai Montbéllo, 5e 354.2346.
One of last remaining suppliers in this field: lithography crayons, inks, waxes, etching tools etc.

**Grognard** 27 rue de la Huchette, 5e 354.1745.
Zinc, copper, magnesium plates.

**Henry** 133 rue de Rennes, 6e 222.5180.
Zinc plates, tools for wood and copper engraving.

**André Béguin** 2 rue Danville, 14e 321.4116.
Print studio with large selection of print-making materials.

# Framing

**Atelier Jean-Alot** 5-9 rue Pot-de-Fer, 5e 707.7329.

**La Baguette de Bois** 44 rue Lepic, 18e 606.3680.
Gold, copper, varnished wood frames.

**Cadres Lebrun** 155 rue Faubourg St-Honoré, 8e 561.1466.
Antique frames.

**Cadres Lutèce** 13 rue Guénégaud, 6e 326.3930.
Aluminium, perspex, pedestals.

**Centre de l'encadrement** 34 rue René-Boulanger, 10e 206.1153.
Framing materials for do-it-yourself, also framing service and workshops.

**Eidos** 24 rue Manet, 6e 566.7710.
Bases and plinths in steel, marble, plastic, also framing.

**Encadrement d'Art** 57 rue Faubourg Montmartre, 9e 878.4381.

**Françoise Harmel** 19 rue Jean-Jacques Rousseau, 1e.
Unusual framing materials and designs, also sculpture bases, but pricey.

**Claude de Muzac** 6 rue Bourbon-le-Chateau, 6e 354.0955.
Antique frames and bases, perspex boxes and frames — very smart.

**Le Chapitre** 36 rue St. Louis-en-l'Isle, 4e 633.5609.
Well-known and used. Wide choice of frames and 24 hour service.

# Restoring

**Atelier Rostain** 17 Quai des Grands-Augustins, 6e 326.7610.
Restorer of paintings, prints, murals.

**Jean-Paul Lédeur** 61 rue Raymond-Losserand, 14e 320.0022.
Specialist in restoring paintings and prints — antique and modern relining of works on paper, canvas transfer.

**Maison André** 107 Boulevard de Charonne, 11e 370.4020.
Restorer of porcelain, ceramics, ivory, jewellery, weapons, antique furniture.

**Réparation Service** 9 Boulevard Pereire, 17e 227.0270.
Pewter, porcelain, jade etc.

# Art Transporters

**André Chenue** 5 rue de la Terrasse, 17e 763.0311.
Packing and international transportation including Customs.

**Gougeon** 54 bis rue Dombasie, 15e 828.1783.
Specialised in transporting sculpture/statues.

**I.A.T.** 60 rue Saint Sabin, 11e 806.5050.
International art transporters.

**Royer** 14 rue du Cherche-Midi, 6e 222.3195.
Long established art transporter.

## Fabrics

**Marché St Pierre** 2 rue Charles Nodier, 18e 606.9225.
Four floors of fabrics: ends of lines, faulty runs and some normal
Wools, silks, cottons and synthetic. A reknowned and cheap
Aladdin's cave often crowded but worthwhile. Surrounding
streets packed with similar shops at the foot of Montmartre.
Open Mon-Sat.

# ART MAGAZINES

**Alternes** 252 rue de la Convention, 15e.
Quarterly art volume.

**Amateur d'Art** 5/7 rue Curnonsky, 17e 731.8530.
Editor: Michel Boutin. Traditional approach and content.

**Archi-Créé** 106 Boulevard Malesherbes, 17e 766.0460.
Editor: Joelle Letessier. Bi-monthly magazine covering industrial
and interior design.

**Architecture d'Aujourd'hui** 67 Avenue de Wagram, 75842 Paris
Cedex 17.
Editor: Marc Emery. Monthly architecture magazine with inter-
national coverage and summary of articles in English.

**Artistes** 16 rue du Parc-Royal, 3e 278.5202.
Editor: Bernard Lamarche-Vadel. Bi-monthly, beautiful lay-out
with in-depth articles on individual artists and art world figures,
also covers fashion, photo, and current exhibitions with avant-
garde leaning.

**Artpress** 12 Avenue Matignon, 8e 225.4168.
Editor: Catherine Millet. Committee Includes Daniel Gervis of
FIAC fame. Contemporary art magazine covering all fields:
cinema, dance, theatre as well as selected gallery reviews and
analysis of new movements. Monthly.

**Atelier des métiers d'art** 18 rue Wurtz, 13e 589.8520.
Editor: Colette Save. Monthly crafts magazine.

**Banc-Titre** 84 rue Baudricourt, 13e.
Monthly animation magazine.

**Canal** 19 rue du Départ, 14e 320.8202.
Editor Alain Macaire. Most useful and eclectic of monthly art
mags with inside brochure listing art activities of the month.
Current art information reviews — cinema, dance, performance,
theatre, books.

**Cimaise** 8 rue Recamier, 7e 544.0482.
Editor: Jean-Robert Arnaud. Luxurious bi-monthly magazine
with articles on individual artists currently exhibiting and
coverage of major international art events. Translation in English
too.

**Connaissance des Arts** 25 rue de Ponthieu, 8e 359.3022.
Editor: Philip E. Jodidio. Monthly art and antiques magazine with emphasis on art history articles but also section on current art activities.

**Double Page** S.N.E.P., 24 Place des Vosges, 3e 271.3333.
Editor: J. P. Mahaim. More of a monthly photography book with each issue devoted to one photographer on one theme with text.

**Flash Art** 36 via Donatello, 20131 Milan, Italy. (2)236.4133.
Editor: Giancarlo Politi. Bi-monthly European art magazine in English and French. Gallery reviews and coverage of new art movements. Paris correspondents: Bernard Blistène, J-M. Prévost. French distributor: J-P. Sabouret tel: 624.6961

**Le Fou Parle** 10 rue de la Félicité, 17e
Editor: Jaques Vallet. Quarterly art and humour magazine.

**Galerie des Arts** 106 rue de Richelieu, 2e 297.4960.
Editor: André Parinaud. Quarterly magazine covering aspects of contemporary art. The same publisher tried a weekly art magazine — bravely — but it folded.

**Gazette de l'Hôtel Drouot** 99 rue de Richelieu, 2e 261.8178.
Weekly bulletin, out on Fridays, with all auction news, previews, dates and results.

**L'Oeil** 10 rue Guichard, 16e 525.8560.
Editor Gen Sec.: Solande Thierry. Remains the arts glossy with excellent reproductions of art and antiques, also reviews of current exhibitions. Monthly.

**L'Officiel des Galeries** 15 rue du Temple, 4e 887.8066
10 issues/year. Handbook with useful listing of galleries, artists and private view dates. Galleries pay to be listed so it is necessarily selective.

**Opus International** 4 rue de Nevers, 6e.
Editor: G. Gassiot-Talabot. Also J-L. Chalumeau, Anne Tronche, G. Fall. Bi-monthly. Lively coverage of art controversies, artists and gallery reviews as well as in-depth articles.

**Photo** Editions Filipacchi, 63 Ave des Champs-Elysees, 8e 256.7272.
Editor: Frank Tenot. Part of Photo magazine international chain — good information section on exhibitions, competitions, books etc.

**Photo-Collectioneur** Créatis, 50 rue du Temple, 4e 887.2856.
Bi-monthly magazine with photography auction news, exhibition coverage, interviews — English translation.

**Photo-Reporter** 30 bis rue Spontini, 75116 Paris. 704.6172.
Editors: S. Slama, D. Lefur, P. de Roquefeuill. Monthly photo magazine with accent on photo-reportage, technical data, general info.

**Plages** 1762 rue du Vieux Pont de Sèvres, 92100 Boulogne. 322.4768.
Editor: Roberto Gutierrez. Artists subscribe then write about themselves and their work, with illustrations, over a few pages of an issue. Quarterly.

**Unfinitude** Editions de la Nèpe, le Moulin de Ventabren, 13122 Ventabren.
Collection editor: Angéline Neveu. Regular publication/ creation of 100 page photocopied books — poetry/copy art — with surreal feel.

**Zoom** 2 rue du Fbg. Poissonière, 10e 523.3981.
Editor: Joel Laroche. Internationally recognised high quality photography magazine also covering related graphics and painting occasionally. Stunning photographs and very useful info section/run-down on all photographic events. Backnumbers can be bought considerably reduced.

Two Paris-based English-language publications exist:

**Paris Free Voice** 65 Quai d'Orsay, 7e.
(art Margaret Horgan), a monthly free newsheet with articles on Paris and calendar of cultural events, lots of classified ads. — accommodation, second-hand, odd jobs etc.

**Passion** 18 rue du Pont-Neuf, 1e 233.0024.
Editor: Robert Sarner. Arts: Xiane Germain. More exciting than above. Started in 1981 and progressively becoming more professional with some excellent articles, interviews, reviews covering all aspects of Parisian scene. Monthly. Very American-in-Paris.

As may be seen from the above list, there is a plethora of analytical art magazines, but few covering current art activities and 'alternative' events and those publications which do feature such news tend to become defenders of certain gallery circuits. However art reviews in daily and weekly publications manage to give reasonable coverage, again with strong preferences, and **Libération** lists news about alternative events, associations, workshops etc. without any apparent selection.

# ART CRITICS

Sending photos and exhibition details to the Press is a game of roulette with high odds so if you have the patience it is advisable to phone the newspaper or magazine to try and contact the critic personally. Below is a list of the Paris daily newspapers and weekly magazines and their respective critics. Remember too the specialised art press, in previous section.

## Newspapers:

**Le Matin** 21 rue Hérold, 75001 Paris. 296.1665.
Pierre Cabanne and Mme Maiten Bouisset cover major exhibitions and some contemporary galleries.

**Le Monde** 5 rue des Italiens, 75427 Paris Cedex 09. 246.7223.
Geneviève Brérette (contemporary art), Hervé Guibert (photography) Paule-Marie Grand (crafts).

**Le Figaro** 37 rue du Louvre, 75081 Paris Cedex 02. 233.4400.
Pierre Mazars (museum exhibitions and art history), Jean-Marie Tasset and Jeanine Warnod both cover contemporary art. Michel Nuridsany (photography and some conceptual work).

**Le Quotidien de Paris** 2 rue Ancelle, 92521 Neuilly sur Seine. 747.1232.
Marie-Christine Huguonot.

**Le Nouveau Journal** 108 rue de Richelieu, 75002 Paris. 261.8082.
André Parinaud.

**L'Humanité** 5 rue du Faubourg Poissonière, 75002 Paris. 246.8269.
Raoul Jean-Moulin (contemporary art), Jean Rollin (museums), Lucien Curzi (photography).

**France-Soir** 100 rue de Réaumur, 75002 Paris. 508.2800.
Nicole Duault.

**La Croix** 3 rue Bayard, 75393 Paris Cedex 08. 562.5151.
Jeanine Baron (contemporary art), Michel Erhsam (photography).

**Libération** 9 rue Christiani, 75883 Paris Cedex 18. 262.3434.
No regular art-critic, but cultural pages generally supervised by Jean-Pierre Thibaudat. Also Hervé Gauville.

**International Herald Tribune** 181 Ave Charles de Gaulle, 92200 Neuilly sur Seine. 747.1265.
Michael Gibson.

## Weekly magazines:

**Le Nouvel Observateur** 11 rue d'Aboukir, 75081 Paris Cedex 02. 260.3691.
France Huser (contemporary art museums) Alain Dister (photography).

**L'Express** 61 Avenue Hoche, 75380 Paris Cedex 08. 755.9798.
Otto Hahn, Pierre Schneider.

**Les Nouvelles Littéraires** 10 rue Saint Antoine, 75004 Paris.278.3321.
Jean-Jacques Lévèque (contemporary art, museums), Dominique Carré (photography and occasionally contemporary art).

**Le Point** 140 rue de Rennes, 75006 Paris. 544.3900.
Jean-Louis Ferrier.

**Pariscope** 63 Ave des Champs-Elysées, 75008 Paris. 256.7272.
Josette Melèze (museums, contemporary art, listing).

# BOOKSHOPS

All are open on Saturdays, most closed Monday mornings.

## Anglo-American:

**Attica** 34 rue des Ecoles, 5e 326.0953.
Good paperback section and political/historical books — mainly orientated towards university courses. Separate English-teaching bookshop.

**Brentanos** 37 Avenue de l'Opéra, 2e 261.5250.
Of Amercian parentage, one of the anglo-american classics in Paris. Paperbacks downstairs, good sprinkling of art-books amongst hard-backs — also dance, cinema. Special guide-book section next-door.

**Diffusion Albion** 13 rue Charles V, 4e 272.5071.
Tucked away in Les Marais — new and second-hand British/American books, info about poetry readings and literary related activities. Quite small selection.

**Galignani** 224 rue de Rivoli, 1e 260.7607.
Spacious and extremely well stocked, a pleasure for browsers, the original English Bookshop in Paris. Some unusual arts books, wide range of paperbacks. Convenient for Louvre, Jeu de Paume etc.

**Shakespeare & Co** 37 rue de la Bûcherie, 5e.
Situated opposite Notre Dame on Left Bank, respectable opening hours: midday to midnight. Carrying on the legend from Sylvia Beach's days when it was a haven for passing American writers and their signed photos remain. Haphazardly stocked, not always the cheapest, though second-hand books available.

**W. H. Smith** 248 rue de Rivoli, 1e 260.3797.
Another Anglo-Saxon institution in Paris, better stocked than British counterparts in chain. Good for guides, magazines, press, paperbacks and there's always the tea-shop and restaurant for homesick Brits.

**Trilby's Bookshop** 18 rue Franklin, 16e 520.4049.
Not far from Palais de Chaillot in this respectable district: U.S. and U.K. magazines, books (second-hand too), poetry readings.

**Village Voice** 6 rue Princesse, 6e 633.3647.
The youngest of those mentioned. American spirit with small café part of anglo-american literature, mags, artbooks — though limited space — and upstairs gallery for publication-related exhibitions and poetry readings. Open 11-10pm except Monday. Nice little St Germain street to explore too.

If in Paris for a longer stay don't forget the national cultural centre libraries:

**American Library** 10 rue Général Camou, 7e 551.4682.

**British Council Library** 9 rue de Constantine, 7e 555.5499.

**Canadian Cultural Centre Library** 5 rue de Constantine, 7e 551.3573.

# Other foreign bookshops:

**Librairie Allemande** 82 rue de Rennes, 6e 548.7089.
German books, occasional exhibitions.

**Librairie Espagnole** 72 rue de Seine, 6e 354.5426.
Spanish and Latin-American books.

**Librairie Internationale 141** 141 Boulevard St-Germain, 6e 329.3820.
Anglo-American, German, Italian, Spanish books in pleasant bookshop.

**Librairie du Marais Noir** 44 rue Vielle-du-Temple, 4e 271.9961.
Friendly bookshop specialising in French translations of foreign literature, cinema and art books. Upstairs gallery with some interesting exhibitions by young artists.

**Maison du Livre Etranger** 9 rue Epéron, 6e 326.1060.
A mixed languages bookshop.

**Maison du Livre Italien** 54 rue de Bourgogne, 7e 705.0399.
Italian books including those notoriously beautiful Italian artbooks.

**Marissal-Bücher** 42 rue Rambuteau, Quartier de l'Horloge, 3e 274.3747.
Well situated beside Beaubourg — German publications, some art books, English film books and occasional art exhibitions.

**Nouveau Quartier Latin** 78 Boulevard St-Michel, 6e 326.4270.
Retail outlet of English language books in France, separate room for art books.

**Puerto del Sol** 10 rue Sainte-Beuve, 4e 544.7828.

# Arts bookshops:

**Artcurial** 9 Avenue Matignon, 8e 256.7070.
Part of large-scale arts complex — excellent art bookshop: spacious, books well displayed, rarely crowded, covering fine-arts, photography, graphics, design, architecture, with international publications. Good selection of art magazines and occasional exhibitions.

**Atmosphère** 7/9 rue Francis-Pressensé, 14 e 542.2926 (Olympic Entrepôt).
Open afternoons till 9pm. Film bookshop with specialist books, posters, photos situated inside a cinema complex with restaurant and gallery so good for evening browsing.

*Salon de thé in Passage Vivienne.*

**Bibliothèque des Arts** 3 rue Corneille, 6e 634.0862.
Own art editions mainly on history of art.

**De Nobele** 35 rue Bonaparte, 6e 326.0862.
Long established — historical and contemporary art-books.

**Documenta** 45 rue St Merri, 4e 271.2442.
One of many surrounding Beaubourg. International section of
mostly out of print and end of line books so needs careful sifting

**Fischbacher** 33 rue de Seine, 6e 326.8487.
In heart of rue de Seine gallery-circuit, specialising in international art books, primitive arts and applied arts.

**FNAC** Montparnasse, 136 rue de Rennes, 6e (other branches see PHOTOGRAPHY GALLERIES) Particularly comprehensive fine arts/architecture/photography section on 2nd floor.

**Flammarion 4** Librairie du Centre Pompidou, Plateau Beaubourg, 4e 278.6740.
Another excellent art-book source though often overcrowded. Fine-arts, photography, film, music, architecture, graphics and design, also exhibition catalogues from the Centre and galleries world-wide, art magazines.

**Jean Fournier** 44 rue Quincampoix, 4e 277.3231 (in courtyard). Large selection of historical and contemporary art-books situated inside gallery.

**Garnier Arnoul** 39 rue de Seine, 6e 354.8005.
Books on performing arts - theatre, dance etc.

**La Hune** 170 Boulevard St-Germain, 6e 548.3585.
General bookshop with 1st floor devoted to graphics, photography, also good selection of fine-arts books.

**Impressions** 46 rue de Seine, 6e 325.3470.
Newcomer to this street. Contemporary look to art-books, catalogues, posters — also covering decorative arts and fashion. Occasional exhibitions.

**Les Temps Futurs** 8 rue Dante, 5e 325.8519.
A chance to discover the art of B.D. (Bandes Dessinées = comics) and see what happened after Beano and Co. Now a prolific European/American art-form.

**Librairie Dupré** 42 rue de Berri, 8e 563.1011.
Photography, architecture and graphics books and magazines.

**Librairie des Femmes** 74 rue de Seine, 6e 329.5075.
Mainly Feminist literature but very art-orientated with some interesting exhibitions in bookshop.

**Librairie Jullien Cornic** 29 Ave Matignon/118 Faubourg St-Honoré, 8e 562.0339.
International art books, catalogues, thematic works, search service available. Decorative and applied arts, costume, textiles at no. 33 Ave Matignon. 359.1090.

**Librairie du Photographe** 189 rue St-Jacques, 5e.
Books, magazines, technical manuals on photography,

**La Chambre Claire** 14 rue Saint-Sulpice, 6e 634.0431.
New and excellent photography and graphics bookshop, gallery downstairs.

**Le Coupe-Papier** 19 rue de l'Odéon, 6e 354.6595.
Specialist bookshop for performing arts — theatre, dance, film, circus etc. Knowledgeable and friendly staff to help you.

**Minotaure** 2 rue des Beaux-Arts, 6e 354.7302.
Old and new books on film, photography. Small but crammed with books.

**Moniteur** 7 Place de l'Odéon, 6e 325.4858.
Large well stocked bookshop specialising in architecture, urban ism also interior design and photography sections. Exhibitions related to design/architecture.

**Obliques** 58 Quai de l'Hôtel-de-Ville, 4e 274.1960.
Small bookshop devoted to limited edition books and own editions of "Obliques" — a mainly literary publication.

**Photo-Librairie** 49 Ave de Villiers, 17e 267.5012.
Photography books.

**Photo-Librairie Nicéphore** 2 Place Léon Deubel, 16 e 524.6320.
Photography books.

**Sources** 49 rue de Seine, 6e 325.0785.
Artbooks, prints.

**XXe Siècle et ses sources** 4 rue Aubry-Le-Boucher, 4e 278.1549.
Fine and decorative arts in small specialised bookshop — a refreshing contrast to nearby 'jumble' bookshops on Plateau Beaubourg.

# ART LIBRARIES

**Bibliothèque des Arts Décoratifs** 109 rue de Rivoli, 1e 260.3214 ext 936.
Open 10-5.30pm Tues-Sat., Mon 1.45-5.30pm.
Open to public but for reference only, no lending. Books on crafts, fine-arts, architecture, graphics, peroidicals. All on card-index therefore no browsing. Museum and salon catalogues too. Photocopier.

**Bibliothèque Forney** 1 rue du Figuier, 4e 278.1460.
Open 1.30-8.30pm Tues-Fri., Sat 10-8.30pm.
Reference and lending library, also provide postal lending ser-vice to craftsmen outside Paris (tel: 274.0863). Large collection of books on decorative and applied arts, crafts, fine arts, graphics, photography, architecture, printmaking, cinema. Not all available on loan. Constantly updated card-index for catalogues, articles in periodicals, and also for old and contemporary posters, slides. Wonderful setting in 15th-16th century 'hotel'. Reading-room for periodicals (back-numbers on loan) with wide selection of inter-national publications covering all arts/techniques. Photocopier, slide library.

**Bibliothèque du Centre Pompidou**
Open Mon, Weds, Thurs, Fri: 12-10pm. Sat & Sun 10-10pm.
Reference only. Art section down escalator from library entrance. Much used and advantageous in that all books are dis-played so browsing is possible. However obviously not as widely stocked as above. Selected international art magazines. Photo-copying machines available.

**Bibliothèque des Arts Graphiques** 6 bis rue Huyghens, 14e 327.5273.
Open Tues, Thurs 5-8pm, Sat 3-5pm.
Typography, printmaking techniques, history of printing.

**C.N.M.H.S.** Hôtel de Sully, 62 rue Saint-Antoine,4e 887.2414.
National centre for historic buildings in France. Library contains books and slides (on loan to teachers) on monuments, sites, chateaux etc.

**Institut des Hautes Etudes Cinématographiques** 28 Ave Corentin Cariou, 19e 201.6271.
Inside film-school, library specialising in cinema techniques.

Other specialist libraries can be used in the relevant museums for research - (see MUSEUMS) and of course there is always the Bibliothèque Nationale which requires specific reasons for access. For a list of local lending libraries go to the Hôtel de Ville — they are often housed in local town-halls.

# ART SCHOOLS

## State art-schools

**Ecole Nationale Supérieure des Arts Décoratifs** 31 rue d'Ulm, 75005 Paris. 329.8679.
Graduate and post-graduate courses (2 and 3 years respectively but can take longer) covering interior design, industrial design, stage design, fashion, animation, video, photography, textiles and fine arts. School's own diploma.

**Ecole Nationale Supérieure des Beaux-Arts** 17 Quai Malaquais, 75006 Paris. 260.3457.
3-5 year courses leading to diploma. Departments of drawing, painting, sculpture and printing with some well-known artist-teachers, but standards are not exceptional and the building is very overcrowded.

**Ecole Nationale Supérieure des Arts Appliqués et des Métiers D'Art** 63-65 rue Olivier de Serres, 75015 Paris. 533.7206.
3-4 year courses in applied arts: industrial 'aesthetic', ceramics, textile design and creation, interior design, visual arts. B.T.S. diploma.

**Ecole Supérieure des Arts Appliques (Duperre)** 11 rue Dupetit Thouars 75003 Paris. 278.5909.
School diploma in various applied art fields such as tapestry, ceramics, photography, screen-printing, fashion-drawing, comic strips, animation films, modelling, audio-visual. BTS diploma (3 years) in visual expression, fashion, textiles, painting/drawing.

**Ecole Nationale Supérieure des Arts et Industries Graphiques (Estienne)** 18 Boulevard Auguste Blanqui, 75013 Paris. 570.9619.
4 year course for school diploma in all printing techniques for art and industry. Also B.T.S. in visual expression, graphics, printing. High standard.

**Ecole Nationale Supérieure de Création Industrielle** 46/48 rue St. Sabin, 75011 Paris. 338.0909.
Opened in 1982 to fill the need for a French school of industrial design. Ambitious and unorthodox pedagogy leading to school's own diploma — between 2 and 5 years depending on previous activities.

**Ecole Boulle et L.E.P.** 9 rue Pierre Bourdan, et 57 rue de Reuilly, 75571 Paris Cedex 12. 346.6734.
Variety of courses starting at 14 years, in craft techniques, others such as B.T.S. (3 years) in interior design furniture and industrial 'aesthetic' — well recognised.

**Ecole Nat. D'Art, Ville Nouvelle,** Parking P2 95000, Cergy-Pontoise 030.5049 new graphics school.
The shortage of state art-schools is made up for by numerous private establishments with varying standards and often high fees. Below is a list of some. For more extensive lists see either the Centre National D'Art sur les métiers d'art at the Musée des Arts decoratifs or the C.I.D.J. The schools below have part-time and full-time courses which last for between 1 and 4 years.

# Private art-schools

**Academie D'Art Roederer** 3 Place des Vosges, 4e 272.6186.

**Academie Charpentier** 2 rue Jules Chaplain, 6e 354.3112 (2 annexes).

**Academie de Port-Royal** 4 rue Montlouis, 11e 373.9003.

**Atelier Corlin** 7 rue E. Dubois, 14e 707.9737.
Painting, drawing, applied arts.

**Atelier de Dessin et D'Arts Decoratifs** 25 Passage d'Enfer, 14e 320.6801.

**Atelier Leconte** 37 rue Froidevaux, 14e 321.5600.

**Atelier de Sevres** 47 rue de Sevres, 6e 222.5973.

**Centre Privé D'Enseignement Publicitaire** 9 ter rue Auguste Barbier, 11e 357.1493 (graphics)

**Centre D'Initiation Aux Art Plastiques** 1 Place Leon Blum, 11e 379.9875.

**Copag** (graphics and advertising) 89 Boulevard Pasteur, 15e 321.3041.

**Ecole de Dessin Techniques et Artistique Sornas** 18 rue des Bons Enfants 1e 261.4631.

**Ecole du Louvre** 34 Quai du Louvre, 1e 260.3926 ext. 36.77.
3 year course in history of art and archaeology. Also has lectures open to public.

**Ecole Supérieure des Arts Graphiques** 29-31 rue du Dragon, 6e 222.5507

**Ecole d'Arts Plastiques Mixte et Privée** 10 bis rue de Seine, 6e 354.2314.
(Painting, drawing, modelling, engraving).

**Ecole Supérieure des Arts Modernes** 66 rue des la Pompe, 16e 504.8651.
(Interior design, graphics).

**Ecole Supérieure de l'Union Centrale des Arts Decoratifs** 6 rue Beethoven, 16e 520.5405.

**Ecole Supérieure d'Art et Technique** 23 rue Saint Pierre, 92100 Boulogne 605.0337.

**Parsons School of Design** at American College in Paris, 31 Ave Bosquet, 7e 555.9173.
American run school with courses in fine-arts, illustration, interior design, photography, leading to B.A. degree.

**Paris American Academy** 9 rue des Ursulines, 5e 325.3509.
Set up in 1966 as a summer school for art-courses, it now runs all year, painting, sculpture, lithography, pottery, fashion. Residential.

# Local Art Classes

Various municipal bodies exist with a wide spectrum of day and evening courses available at minimal charge. The ADAC centres were set up recently and are generally more dynamic with workshops in fields ranging from video to printmaking techniques. One centre is located on a mobile barge — worth it if you can catch it (phone 628.6716 for itinerary/classes). All classes are open to local residents.

1st arrondissement:
**ADAC** 23 rue Molière 261.0091. Graphics.

2nd arrondissement:
**ADAC** Ecole primaire, 3 rue de la Jussienne 326.1354.
Photo (dark-room), framing.

**Atelier d'Expression et de Voisinage** 3 rue de la Jussienne 261.5502.

3rd arrondissement:
**Carreau du Temple** rue de Picardie 372.0506.
Maquette and model-making, interior design.

**Centre Inter-Génération** 2 rue Elzévir 271.9925.
Painting, drawing.

4th arrondissement:
**ADAC** Atelier Mire 12 rue des Jardins Saint-Paul 271.1029.
Pottery.

**Cours Municipaux** 6 bis Place des Vosges 887.7232.
Painting and drawing.

**Cours Municipaux** 16 rue du Renard 887.7293.

5th arrondissement:

**ADAC** Centre Culturel du Lycée Henri IV 23 rue Clovis 354.5870. Sculpture, ceramics, film-making, stage design and costumes, important photography section run by Guy le Querrec — with darkroom.

**Inter 5** 240 rue Saint-Jacques 354.3532.

**Cours Municipaux** 21 rue de Pointoise 354.5365.

6th arrondissement:
**ADAC** 5 rue des Beaux-Arts, 326.1354. Book-making and printing techniques, architecture.

**Association Philotechnique** 47 rue St-André-des-Arts 326.4828.

**M.J.C.** 9 Place Saint-Michel 354.1658.

7th arrondissement:
**Cours Municipaux** 8 rue Chomel 548.9074.

**Le Bon Conseil** 6 rue A. de Lapparent.

9th arrondissement:
**Cours Municipaux** 15 rue Turgot 878.3675.

**Centre de Jeunesse et Loisirs Valeyre** 24 rue de Rochechouart 878.2012.

10th arrondissement:
**M.J.C.** Centre J. Verdier 11 rue de Lancry 202.2630. Photography with darkroom, comic-strip drawing.

**Atelier d'Expression Culturelle et de Voisinage** 28-8 rue Lucien Sampaix 209.3408. Comic-strips.

**ADAC** 1 rue Marie-et-Louise 241.8021.
Glass-blowing and engraving.

11th arrondissement:
**ADAC** 141 rue de la Roquette 372.0506. Painting, drawing.

**Cours Municipaux** 111 Ave Parmentier 357.5146.

**CAADIA** 11 rue Froment 805.2827.
Full-time courses in graphics, industrial design, architectural drawing and advertising techniques.

12th arrondissement:
**ADAC** 67 rue de Reuilly 628.6716.
Drawing, ivory miniatures, floral arts.

**Cours Municipaux** 8 rue Charles Baudelaire 307.4471.

**C.I.S.P.** 6 Ave Maurice Ravel 343.1901. Photography.

13th: arrondissement:
**ADAC** 3 Place Souham 585.8859. Wood-engraving, icon restoration, comic-strip drawing, animation

**ADAC** Les Olympiades, 44 Ave d'Ivry 585.8859.
Sculpture, drawing, painting.

**Centre Daviel** 24 rue Daviel 585.0599.

14th arrondissement:
**ADAC** 4-12 rue Didot 543.4684. Pottery, painting, animation.

**Cours Municipaux** 80 Bld du Montparnasse 354.1289 & 46 rue Boulard.

15th arrondissement:
**ADAC** Atelier Annick Le Moine, 21 Ave du Maine 222.4701. Calligraphy.

**ADAC** Rond-point XV, 127-133 rue Falguière 326.1354. Leatherwork, illustration.

**Cours Municipaux** 3 rue Corbon 828.1807 & 33 bis rue Miollis 306.8218.

16th arrondissement:
**ADAC** Musée en Herbe, Jardin d'Acclimatation 747.4766. Animation.

**Cours Municipaux** 3 Impasse des Belles Feuilles 553.2318.

**M.J.C.** "Point du Jour" 1 rue du Général Malterre 525.1419.

17th arrondissement:
**Interclub 17,** 47 rue de Saussure 227.6881/545.0164. Photography techniques - darkroom B/W, colour.

18th arrondissement:
**Atelier Pascal** 79 rue des Poissoniers 259.7312. Stone-engraving, sculpture.

**Cours Municipaux** 18 rue Saint-Isaure 606.7257 & 62 rue Lepic & 26 rue du Mont Cénis 606.1406.

19th arrondissement:
**ADAC** Théâtre Présent, 211 Ave Jean-Jaurès 203.0255. Photography (darkroom) restoring.

**ADAC** 35-45 rue de Flandre 201.6816. Metal sculpture, woodengraving, furniture design and making.

**ADAC** 20-24 Allée des Orgues-de-Flandre 201.6816. Collage, drawing, painting.

**Centre d'Animation Mathis** 15 rue Mathis 241.5080.

20th arrondissement:
**ADAC** 66 rue des Couronnes 585.8859. Leatherwork, jewellery making.

**Centre d'Animation de l'Est Parisien** 110 rue des Amandiers 797.1959. Comic-strip drawing.

For further information about **ADAC** courses and new centres: 27 Quai de la Tournelle, 5e 326.1354. The Hotel de Ville 'Salon d'Accueil' gives information about other municipal classes.

## Recruiting art-teachers

Apply to individual schools: selection takes place in May-June, sometimes in October. Or send relevant information to the Ministère de la Culture, Délégation Générale à la Formation et aux Enseignements, 3 rue de Valois, 75042 Paris Cedex 01. Phone 296.1040 ext. 20.06. This is kept for two years and applicants are

informed when a relevant post is open. For municipal art-schools and classes, apply to the local town-hall. Reforms in organisation and teaching methods, long awaited, are on their way and plans are also afoot for a new municipal art-school and two new national ones on the outskirts of Paris.

# SUMMER OUT OF PARIS — THE FESTIVALS

With The closure of the gallery season in Paris in early July art-seeking travellers are often disappointed at the lack of cultural activity going on in the capital . . . little do they know that it's still happening but has just been displaced to accomodate Parisians 'en vacances' in the South. All branches are catered for: dance, jazz, photography, film, classical music and more, so below is a list of the principal festival centres in case the temptation of sun and culture is too much, although some festivals take place outside the summer months. First trains out from the Gare de Lyon.

## Visual Arts and Photography

**Arles** Recontres Internationales de la Photographie, 16 rue des Arènes, 13200 Arles. tel: (90) 96.76.06. July-August.
Conceived in 1969 and still going strong despite inevitable criticism, the "rencontres" include numerous photography exhibitions of historical and contemporary interest and workshops run by "star" photographers. Slide projections, portfolio displays of young hopefuls and debates round it off.

**Cagnes-sur-Mer** Festival International de Peinture, Bureau du Festival, 06800 Cagnes-Sur-Mer. tel: (93) 20.87.29. June-September.
About 40 countries are represented in this vast display of painting just along the coast from Nice. Not known for avant-garde accent

**Chambéry** Festival de la Bande Dessinée, director Robert Viard, 11 rue de Chardonne, 73000 Chambéry (79) 70.39.37. October.
As the summer rolls past, move upwards into the Alps to see this display of the art of comic-strips — taken seriously in Europe as its quality can be astonishing. **Angoulême** also holds a Salon International de la Bande Dessinée in January, a long-standing meeting-place for all involved. Information from Bureau du Tourisme, Hôtel de Ville, 16016 Angoulême Cedex. tel (45) 95.16.84.

**Jouy-sur-Eure** Biennale Européenne de Sculpture de Normandie, Centre d'Art Contemporain, 2 rue de Beauregard, Jouy-sur-Eure (32) 36.61.55.
July in Normandy for a bi-annual occasion: excellent panorama of contemporary European sculpture.

96

# Film

**Annecy** Rencontres Internationales du Cinéma d'Animation. For information phone Paris 878.5988.
Cartoon film festival generally in April.

**Besançon** Festival International du Film Musical et Choréographique 20 rue Isenbart, 25000 Besançon tel: (81) 80.73.26.
10 days in October.

**Cannes** Festival International du Film, Palais des Festivals, 06406 Cannes tel: (93) 38.20.11.
No need for introductions — 2 weeks in May for non-stop viewing.

**Deauville** Festival du Cinéma Américain, Office du Tourisme, 14800 Deauville. tel: (31) 88.21.43.
One week of new American films in early September often just before their general release in Paris. Some independent films shown too.

**Hyères** Festival International du Jeune Cinema, director M. Poscia, Ville la Voute, 83400 Hyères tel: (94) 65.22.73.
10 days or so in September of young film-makers with some rare experimental work.

**Pradès** Film Festival tel: (68) 96.25.37.
About 40 kms. from Perpignan. July is the time with retrospectives and unreleased films.

# Dance

**Arles** Semaines Internationales de la Danse, Festival, 35 Place de la République, 13200 Arles tel (90) 96.47.00. Booking (90) 96.39.18.
Some important international dance companies as well as young European choreographers throughout last fortnight in July.

**Avignon** see mixed festivals below.

**Châteauvallon** Danse à Châteauvallon, Centre de Rencontres, 83190 Ollioules tel: (94) 24.11.76.
Top American companies and some more classic performers, young choreographers' competition and exhibitions of dance-photograpy, films, workshops etc. July-August.

**Montpellier** Festival International "Montpellier Danse", Théâtre Municipal, 11 Bld. Victor Hugo, 34000 Montpellier (67) 66.31.11. Started in 1081 this rapidly expanding festival favours the younger French companies but also has a good sprinkling of more exotic international companies. Workshops, discussions, photo exhibitions and films. First fortnight in July.

**Aix-en-Provence** La Danse à Aix-en-Provence, Office du Tourisme, 13100 Aix tel: (42) 26.23.38.
Young dance companies also street-performances, workshops and discussions. Second fortnight in July.

# Jazz

**Angoulême** Festival International "Jazz en France", Théâtre Municipal, 16000 Angoulême (45) 95.30.40.
Accent on French and Antillais musicians but Americans and Europeans also represented. Films and photography too for one week in May.

**Antibes** Festival International de Jazz, Maison de Tourisme, Place Charles-de-Gaulle, 06 Antibes (93) 33.95.64.
This internationally reknowned festival generally presents some of the top musicians world-wide — held in second fortnight of July. Joy for jazz enthusiasts.

**Nice** Grande Parade du Jazz, Hotel Mercure, 2 rue Halévy, 06 Nice (93) 81.30.14.
The other real goodie set in the gardens of the Arènes de Cimiez high up in Nice — countless top names play throughout the first fortnight of July overlapping with Montreux (Switzerland) at the beginning and Antibes at the end, so plot your itinerary with care.

**Nîmes** Jazz Club, 45 rue Flamande, 30000 Nimes.
Workshop as well as concerts by the same stars as Nice and Antibes — takes place during one week in mid-July.

**Salon-de-Provence** Festival International de Jazz, Office du Tourisme, 13300 Salon-de-Provence tel: (90) 56.0355.
A smaller festival usually with one concert an evening during one week in mid-July — similarly high standard as above.

# Classical Music

The number and variety of classical music festivals in France throughout the year make any selection virtually impossible. Various brochures are available at the Office du Tourisme with detailed listings and dates.

# Mixed Arts Festivals

**Aix-en-Provence** Festival International d'Art Lyrique et de Musique, Bureau du Festival, Palais de L'Ancien Archevêché 13100 Aix-en-Provence.
Opera, orchestral concerts and soloists throughout second fortnight in July.

**Avignon** Festival D'Avignon, Office du Tourisme, 84000 Avignon.
This superb town is taken over for a month (July-August) by armies of performing and visual artists — theatre, dance, films, photography, music, street performances *et al.* Off-off activities multiply too with the years. If you can find a hotel-room it's worth the trip.

**Bordeaux** Sigma Festival, Centre Sigma Lainé, 3 rue Ferrère, 33000 Bordeaux (56) 44.60.27.
An uninstitutional mixed festival of contemporary arts, - dance, theatre, music, films, video, photography and painting exhibitions — which lasts about 2 weeks in November — when the Provençal/Riviera party is well over.

**Lyon** Symposium d'Art Performance, Espace Lyonnais d'Art Contemporain, Centre d'Exchanges, Lyon Perrache 69002 (7) 842.2739.
Exhibitions of related artists (Beuys, Gilbert and 'George,' Rainet, Vostell etc), performance by young international artists in May.

**Lyon** Festival International de Lyon, 82 rue de Bonnel, 69003 Lyon (7) 871.0573.
Concerts, opera, dance, theatre within a fairly classical framework for 2 weeks in June.

**Versailles** Festival, Theatre de Versailles, 78011 Versailles 950.7118.
From mid-May to the end of June all stops are pulled out to take Versailles back into its 'glorious' past and there are some spectacular events — fireworks on the Grand Canal in homage to Venice as well as concerts and plays in the chateau.

**La Rochelle** Maison de la Culture, La Rochelle.
An up-and-coming festival covering film, contemporary music, dance and visual arts. Activities divided between March, May and early July.

# Festivals in Paris

**Biennale de Paris** Grand Palais, Porte J, Ave Winston-Churchill, 75008 Paris 256.3344.
Quite a momentous occasion for the arts, every 2 years (1980, 1982, 1984 etc) in October though it is projected for May in 1984 when it will at last have one site for all activities at the new Parc de la Villette (see Future Museums) 45 countries were represented in 1982 with activities covering painting, installations, architecture, experimental cinema, photography, video-art, sounds/voices, new music. Essentially aimed at exposing young artists (under 35) not necessarily within the commercial circuit, and giving the public a chance to see what's boiling.

**Festival d'Automne** 156 rue de Rivoli, 75001 Paris. 286.1227.
Theatre, music — classical and new — dance. Events take place in various Parisian theatres and also at Beaubourg from October to December to kick off after the summer.

**Festival-Estival de Paris** 5 Place des Ternes, 75017 Paris 227.1268.
Principally a series of classical music concerts arranged from mid-July to mid-September.

**Festival de l'Ile-de-France** 15 Ave Montaigne, 75008 723.4084.
Concerts arranged in the numerous castles and palaces surrounding Paris, some fabulous settings. May-July.

**Festival International de la Danse** 15 Ave Montaigne, 75008 Paris 723.4084.
Paris too dances. If you miss it all down south it always homes back to the centre (despite intense government efforts at decentralisation — the roots are too deep). Most performances take place at Beaubourg, others at the Théâtre des Champs-Elysées throughout October.

**Festival International de Jazz** A.N.D.C. 5 rue Bellart, 75015 Paris 783.3358.
One week in late October devoted to jazz concerts though not the same names as the summer glut.

**Festival du Marais** 46 rue François Miron, 75004 Paris 887.7431.
June and July see the courtyards and Renaissance settings of the Marais filled with plays, concerts, jazz, café-théâtre, exhibitions, and performances for children.

**Festival de Montmartre** 606.5048.
September is Montmartre's month for concerts, dance and plays dotted around its heights and leading-up to its grape harvest celebration in early October (corner of rue des Saules and rue St Vincent) a long-standing tradition taken very seriously.

**Festival International du son et de l'Image Vidéo** 20 rue Hamelin, 16e 505.1317.

**Festival International de l'Avant-garde du Film, de la Vidéo et de l'Audiovisuel** c/o Salon Art, Video et Cinema 26 rue Charles et René Auffray, 92110 Clichy 731.2976.
Autumn festival with projections, debates, meetings etc.

**Foire Internationale d'Art Contemporain (FIAC)** O.I.P. 62 rue de Miromesnil, 75008 Paris. 562.8458. Committee president Daniel Gervis, 34 rue du Bac, 75007 Paris 261.1173.
Started in 1973 the FIAC has now become an annual barometer of tendencies in the gallery circuit, lasting 12 days in late October a labyrinth of international gallery stands at the Grand Palais. About 150 galleries participate after a selection process which remains mysterious but leaving tendencies to the galleries. Very expensive entrance fees but well worth it for art-gourmets/gourmands.

**Mois de la Photo** Paris Audiovisuel, 44 rue du Colisée, 75008 Paris 359.0080. Director: Henri Chapier.
This month (October/November) is a bi-annual event, started in 1980 supposedly alternating with a video festival, and organises exhibitions, workshops, discussions in various national and private galleries all over Paris — essential visiting for any potential photographer, enthusiast or professional.

# GENERAL PARIS INFORMATION

## Transport and Travel

**Metro:** Must be one of the cheapest and most efficient systems in the world. Buy a 'carnet' of ten tickets (valid for buses too) rather than single more expensive tickets. Each ticket is valid for any distance within the gates (Portes) of Paris but keep it on you after you've got through the man-eating check-points, as inspectors abound. First-class carriages can be used before 9am and

after 5pm by anyone. For longer stays the "carte orange" makes travelling even cheaper: valid for one calendar month and an infinite number of journeys by metro or bus — currently 110F for central zone. Tourist tickets for unlimited travel are available for 2, 4 or 7 days. The **RER** is an extension of the metro system and stretches far out into the suburbs — if you use it for central Paris the same ticket system applies, but for suburban forays buy an extra ticket at the automatic machines for the specific destination. First metros run at about 5.30 am, last ones between 12.30 and 1 am. Various metro stations have occasional art/crafts/ photography exhibitions which can make life more enjoyable: in particular Auber and La Défense. Also see the Louvre replicas at its metro station, and "Rodin's 'Le Penseur' and Balzac — who stares loftily at passing trains in the Varenne station.

**Bus:** Obviously a more picturesque way to travel and generally frequent though traffic in central Paris can get stuck at unexpected hours. Two tickets required for longer journeys. Most buses stop running around 9pm and Sunday hardly exists on the schedule. Night buses do exist, all radiating from Châtelet and destined for the gates of Paris.

**Taxi:** Easy to find but don't be surprised by accompanying ferocious/ docile hounds particularly at night. Tip of 10 per cent expected. Radio-taxis: 200.6789; 739.3333; 735.2222; 203.9999; 270.4141.

**Bike:** Definitely hazardous and Parisian traffic makes no allowances despite the fluorescent green bicycle lanes recently painted along the main boulevards. They can however be hired for varying periods:

**PARIS-VELO** 2 rue du Fer -à-Moulin, 5e 337.5922 (metro:Censier-Daubenton). A very friendly long-standing place which also sells second-hand bikes.

**MAISON DU VELO** 8 rue de Belzunce, 10e 281.2472 (metro: Gare: du Nord). Closed Sunday and Monday. For hire and for sale.

For weekend cycling outside Paris try the RER system: various stations including Vincennes, Fontenay-sous-Bois, St. Germain-en-Laye, hire out bikes for the day (open 9am-8pm).

**EDMOND GALON** 80 rue Montmartre, 2e 236.5093.
**PGL** 40 rue Gay-Lussac, 5e 254.0575.
Both these addresses hire out solexes for those who are in more of a hurry.

**Car-Hire:** Avoid the multi-national, more expensive car-hire firms and compare rates between Mattei, Milleville, Transam — amongst the more reasonable.

# Travel outside Paris

Limited funds: for those under 26 reduced railway tickets (B.I.G.E.) can be bought from student travel agencies (A.J.F. Transalpino). For over 26 try long-distance buses — e.g. 12 hrs to Milan, 24 hrs to Valencia. Bus-station at Place Stalingrad provides

information and tickets for Italy, Greece, Yugoslavia, Spain and Morocco. A.J.F. can also advise as well as for Amsterdam, Copenhagen and London.
Less limited funds: Charters from Paris are not as cheap or as plentiful as from London or Brussels. Many U.S.A. charters leave from Brussels or Luxembourg and travel agents in Paris will arrange transfer by coach.

The principal travel agents dealing in cheap flights for Europe and worldwide are:

**A.J.F. (Accueil des Jeunes en France)** 119 rue St Martin, 4e 277.8780 also at 16 rue Pont-Louis-Philippe, 4e 278.0482.
A useful organisation for travellers dealing with student hostels and hotels, student cards, travel arrangements and general cheapo deals.

**C.I.E.E. (Council for International and Educational Exchanges)** 49 rue Pierre-Charron, 8e 359.2369 also at 51 rue Dauphine, 6e 326.7965.
Information on accommodation, summer courses for foreigners as well as a travel service with reasonable charter flights [U.S.A., Canada etc.)

**Delta Voyages** 5 rue des Ecoles, 5e 329.2117.
Flights world-wide.

**Hoverspeed** 24 rue Saint-Quentin, 10e 208.1196.
Hovercraft/coach to London about 8 hours — cheapest one-way possibility.

**Jeunes sans Frontières** 6 rue Monsieur-le Prince, 6e 325.5335.
Other branches in Paris but this street is packed with travel agents, also round the corner in rue de Vaugirard. Charter flights world-wide.

**Nouvelles Frontières** 37 rue Violet, 15e 578.6540 also at 5 Ave de l'Opéra, 1e 260.5670.
Another good area for tracking down flights. NF generally have some of the lowest prices.

**Airports** ORLY 844.3210 passenger information.
ROISSY 862.2280 passenger information.
To get to the airports: take ORLY-RAIL (line C of RER from St Michel or Gare d'Austerlitz) trains every 15 mins., journey about 40 mins., or for Charles de Gaulle airport, ROISSY-RAIL (line B of RER from Gare du Nord) same timing. Buses to airports go from the Invalides terminal for Orly — every 10 mins. and from Porte Maillot for Roissy — every 15 mins. Both bus journeys take about 30 mins.

**Train stations** For general SNCF info phone 261.5050 which also has English-speaking operators between 8am-10pm.
24-hour info service at each station:
**Gare du Nord** 280.0303 northern France, Belgium, Holland, Scandinavia, England (and the inevitable night-train).
**Gare de Lyon** 345.9222 southern France, Italy, Greece.
**Gare d'Austerlitz** 584.1616 south-west France, Spain, Portugal.
**Gare de I Est** 208.4990 eastern France, Germany, Switzerland, Austria and onwards.

**Gare de Montparnasse** 538.5229 western France, Brittany.
**Gare St Lazare** 538.5229 Normandy, some trains to England, Holland.

For guides in English, maps etc. see BOOKSHOPS section. The FNAC also covers travel literature/guides extensively. Otherwise a place with a name like "Le Rêve qui trotte" (the trotting dream) has to be well stocked for globe trotters: 6 rue de Jarente, 4e. And don't forget your "London Art and Artists Guide" or your "New York Art Guide" when appropriate
Last but not least, an unclassifiable system for getting round France and Europe cheaply — a hitching agency i.e. central listing of car-drivers willing to take passengers who contribute to petrol costs. You register your destination and their recently computerised system pops out the answer . . . **Provoya/Allostop** 84 Passage Brady, 10e 246.0006 (metro: Château d'Eau).

# Emergency Information

**Post Offices** Normal post-office opening times are Mon-Fri 8am-7pm., Saturday 8am-midday. Stamps can also be bought at Tabacs. A late post-office exists at **71 Ave des Champs-Elysées,** 8e (metro: Georges V) open Mon-Sat 8am-11pm., Sunday 10am-12/2pm-8pm. The central post-office at **52 rue du Louvre** 1e (metro: Louvre) is open 24 hours every day and also has telephones. Telegrams in English — phone 233.2111.

**Banks** Most banks are open 8.30am-4.30 or 5.30pm depending on whether they close at lunchtime, weekdays only. For weekend emergencies the Union des Banques à Paris, **125 Champs Elysées, 8e** (next door to the Tourist Office — metro: Etoile, Georges V) is open Sat. and Sun 10.30-1/2-6pm. The C.C.F. **117 Champs-Elysées 8e** is open Mon-Sat 8.30am-8pm. The money-exchange offices at the main stations are also open late — till 8pm and at the Gare du Nord until 10pm.

**Drugstores** Whether suffering from hunger, thirst, nicotine-withdrawal, no birthday present, newspaper/magazine despair or urgent need to take Paris-by-night photos, the chain of drugstores will comply, at a price. They are open till 2 am every day.
St-Germain: 149 Boulevard St-Germain, 6e (metro: St-Germain-des-Près).
Opéra: 6 Boulevard des Capucines, 9e (metro: Opéra).
Champs-Elysées: 133 Ave des Champs-Elysées, 8e (metro: Etoile)
Matignon: 1 Avenue Matignon, 8e (metro: F-D.-Roosevelt)

# Antiques, Auctions and Markets

Various antique centres exist, chic and otherwise, as well as a number of auction houses. However most antique/brocante buying and selling goes on at seasonal antique fairs, some of which are listed below, but keep your eye open for posters and ads.

## For upmarket antiques:

**Cour des Antiquaires,** 54 rue Faubourg St. Honoré, 75008 Paris.
metro: St Philippe-du Roule.

**Louvre des Antiquaires,** 2 Place du Palais-Royal, 75001 Paris.
metro: Palais-Royal. Closed Sunday & Monday.
Here there are over 250 antique stalls/shops under one smart
roof in an impressive complex opened a few years ago. You
name it . . . they should have it at a price. They also hold changing
exhibitions of antiques with unusual themes.

**Village Saint-Paul,** between Quai des Céléstins and rue St Paul in
4e. metro: St Paul or Sully-Morland. Shops closed Tuesday &
Wednesday.
Here there is a varying standard and quality from shop to shop
but interesting finds can be made in the bric-a-brac, and it is a fas-
cinating area to explore also harbouring craft shops and the odd
gallery.

**Village Suisse,** 54 Ave de la Motte-Piquet, 75015 Paris. metro:
Motte-Piquet. Closed Tuesday and Wednesday.
A conglomeration of smart, expensive antique shops not known
for bargains.

Art Nouveau and Art Deco addicts should see the streets in and
off rue des Saints Pères:- rue de l'Université, rue de Lille, rue
Jacob, Bonaparte etc. where some superb pieces can be found.
Rue St Honoré also has a number of shops grouped in inner court-
yards with not too outrageous prices at les Halles end.

## Auction Houses:

**New Drouot** 9 rue Drouot, 75009 Paris. 246.1711/770.1717.
The French equivalent of Sothebys or Christies is now housed in a
newly opened complex complete with several auction rooms,
viewing rooms, a bookshop, transport facilities and banks . . . to
facilitate buying. For auction information see the Saturday
papers  or their calendar out on Fridays (Gazette de l'Hòtel
Drouot).

**Sotheby, Parke Bernet** 3 rue de Miromesnil, 75008 Paris.
266.4060.
Still spreading their vast wings — valuations only. No auctions in
Paris.

**Christie's France** 17 rue de Lille, 75007 Paris. 261.1247.
Valuations.

**Crédit Mûnicipal** 55 rue des Francs- Bourgeois, 75004 Paris.
271.2543.
This is the municipal pawn office which holds regular auctions of
unclaimed items and if your funds are running low they provide 6
month loans on goods valued at over 500 F and 1 year loans for
lesser articles.

**Dépôt Alésia** 117 rue d'Alesia, 75014 Paris. 542.4242.
Open Mon-Sat 9-7.30pm.
As we slide downmarket it's worth mentioning this antique and
general junk consignment depot.

**Salle des Ventes des Particuliers** 34 rue de Ciseaux, 75012 Paris.
343.0355.
General auctions of mainly second-hand furniture.

**Le Petit Drouot** 64 rue Doudeauville, 18e. (Metro: Marx-Dormoy).
Almost daily sales of household equipment, furniture, books, clothes — things that don't reach the real Drouot standard. Doors open 9am, auction 9.05.

**Salle des Ventes Saint Antoine/Ledru-Rollin** 104 rue du Faubourg St Antoine 75012 Paris. 307.6371. General household furniture etc.

Auctions outside Paris:
The 'hotel des ventes' situated outside Paris are often worth the trip as items can be picked up before being sucked into the Parisian circuit. Again see Saturday papers for notification — the sales are usually at the weekend.

Galerie de CHARTRES 1 bis Place du General De Gaulle, 28 Chartres.
Hôtel des Ventes d'ENGHIEN 2 rue du Docteur Leray.
Hôtel des Ventes de FONTAINEBLEAU.
Hôtel des Ventes de l'ISLE-ADAM 1 rue Mellet, 95290 l'Isle-Adam.
Hôtel des Ventes de ST GERMAIN-EN-LAYE 9 rue des Arcades, St. Germain-en-Laye.
VERSAILLES — Hôtel des Chevau-Légers, 3 Impasse des Chevau-Légers, 78 Versailles.
Galerie des Chevau-Légers, 6 bis Ave de Sceaux, 78 Versailles.

## Antique Fairs:

**Salon des Antiquaires:** late November/early December, Place de la Bastille **Foire à la Ferraille et aux Jambons:** twice yearly in early October and before Easter at the giant hall of the Porte de Pantin. It's not only old iron and ham as suggested by its name which goes back to the first fair of its kind in 1222 . . . though there is plenty to eat and drink together with an enormous display of antique/junk stalls. Dealers come from all over France to buy and sell but forget about finding bargains.
**Salon de la Curiosité:** late February/early March. Old station at Bastille.
**Foire à la Brocante de Chatou:** Ile de Chatou. Same periods as "Ferraille et Jambons".

Another useful organisation to know about for buying general household junk and the occasional 'antique' is EMMAUS a charity/community which picks up unwanted furniture and articles from homes all around Paris and then resells in one of its centres in the suburbs — from books, to crockery to clothes to general furniture. The prices vary considerably depending on the taste of whichever man put on the sticker . . . so it may or may not be worth it. There are 6 centres — here are two addresses to put you on the track:
Emmaus: 7 Ile de la Loge, 78380 Bougival. 969.1241. Open Mon-Sat 2-5.30pm and Thursday & Sat mornings.
Emmaus: 38 Ave Paul-Doumer, 93360 Neuilly-Plaisance. 300.0552. Open Mon-Sat 2-5.15pm & Sat morning.

*Marché d'Aligre.*

## Flea Markets:

**Marché d'Aligre** Place d'Aligre, 12e metro: Ledru-Rollin.
Takes place most mornings till about 1pm except Monday. The small secondhand bric-a-brac section is well frequented, a favourite for Sunday mornings, and sometimes provides some surprising finds. The rest is fruit and veg at all time low prices but the quality is often questionable.

**Marché du Kremlin-Bicêtre** metro: Porte d'Italie. Thursday, Sunday and Tuesday mornings only. Pretty pucy this one but it depends what you're looking for — occasional bargains.

**Marché de Montreuil** metro: Porte de Montreuil.
Open all day Saturday, Sunday and Monday morning. A one time favourite which has now been over-discovered and invaded by jeans stalls but it is large and varied and some stalls change over at midday giving you even more variety. Beware of the 2nd hand clothes prices which, due to trendiness, can be ridiculous over-taking those in Les Halles.

**Marché aux Puces** St Ouen metro: Porte de Clignancourt. Open all day Saturday, Sunday and Monday. Not quite what it used to be which was **the** original Parisian flea market. It has now been over-developed and commercialised but its sheer size means there is enough competition to keep some prices down. A strange mixture of old and new, mundane and exotic, but worth a stroll. Avoid any public holiday (Easter etc.) as you literally cannot move through the crowds and also remember that the pick-pocketers on this metro line are amongst the cleverest and quickest on the job — the platforms buzz with their anticipation.

**Marché de Pantin** metro: Porte de la Villette.
Sundays only. Difficult to find and not so well known therefore worth looking at.

**Marché de Vanves** metro: Porte de Vanves.
Saturday and Sunday all day. The 'brocante' section of this enor-mous fruit and veg market stretching along Boulevard Brune is tucked away in a side street and can still be good for trendy bric-a-brac, furniture and clothes depending on who's selling off their wardrobe/household, though there are specialists too.

## Other specialist markets:

**Book market** (les bouquinistes) Quai du Louvre, de la Mégisserie etc.
Visually you can't miss them — featured on numerous postcards and guide-books — and it's fun to fumble through prints, books and vintage magazines.

**Marché aux Fleurs** Place Louis-Lépine metro: Cité.
Open Mon-Sat 8-7pm. If you have any bureaucratic dealings at the Préfecture this small flower/plant market makes a nice con-trast whether on your way in or out.

**Marché aux Oiseaux** Takes place on the same square on Sun-days, a picturesque and noisy bird markèt. During the week take a walk along the Quai de la Mégisserie (between Châtelet and Pont-Neuf) to look at chickens, rabbits, and unknown fellows scuttling in their cages rather forlornly while the Parisian traffic tears by beside them.

**Marché aux Timbres** Cours Marigny metro: Champs-Elysees-Clémenceau.
On Thursday, Saturday & Sunday from 10am to evening. This col-lection of stalls runs up one side of the Avenue Gabriel and is a haven for philatelists and postcard collectors — also an odd sight in this area

# Music Places

## Jazz

Paris is traditionally rich in jazz-bars/cellars/concerts and this line of contemporary music in fact reflects very accurately the French intellectual and analytical approach to the arts in general — more cerebral and technical than blood and guts. Below is a list of regular jazz venues — entrance with live music around 50 F but this can rise with guest artists and concerts. See weekly 'Pariscope' or 'L'Officiel' for fuller and more specific listing.

**Bofinger** 5 rue de la Bastille, 4e 272.8782 metro: Bastille.
Rather expensive jazz restaurant.

**Bilboquet** 13 rue St-Benoit, 6e 222.5109 metro: St-Germain.
Bar/restaurant with first classs jams.

**Caveau de la Huchette** 7 rue de la Huchette, 5e 326.6505 metro: St-Michel.
Old favourite — jazz bar in cellar with changing musicians — from 9.30pm.

**Chapelle des Lombards** 19 rue de Lappe, 11e 357.2424 metro: Bastille.
Once a jazz must, now changed to mixed sounds from changing groups. 10.30pm onwards.

**Cloitre des Lombards** 62 rue des Lombards, 1e 233.5409 metro: Chatelet.
Jazz, reggae, salsa. 2 sessions per evening. Closed Monday. From 8pm.

**Le Dunois** 28 rue Dunois 13e 584.7200 metro: Nationale.
Changing jazz and rock concerts.

**Le Furstemberg** 25 rue de Buci, 6e 354.7981 metro: Odeon.
Traditional smart jazz bar.

**New Morning** 7-9 rue des Petites-Ecuries, 10e 523.5141 metro: Chateau d'Eau.
Recently opened jazz bar: decent comfortable space and top jazz musicians. From 9.30 pm.

**Petit Journal** 71 Bld St-Michel, 6e 326.2859 metro: Luxembourg.
Jazz-bar with changing jazz musicians — some big names. Closed Sunday. From 9pm.

**Petit Opportun** 15 rue des Lavandières-Ste-Opportune, 1e 236.0136 metro: Châtelet.
Jazz-bar with changing musicians from 11pm.

Also check **American Centre, Lucernaire Forum** and **Théâtre du Petit Forum** (3rd level, Forum des Halles) for occasional concerts.

## Discos

Numerous, varied atmospheres from new wave sleaze to Champs-Elysées ease. The action never starts before midnight. Entrance with drink between 50F and 100F.

**Bains-Douches** 7 rue Bourg-l'Abbe, 3e 887.3440 metro: Etienne-Marcel.
50's revival type atmosphere in Siberian steppes decor. Squashed but there's a restaurant upstairs. Some good rock concerts. Temporary closed so phone first.

**Gibus** 18 rue du Fbg du Temple, 11e 700.7888 metro: République.
Long-standing young and heavy rock/new wave disco - regular live concerts include some of new British groups. Not for the delicate.

**Lola** (ex-Bus Palladium) 6 rue Fontaine, 9e 874.5499 metro: Blanche.
Very young monied trendies rocking and rolling. Mods and rockers rebattle it out.

**Le Main Jaune** Place Porte de Champerret, 17e 763.2647 metro: Pte Champerret.
Roller-disco.

**Le Palace** 8 Faubourg Montmartre, 9e 246.1087 metro: rue Montmartre.
Fabrice Emer's dream palace in converted theatre — lasers oblige. The in place for a few years, still has some excellent concerts.

**Le Privilège** 1 ter, Cité Bergère, 9e 246.1087 metro: rue Montmartre.
Opened to protect the chicer Palace clientele from invading heavies. Entrance round corner but very subjective vetting. If you're accepted you can dine in neo-classical splendour and watch Parisian stars twirling.

**Rose Bon-Bon** 6 rue Caumartin, 9e 268.0520 metro: Havre-Caumartin.
Its popularity waxes and wanes but not a bad rock & roll haunt with reasonable sprinkling of curiosities.

**Le Sept** 7 rue Sainte-Anne, 1e 296.4705 metro: Quatre-Septembre.
Upstairs restaurant to spot male couturiers and downstairs gay meeting-place.

**Régine** 49 rue de Ponthieu, 8e 359.2113 metro: F-D. Roosevelt.
If you must look at Parisian high-society, this is where to go but necessitates flashing Cartiers, Rolls and an accompanying regular to get in.

**Le Tango** 11 rue au Maire, 3e 272.1778 metro: Arts et Métiers.
Latest 'in' disco, that is winter 82/83, with rumba and similar hot rhythms/atmosphere within pink walls.

## Classical Music

It has been part of recent municipal policy not to reserve any one concert-hall for a particular form of music so, apart from the Opera (booked up a year in advance quite often) there are no exclusively classical music places. The following do however have regular classical concerts — again see the weekly entertainment magazines for more details. **Salle Pleyel** (563.8873), **Salle**

**Gaveau** (563.2030), **Théâtre Musical de Paris** (233.4444), **Théâtre des Ch-Elysees** (723.4777), **Maison de la Radio** (524.1516). Many churches hold regular recitals and entrance is often refreshingly free so check out Notre Dame (Sundays), Eglise St Germain, St Merri, St Sévérin, St Julien-le-Pauvre, St François Xavier and the Madeleine. For concerts of new contemporary music see the IRCAM programme at the Centre Pompidou. The Musée d'Art Moderne also holds concerts.

# Café-Théâtres

The café-théâtre boom took off in the late 60's with its combination of short, often satirical plays or monologues and an eating area or bar. It broke the snob-value of the traditional theatre circuit, giving young actors and actresses as well as playwrights a chance to demonstrate their talents. Unfortunately it requires a fairly advanced knowledge of the language — not recommended for beginners — as much of it is in slang or relying heavily on puns. Entrance about 40F, student reductions, sometimes drink included. Below is a short selection — see weekly *Pariscope and l'Officiel* for further listing.

**Au Lapin Agile** 22 rue des Saules, 18e 606.8587 — Montmartre. Not really in this category — more an animated eating place — traditional French songs. Many now famous French singers started here and the Montmartre atmosphere still continues.

**Café d'Edgar** 58 Bld Egar Quinet, 14e 320.8511 metro: Edgar-Quinet.
One of the very originals, still maintaining a high comical standard. Several shows simultaneously to choose from.

**Café de la Gare** 41 rue du Temple, 3e 278.5251, metro: Rambuteau.

Born out of 68 sentiments it remains popular. Situated behind Beaubourg and worth a visit. Free soup was served in the old days . . .

**Cour des Miracles** 23 Ave du Maine, 15e 548.8560 metro: Montparnasse.
Another original — consistently well received shows. Restaurant open till 1am.

**Petit Casino** 17 rue Chapon, 3e 278.3650 metro: Rambuteau. Situated in the Marais — two different sessions every evening with optional dinner and as much wine as you like.

**Point Virgule** 7 rue Sainte-Croix-de-la-Bretonnerie, 4e 278.6703. Closed Sunday and Monday.
3 consecutive shows every evening. Good reputation.

# Salons de thé

A growing trend providing a means of escaping Parisian frenzy, when even normal cafes with jingling, bleeping pinball and space-invader machines can become too much. The list includes both the traditional style serving tea/coffee and cakes and also the younger offspring which often serve meals too.

*Passage Véro-Dodat.*

## Les Halles/Bourse

**A Priori thé** 35 Gallerie Vivienne, 2e 297.4875.
Closed Sunday. Located in a covered passage running between rue Vivienne and rue des Petits-Champs, worth visiting for numerous odd shops. Tea-room run by Americans with extensive range of salads, cakes, teas; calm atmosphere and mixed clientèle. Sit outside in passage to admire neo-classical architecture and skylights. Near Bibliothèque Nationale.

**La Quincampoisse** 13 rue Quincampoix, 1e.
Dangerously near take-away croissant stands but maintains elegance — tea and cakes surrounded by regular painting exhibitions. Convenient for Beaubourg.

**L'Arbre à Souhaits** 15 rue du Jour, 1e 233.2769.
Closed Sunday. On a trendy street. behind St Eustache by the hole. Milk-shakes, fruit-juices, tarts etc. in ecological ambiance. Also serve Indian food.

## Le Marais

**Le Jardin de Thé** 81 rue St-Louis-en-l'Isle, 4e 329.8152.
Open midday-midnight. Nice old-fashioned setting for consuming gooey cakes, desserts also salads and of course tea, but can be crowded.

**The Lady Jane** 4 Quai d'Orléans, 4e 329.8827.
Open till 1.30am. Also on the Ile Saint-Louis and also a chic crowd — usual salads, quiches etc and fun atmosphere.

**Eurydice** 10 Place des Vosges, 4e 277.7799.
Open midday-10pm closed Monday & Tuesday. The porticos outside aren't repeated inside: a vaguely high-tech decor with background jazz for eating vegetarian dishes and choccy cake. Any excuse to linger in this square. Maison de Victor Hugo is a few doors away.

**Dattes et Noix** 4 rue du Parc-Royal, 3e
Open midday-midnight. Located on a lovely Marais square surrounded by 'hotels' — one houses the Swedish Cultural Centre and around another corner is the Musée Carnavalet. This salon de thé is scrubbed clean — imaginative cakes, quiches and loads of teas.

**4e sans ascenseur** 8 rue des Ecouffes, 4e 887.3926.
Closed Sunday evening and Monday. Hanging-plants atmosphere — a popular place off the rue des Rosiers, the Jewish quarter with its exotic shops. Milk-shakes, teas and all kinds of tarts and salads.

**Le Clichy** 5 Boulevard Beaumarchais, 4e 887.8988.
Closed Monday. To finish off the Marais, a traditional patisserie with tables at the back — a real classic. Superb homemade ice-creams and sorbets, dripping and/or crunchy cakes. Right next to the Bastille.

## Montparnasse

**Salon Belusa** 86 rue du Cherche-Midi, 6e 222.5258.
Open midday-6pm weekdays only. Another rare old-style salon de thé with everything one can expect though quite pricey. Near the Musée Hébert.

**Olympic-Entrepôt** 7-9 rue Francis- Pressensé, 14e.
Open every day and evening. Part of cinema/bookshop/restaurant complex — a good place for a milkshake or fruit-juice before/after cinema. Also a gay rendezvous. Exhibitions of photos, drawings.

**Les Fiancés en Folie** 12 rue Francis-Pressensé, 14e 540.9430. Open 5pm-midnight. Closed Monday & Thursday. Annoyingly idiosyncratic opening hours/days but inventive snacking accompanied by fruit-juices in slightly tarnished atmosphere. If it's closed you can always go to the Entrepôt across the road.

## Saint Germain

Not so hot on salons de thé round here — better on bars — but there are a few.

**Village Voice** 6 rue Princesse, 6e 633.3647.
Open 11am-10pm. Closed Monday. Here is true American spirit with homemade chocolate cakes, inventive salads and sandwiches, fruit juices etc. amidst books and art exhibitions.

**Un Moment - en Plus** 1 rue de Varenne, 7e 222.2345.
A similar spirit reigns here — more books than cakes and space is limited but fun.

**La Palette** 43 rue de Seine, 6e.
Closed Sunday. Open till midnight. OK so it's out of place among sedate salons de thé. The traditional artists/hangers-on/local eccentrics; rendez-vous with a remarkable early 1900's interior, rickety tables and stuffed with paintings and exhibition posters. Conveniently situated in heart of Left Bank gallery cluster — more beer and wine is served than tea and coffee.

**La Fourmis Ailée** 8 rue du Fouarre, 5e.
Open 11-7pm. Closed Tuesday. Bookshop/tearoom near Quais and Notre-Dame.

## Right Bank

**Angélina** 226 rue de Rivoli, 1e 260.8200.
Open 10-6.30pm. One of the originals as it's been open since 1903 and still has the elegance of that epoch. Exquisite hot chocolate and patisseries for a winter afternoon but there are sometimes queues . . . next to Galignani's bookshop and convenient for Jeu de Paume, Musée des Arts Decoratifs, Louvre.

**Ladurée** 16 rue Royale, 8e 260.2179.
Open 8.30-7pm. Closed Sunday. Fashionable and chic tea-sipping rooms with chic-eek prices. Near Madeleine and Faubourg St-Honoré.

**Carette** 4 Place du Trocadéro, 16e 727.8856.
Open 8-7pm weekdays only. Convenient for conversing pre or post cinemathèque viewing, or for digesting anthropological shocks at the Musée de l'Homme. Right Bank trendies and intellectuals make the crowd.

**La Tartarine** 8 rue du Champs de Mars, 7e 551.2801.
Salon de thé with vegetarian lunches and snacks in an unexpected area — also occasional painting exhibitions.

Last but not least comes **La Mosquée** 39 rue Geoffroy St Hilaire, 5e (metro: Place Monge) which is the Parisian Moslem centre in all its decorative splendour. The tea-room serves sweet mint tea and North African cakes at low tables, tranquil surroundings.

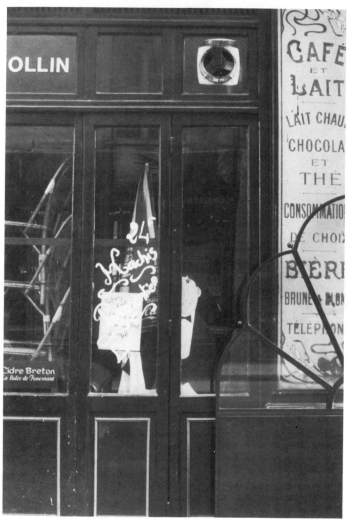

*Café in rue Vieille du Temple.*

# Restaurants and Bars

Being an inferior Anglo-Saxon, culinarily speaking, I don't feel qualified to recommend a list of Gault & Millaut style restaurants (enthusiasts please refer to their bible), nor does that fall within the aims of this guide. Instead, here is a run-down on the main central areas noting a few unusual or good-value eating places and leaving obscure back-street discoveries to the visitor.

Most restaurants have special fixed price 'menus' as opposed to 'à la carte selection — though not always in the evenings — and this helps budgeting as it usually includes service (prix net) and sometimes wine.'S.n.c.' means 'service non compris' which adds 15% to the bill, so beware. Remember too that sitting at tables in cafes and bars boosts the price of a drink considerably, and that after 10pm bar prices are open — meaning that you can pay 25 F for a beer on a terrace at very nondescript places if you're unlucky. For draught beer ask for 'un demi' otherwise you're automatically served the pricier bottled variety. The restaurant prices quoted below are valid for late 82 so allow another 10% per year inflation . . .

## Les Halles/Bourse

Following the birth of Beaubourg and the relaxed-pace filling of the notorious Les Halles 'hole' the area has become the current booming in district. An extensive choice of restaurants exists, some relying more on their decor than their food to attract customers. American influence is strong and fast-food is gaining ground rapidly but for more relaxed 70's style go to **Mother Earth's** 66 rue des Lombards, an old favourite for chilis, Californian salads etc. and background rock.

**Joe Allen's** another original, 30 rue Pierre-Lescot 263.7013. Serves all-American fare and you can also limit yourself to a vaporous cocktail.

**Le Studio** 41 rue du Temple, 4e 274.1038 is worth a visit for the courtyard which also houses the Café de la Gare (cafe-théâtre) and a dance school. So to the clippety-clap of the tap-dance class you can indulge in American-Mexican goodies, a Sunday Mexican brunch or listen to live music on Monday nights.

**Le Pacific Palissade** 51 rue Quincampoix, 4e 274.0117. More exotic: raw fish Tahitian specialities or good old spare-ribs. Pacific island atmosphere with fresh-fruit cocktails and good sprinkling of dazzling models and prêt-à-porter crowd make it currently very in. About 100 F.

**Les Bouchons** 19 rue des Halles, 1e 233.2873. Continues the escapist tendencies with spacious colonial atmosphere, Antillais/Caribbean specialities and elegant service. Over 100 F. Also doubles as salon de thé (open noon-1am).

**Dona Flor** 10 rue Dussoubs, 2e 236.4655. Open till 2am, closed Sunday. More tropical delights in warm atmosphere, brightest colours in Paris and neon fruit sculptures. Brazilian delicacies and clientèle — the rum flows. Menu 85 F

**Restaurant Véro-Dodat** 19 Passage Véro-Dodat, 1e 508.9206. Traditional French cuisine (ah . . . at last) in little restaurant tucked away in a covered passage — lunchtime only, about 60 F worth it for old-world atmosphere.

**Auberge du Palais-Royal** 10 rue Jean-Jacques Rousseau, 1e 261.7006.
Around corner from above, friendly small place with 50 F menu, closed Tuesday. Fairly classic French food. Not far from the Louvre.

**La Galtouse** 15 rue Pierre-Lescot, 508.0461. Reasonable menu and outside tables so good for lunch in the sun, watching the Forum-des-Halles crowd. Evening outside means you're constantly plied by passing entertainers and 'merchants'. Immediately opposite is **La Grande Marmite** with an equally reasonable 'menu' and generally friendlier service, also with terrace.

**Le Gosier en Pente** 5 rue Sauval, 1e.
A gourmet's goody with Perigordin cuisine and all its riches — not over-priced, à la carte count 80-90 F. Warm and small, friendly service.

**Centre Ville** 9 rue la Grande Truanderie, 1e 260.1953
Back to the trendies though it's past it's 'in' peak. Still some stylish Parisians in high-tech surroundings and 50's music — bar and restaurant.

**Le Tribulum** 2 rue Cossonnerie, 1e 236.0101.
Amazing installation of flying figures and costumes for a spacious bar on corner of rue St Denis. Downstairs are some showcases with exhibits of drawings, masks, accessories and sculptures. Good for late drinking.

**Willi's Wine Bar** 13 rue des Petits-Champs, 1e.
A real British-owned wine-bar for homesick folk; smart vaguely rustic atmosphere with restaurant and bar — closed weekends and after 9pm (those UK licensing hours really get a hold . . .)

**Restaurant du Grand Cerf** Passage du Grand Cerf, 2e (metro: Etienne-Marcel).
For really low budgets — menu around 25 F. Paella and various French/Spanish dishes on large tables in squashed, noisy, friendly atmosphere. Last orders 9.30pm. Sometimes have to wait for table.

Lastly for real late-night wanderers, **Au Pied de Cochon** 6 rue Cocquillère 236.1175 and **La Poule au Pot** 9 rue Vauvilliers 236.3296, nearby, both stay open all night and are classics of Les Halles from the days of the fruit and veg market, though now not cheap. Similarly a historic classic **Au Chien qui fume** 33 rue du Pont-Neuf, 236.0742 in the same area and with more reasonable prices — open till 2am.

# Le Marais

This is the oldest part of Paris displaying some stunning 15th-17th century architecture and although experiencing a boom in internal renovations, no external changes are visible — unlike Les Halles — and at times you can feel far away from fast Parisian rhythms. The Place des Vosges makes a beautiful calm setting for a late summer night's drink under the arches and there are

*Place des Vosges.*

several restaurants of high quality. Nearby is the old Jewish quar-
ter in the rue des Rosiers with the famous **Goldenberg's** res-
taurant as well as other specialised shops open on Sundays.
Across the Seine, Le Marais carries on into the Ile Saint-Louis, a
fairly exclusive island with its mass of craft-shops, food special-
ists, tea-rooms and restaurants.

**Le Piano Zinc** 49 rue des Blancs Manteaux, 4e 274.3242.
At the Beaubourg end of Le Marais, a bar/brasserie with live
music and reasonable food; lively, friendly atmosphere. Even-
ings only. Predominantly gay clientèle.

**Le Petit Gavroche** 15 rue Sainte-Croix-de-la-Brétonnerie, 4e 887.7226.
Ex politicos' haunt, now more general young clientele with thin wallets — very reasonable menu around 35 F with traditional French cooking and relaxed atmosphere. Upstairs is a mass of greenery, downstairs noisier.

**Au Vieux Paris** 75 rue Vieille du Temple, 4e.
Small local place for lunches only Mon-Fri. Inexpensive, unpretentious though sometimes crowded.

**Hélium** 3 rue des Haudriettes, 3e 272.8110
New wave restaurant with old-wave food, pricey but original plastic + balloon setting and occasional exhibitions and music.

**Le Chevalier du Temple** 33 rue des Rosiers 4e 277.4021.
Recently opened on three levels — American atmosphere, brunch, snacks and live jazz around midnight. Its advantage is that it's open 24 hours.

**Repaire de Cartouche** 8 Bld des Filles du Calvaire, 11e 700.2586.
Closer to République but a friendly place with traditional provincial food — menu about 75F.

**Chez Jacques et Madeleine** 17 rue Oberkampf, 11e.
Near the Cirque d'Hiver, reasonable prices and good fish dishes — outdoor tables, evenings only but closed in August.

**Juventus** 10 Place de la Bastille, 11e 343.1833.
Moving down to the Bastille, a large pizzeria reputed by a pizza-fanatic friend to be the best pizza for value in Paris. Frequented by arty types and also has a wide range of Italian cuisine.

**La Tartine** 24 rue de Rivoli, 4e.
Closed Sun, Mon and August. Open till 10pm. Famous old cafe-bar retaining much of original decor and smoky atmosphere with sturdy sandwiches and wine by glass selection.

**Le Trumilou 84 Quai de l'Hôtel de Ville.**
Back down along the Seine an old-style restaurant with fish specialities reasonable menus — unpretentious.

**Au Gourmet de l'Isle** 42 rue St-Louis-en-l'Isle, 326.7927.
On the island 'high street': small friendly and excellent French provincial food. Count on 60-80F.

**La Brasserie de l'Ile** 55 Quai Bourbon.
A classic, situated on western tip of island, facing Notre Dame. Known by Anglo-Saxons particularly popular for Sunday lunch with Alsacian specialities, beer etc. though waiters are hard-worked and consequently abrupt.

**Aux Anysetiers du Roy** 61 rue St-Louis-en-l'Isle 354.0270.
Closed Weds. Moving into another price-range, about 130F. Sophisticated food and setting with regular painting exhibitions — open till midnight.

**Berthillon** 31 rue St Louis-en-l'Isle.
Impossible to miss this ice-cream classic with extremes in exotic flavours some untranslatable. Long queues on summer days.

## St Germain

Despite current rivalry provided by the Beaubourg boom, St Germain is still a popular eating and promenading area, particularly in the summer months. Some excellent, long-established restaurants can be found though prices can rise hysterically, as well as international elements. Bars still shelter itinerant eccentrics as well as individuals on display — the **Café de Flore** and **Les Deux Magots** are long-standing favourites close to the church and if seated outside you are well entertained/harrassed by roving street-artists — mime, fire-eaters, musicians etc. In the rue de Seine **La Palette** is the place to be (see SALONS DE THE) . . . seen,

while if you want to hide out in a wine-bar go to **Au Sauvignon** 8 rue des Saints-Pères (closed Sunday). All are convenient for pre or post gallery visiting. Or, if feeling flush, go to **l'Hôtel** 13 rue des Beaux-Arts 325.2722 where the lush decor of the bar with its piano, antiques, old prints and fountain remains suitably decadent for **the** hotel where Oscar Wilde breathed his last. Open 6pm-2am for drinks and cocktails.

**Restaurant des Beaux-Arts** 11 rue Bonaparte, 6e 326.9264.
Open every day. Bang opposite the Ecole des Beaux-Arts and with an appropriately cheap menu — good fish-soup. Gets crowded and last orders are at 9.30pm.

**Restaurant des Arts 73 rue de Seine.**
Closed at weekend. Another artists' favourite: large tables, friendly service and excellent food for around 40F. Last orders 9.30 unless they're feeling lax. Convenient for eating after vernissages.

**Le Petit Zinc** 25 rue de Buci 354.7934
In the middle of the local food market with seafood specialities — good for oysters. Count on about 100F. Open till 2 a.m.

**La Nouvelle Marinara** 46 rue Dauphine, 6e
Good pizza and fresh pasta specialities, not overpriced.

**La Photogalerie** 2 rue Christine 329.0176.
Chic crowd includes actors, publishers, models eating 'light' food i.e. inventive salads, fish, egg dishes . . . next door to Action Christine cinema which shows good old movies. Lunch around 50 F, dinner hitting 120F.

**Le Jardin de Grégoire** 10 rue Grégoire de Tours.
Open noon-midnight. Another health-conscious restaurant with good range of salads and medium priced menu.

**Le Paradis du Fruit** 29 Quai de Grands Augustins, 6e 354.5142
The name describes it — all dishes and drinks are fresh fruit and/ or veg based. Exotic cocktails, milk-shakes, salads. Count 50F. Open every day, all night Fridays.

**Yakitori** 8 rue des Ciseaux, 633.6949.
Closed Monday. Japanese delicacies — charcoal fired skewered meat. Around 60F.

**L'Ecluse** 15 Quai des Grands-Augustins, 6e.
Closed Sunday. Open 11-2am. Rather chic and plush wine-bar which as a second thought also serves food. Special Bordeauxs for the initiated. Old posters decor.

**Le Bistrot de la Grille Saint-Germain** 14 rue Mabillon 354.1687.
Noisy, lively place with slate menu (i.e. changing) and reasonable
value — about 70F.

**Le Polidor** 41 rue Monsieur-le-Prince 326.9534.
One of Paris' historic restaurants which remains unpretentious.
Past customers have included Artaud, James Joyce, Boris Vian
and long ago Verlaine. Large tables, country cooking around 60F,
but go before 9.30 as it closes early.

**La Foux** 2 rue Clément. Serves Lyonnais specialities, always
excellent and with elegant, friendly service. Menus from 70F.

**L'Epicurien** 11 rue de Nesles 329.5578.
With a name like that the food has to be something — and it is.
South-West France specialities (crab preparations, foie gras and
untranslatable dishes) in peaceful decor, leaving attention for the
food. Up to 200F.

## Montparnasse

Montparnasse inevitably wafts evocations of the 20's and 30's to
every reader of Henry Miller, Jean Rhys, Scott Fitzgerald, Hem-
ingway et al . . . but times have changed and although the boule-
vard is still a late-night haunt with its numerous cafés where the
Left Bank crowd hung out at that time the atmosphere has been
changed by the developers. Traditionally the area has a strong
Breton influence (the station serves that region) hence the con-
centration of crêperies and fish restaurants. For a crêpe and
galette based meal go to the rue du Montparnasse towards the
metro Edgar Quinet where about 5 crêperies rub shoulders. The
unmistakable and controversial Tour Montparnasse together
with a horrifying station complex have succeeded in destroying a
large area but behind the station there still remains a less sophis-
ticated part in the rue de l'Ouest (much loved by squatters) and
the rue du Château which abound in good value Algerian cous-
cous restaurants, 'ecological' eating-places — and a few heavy
bars. The side-streets contain surprises, such as the very good
**Leni's** restaurant in the **Entrepôt** cinema, 7 rue Francis de Pres-
sensé 541.0617 a favourite with actors, gays and the odd intellec-
tual with its natural food, plants, rafters etc. — about 80F.

**L'Ecume** at 99 bis rue de l'Ouest, 542.7116 is a bar and eating-
place with occasional exhibitions and jazz concerts. For a choice
of every possible European beer go to **L'Académie de la Bière** 88
bis, Boulevard de Port-Royal (eastern end of Bld. Montparnasse)
where the real initiates hang out.

**Bergamote** 1 rue Niepce, 14e 322.7947.
An evenings only restaurant, closed Wednesday, with imaginat-
ive fresh and natural food in plants/old lace atmosphere.
Excellent value, about 65F.

**le 102** 102 rue de l'Ouest, 14e 542.7888.
Similar style to above with menu which changes every week,
though rather limited choice. Friendly owners and clientele.
About 60F.

**Télémaque** 15 rue Roger, 14e 320.6638.
Closed Sunday. Very cheap menu for good Greek food — around 30F but as with all really cheap menus you have to get there early, before 9pm. After that it's à la carte.

**Aux Artistes** 61 rue Falguière, 15e (metro: Pasteur).
A restaurant to get any hungry person off the boulevard — a surly Mama behind the bar regiments flocks of enthusiastic eaters, including transvestites from nearby night-club. Don't be put off by garish decor or insults from waiters but get there early for massive portions of good French country cooking — about 50F.

**Wajda** rue de la Grande Chaumière (off main boulevard, metro: Vavin).
Another Montparnassien institution for those low on budget. Cheap menu, about 30F, for basic food and friendly service — Polish dishes and owner. Located in an arty street — suppliers, ateliers (Gauguin and Modigliani) you can actually smell the paint.

**Glacier Calabrese** 15 rue d'Odessa, 14e 320.3163.
Open 10am-midnight. Near the tower. Mamma and Pappa create extravagant Italian ice-creams and sorbets with reasonable prices.

**La Closerie des Lilas** 171 Bld du Montparnasse (corner of Bld St Michel).
Here you can sit where Lenin, Appollinaire, Breton, Hemingway etc. sat in their time thanks to the brass plaques on the tables. Otherwise the tradition continues and it's still an intellectual/artists' favourite, although the prices are for more successful ones. Bar, brasserie (about 75F) and pricey restaurant (about 250F) combine with tinkling piano music. Outside tables in summer and art-gallery in upstairs restaurant combine to make a Montparnasse institution. Open till 2am.

**Le Chat Grippé** 87 rue d'Assas, 6e 354.7000.
Sophisticated cuisine with some fish specialities in an ex-butcher's shop still complete with rococco facade. Menu changes often, so no lack of variety. Lunchtime 50F menu, evenings 100F and well worth it.

**Le Jardin de la Paresse** 20 rue Gazan, 14e 588.3852 (metro: Cité Université).
Set on the edge of the Parc Montsouris looking towards the lake, an appropriately greenhouse/conservatory construction with terrace for leisurely eating on a summer's day or evening. Menu about 100F.

**La Coupole** 102 Bld du Montparnasse 320.1420.
Open till 2am every day. Impossible not to mention this enormous restaurant and terrace-café reeking of the 20's/30's, known to every Parisian visitor. Vast, with high ceilings echoing with plate-clatter and international chatter while the 'stars' do their march-past . . . count on 120F but food is not great, better stick to the Café-bar.

*Near rue Mouffetard.*

**Le Sélect** immediately opposite — if you mention one, you have to mention the other. Mirrors and aspidistras, still an anglo-american haunt though spiced with more exotic characters. Bar and terrace good for observing Coupole crowd through the traffic.

**Rosebud** 11 bis rue Delambre, 14e metro: Vavin.
Little late-night bar — dark, crowded, jazz records with cosmopolitan 'intellectual' Montparnassien clientele. Just behind the Boulevard.

## 5th arrondissement

The 5th arrondissement is a students' haven and harbours a cosmopolitan selection of reasonably priced restaurants, particularly in the rue Mont Ste-Geneviève (metro: Maubert-Mutualité) leading to the Place de la Contrescarpe and the rue Mouffetard. The **Mayflower** pub, 49 rue Descartes, has a wide choice of foreign beers, Irish coffee etc. although they are selective-paranoic about their clientele. Nearer Jussieu and the university block try **Au Roi du Couscous** 11 rue Linné 331.3542, closed Monday, for good cheap couscous or go up the rue des Boulangers to **Aux Savoyards** at no. 14 (closed Sat night and Sunday) for a reliable generously served menu at about 35 F. The two other restaurants in the same street are almost as good, but get there before 10pm.

Down by the riverside vegetarians can go to the **Grenier de Notre Dame** 18 rue de la Bûcherie 329.9829 (closed Sun & Tues) which is smartly 'rustic' decorated and has good tahini pate and other macrobiotic specialities. 30-50 F.

## Other districts:

**Le Rubis** 10 rue du Marché St Honoré, 1e 261.0334.
Closed weekend. Open 7am-10pm. A small traditional charcuterie/cheese and wine bar complete with mirrors and tiles. Wide and reasonably priced choice of wines, friendly 'patrons'. Close to Tuileries.

**Chartier** 7 rue Fbg-Montmartre, 9e 770.8629.
metro: rue Montmartre. Another old favourite with bustling service and no lingering — outweighed by extra low prices. Large, noisy and fun. Last orders 9.30pm.

**Le Tassili** 8 rue de Beaujolais, 1e 260.9959.
metro: Pyramides. Funny little restaurant contrasting with the chic Jardins du Palais-Royal across road in a fascinating wandering area. Open 12-2 and 7-10 for cheap paella, couscous — about 35 F.

**Le Petit Véron** 1 rue Véron, 18e 606.7919.
metro: Abbesses. Closed Sat. midday and Sunday, otherwise open till midnight. Between the heights of Montmartre and the depths of Pigalle, a nice 30's style bistrot full of mirrors with a very reasonable menu.

**Khan** 11 rue Houdon 18e 257.7676. metro: Abbesses, Pigalle.
Open every day till 11.30. If you're yearning for Indian fare (also for take-away) this isn't a bad place, though pricey compared with London equivalents. Count on 80 F though there's a vegetarian menu — about 50 F.

**L'Epidaure** 70 rue Labat 18e 259.0663.
metro: Marcadet-Poissoniers. Moving further north here's a sworn vegetarian/natural eaters's delight which includes organic wine and a cheap menu about 35 F. Closed Monday.

**Le Train Bleu** Gare de Lyon, 12e 343.0906.
Open every day till 10.30pm. For an original setting overlooking the platforms in a fabulous Art Nouveau decor, but you pay for the latter rather than the cuisine. Count 200 F.

**Ha Yuan** 3 Passage Raguinot, 12e 344.1327.
Beside Gare de Lyon. Sliding right down scale to neglected decor but the Chinese food with Shanghai specialities is excellent value for 30 F and service always smiling.

**Le Martin Pêcheur** 79 Boulevard Bourdon, Neuilly 624.3263.
Closed Sun. lunch. To finish on a sophisticated note for lunching/dining on a barge — outside or inside. Count well over 100 F — again you're paying for the original setting. If you opt for it you'll need a taxi.

# Parks and gardens

Roving Londoners and New Yorkers may be taken aback at the reduced dimensions and formal lay-out of the parks in central Paris — to see nature go just a little wild you have to trek outside the city gates to the Bois de Boulogne and Bois de Vincennes. However you can still take a seat by a fountain on a gravel path and relax and if its sunny you won't be alone. Each park and garden has its own specialised clientele and this alone can make up for being whistled off the grass (where you stretched out in blissful ignorance) by a diligent park-attendant.

*Champ de Mars.*

**BOIS DE BOULOGNE** The largest open space in Paris containing both uncultivated and cultivated areas, woods, lakes (boat-hire), a zoo, two race-courses (Auteuil and Longchamp) and more. It's 'Jardin d'Acclimatation' — metro Porte des Sablons — is a recreational area and amusement park combined and also harbours a small zoo. Another area the 'Parc de Bagatelle' — metro Pont de Neuilly — was once privately owned and now contains beds and beds of roses and other well-tended flowers. If you're feeling strong, peckish and it's a sunny day go to the Lac

Inférieur — metro Porte Dauphine — hire a boat and row across to the island where you can lunch outdoors. Bicycles can normally be hired at the main entrances which may help to spot Sunday specialities which include the traditional 'boules' players (plus berets) and the Japanese residents in Paris playing baseball. And as night falls the underworld emerges . . . the main roads are lined with prostitutes, mainly transvestites.

**BOIS DE VINCENNES** serves the opposite side of Paris and its less chic arrondissments, but it has similar pleasures and amenities. Above all it boasts its magnificent 14th century castle — metro Chateau de Vincennes — which housed various Kings of France at the time, their medieval manners being born out by the dungeons. To visit the zoo use the metro Porte Dorée and watch hippopotami whirling their ears, crocodiles snapping jaws and twitchy baboons. (Open 9-5pm daily). The Vincennes racecourse is famous for its sulky-racing and meetings are held regularly throughout the winter — a colourful sight. Its 'Parc Floral' (just down from the Chateau) holds horticultural wonders and is also well supplied with contemporary sculpture, while the Buddhist temple built in 1931 and situated at the south end of the Lac Daumesnil, is a good example of kitsch and contains the largest Buddha in Europe — 5 metres high.

**BUTTES-CHAUMONT** metro: Botzaris or Buttes-Chaumont; Situated in the north-east of Paris this park was laid out in 1863 and is famed for its artificial hills and lake. Good for steep paths but the grass is often out-of-bounds, and local residents keep it well filled.

**JARDIN DU LUXEMBOURG** in the 6th arrondissement and a classic with its formal gardens, fountains, children's play ground, tennis-courts and book-devouring clientele. The generally pleasant surroundings are well supplied with chairs and lead away from the Luxembourg Palace built in 1620 for Marie de Médicis and now housing the Senate.

**JARDIN DES PLANTES** Situated near the Gare d' Austerlitz in the 5th arrondissement it surrounds the Natural History Museum. Weird and wonderful plants are labelled for the ignorant and it also claims a menagerie, a maze and a cramped zoo. Resident chess-players often occupy the shadier areas. For more botany go the other side of Paris to the **ALBERT KAHN GARDENS,** metro Pont de Sèvres, and its fabulous botanical collection in the Maison de la Nature at 1 rue des Abondances, Boulogne (tel: 603.3356).

**PARC DE MONCEAU** is the civilised preserve of the 8th arrondissement and a favourite for nannies plus their smartly dressed wards. Again, a formal lay-out and this time quite small.

**PARC DE MONTSOURIS** Situated south of Montparnasse and bordering on the Cité Universitaire, it is a reasonable size and contains a lake, an observatory of note, and dotted around the lawn above the lake sculptures by Arp, Brancusi, and Laurens. Nearby is a restaurant appropriately named "Le Jardin de la Paresse" (literally: the garden of laziness), backing onto the rue Gazan, which is exceedingly pleasant though expensive for eating outside on a summer's day.

**TUILERIES** Of eternal fame and impossible to miss if you are visiting the Louvre or the Jeu de Paume — the gardens stretch quite a distance along the Seine — sandwiched between the rue de Rivoli and the Quais. It's not easy to forget the city but good for promenading and convenient for taking a rest from museums. Sculptures by Maillol are well displayed at the Louvre end.

## Outside Paris:

**CHATEAU DE SAUVAGE** at Emance. Take the RN10 to Rambouillet, then a local road no. 176. Here you can find 100 acres of zoological reserve in astonishingly natural/wild surroundings — a hideout for rare birds and mammals and you may stumble upon film-crews making low-budget westerns.

**PARC DE SAINT-CLOUD** at Pont de Saint-Cloud. Buses 52, 72 or walk from metro at bridge. Within easy reach of the centre here is another formal park. Bicycles can be hired at gates.

Otherwise see section MUSEUMS OUTSIDE PARIS (Versailles, Sceaux, Chantilly, etc.).

## Fiona Dunlop

Fiona Dunlop was born in Australia in 1952 into an artist's family and brought up in London. She has a BA (Hons) in French from Sussex University and now lives and works in Paris. She has spent several years working closely with galleries in Italy, Monte Carlo, Paris and London (Edward Totah Gallery), as well as working for an internationally famous dress designer. She is now Paris Art correspondent for Arts Review, London and for Artline newspaper, London.

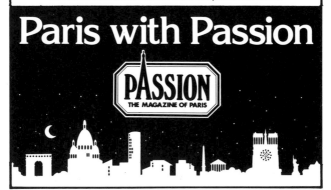

If you have any addresses or details that you think might be useful to add to this guide, I would be grateful if you would send them to me at the address below.

**Fiona Dunlop**
**Paris Art Guide**
**Art Guide Publications**
**28 Colville Road**
**London W.11. 2BS.**
**England**

Name of organisation/restaurant/gallery/bookshop/other information

...................................................................................................................

...................................................................................................................

Address.........................................................................................................

...................................................................................................................

...................................................................................................................

...................................................................................................................

Other information........................................................................................

...................................................................................................................

...................................................................................................................

...................................................................................................................

...................................................................................................................

...................................................................................................................

...................................................................................................................

Thank You.